Photographers of Genius at the Getty

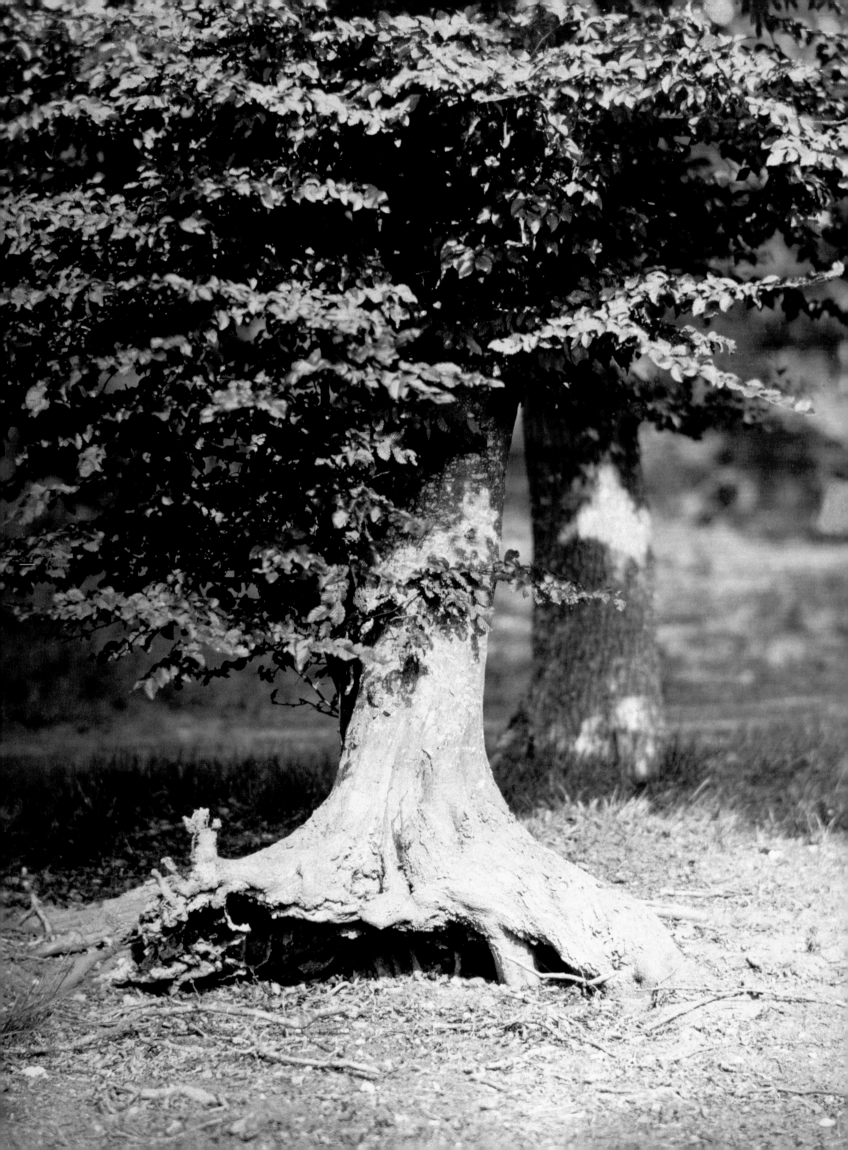

Photographers
of Genius
AT THE GETTY

Weston Naef

THE J. PAUL GETTY MUSEUM *Los Angeles*

© 2004 J. Paul Getty Trust
Third printing

Getty Publications
1200 Getty Center Drive
Suite 500
Los Angeles, California 90049-1682
www.getty.edu

This publication was produced to accompany
the exhibition *Photographers of Genius at the Getty,*
held at the J. Paul Getty Museum, Los Angeles,
from March 16 to July 25, 2004.

Christopher Hudson, *Publisher*
Mark Greenberg, *Editor in Chief*

Dinah Berland, *Editor*
Nomi Kleinmuntz, *Manuscript Editor*
Jim Drobka, *Designer*
Stacy Miyagawa, *Production Coordinator*

Typography by Diane L. Franco
Separations by Robert J. Hennessey Photography
Printed and bound in Germany by Dr. Cantz'sche
 Druckerei

FRONTISPIECE: Gustave Le Gray, *The Beech Tree*
(detail, PLATE 13); PAGE 6: Eadweard J. Muybridge,
Running (detail, PLATE 43); PAGE 8: Man Ray,
Self-Portrait with Camera (detail, PLATE 76);
PAGE 12: Manuel Alvarez Bravo, *Optical Parable*
(detail, PLATE 95); PAGES 13–14: Carleton Watkins,
Thompson's Seedless Grapes (detail, PLATE 34)

Library of Congress Cataloging-in-Publication Data

Naef, Weston J., 1942–
 Photographers of genius at the Getty / Weston
Naef.
 p. cm.
 ISBN 0-89236-748-2 (hardcover)—
ISBN 0-89236-749-0 (pbk.)
 1. Photography, Artistic—Exhibitions.
2. J. Paul Getty Museum—Photograph
collections—Exhibitions. 3. Photograph
collections—California—Los Angeles—Exhibitions.
I. J. Paul Getty Museum. II. Title.
TR645.L72P38 2004
779'.074794'94—dc22
 2003023658

Contents

Photographers of Genius at the Getty

20 2

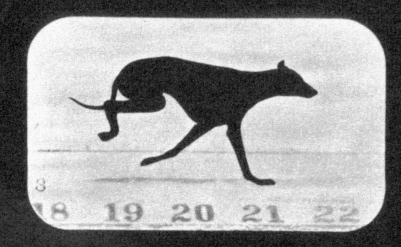

3

18 19 20 21 22

4

20 21

26 2

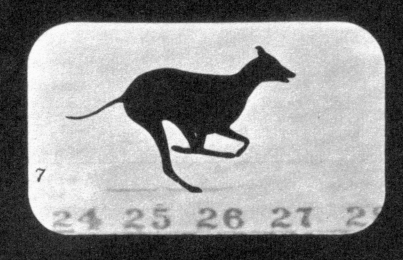

7

24 25 26 27 2

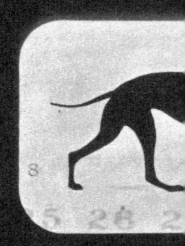

8

25 26

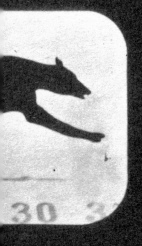

30 3

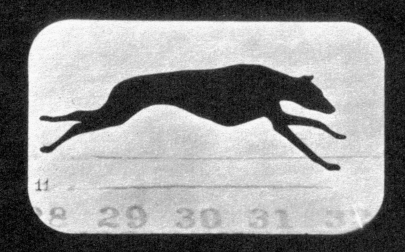

11

28 29 30 31 3

11

29 30

Foreword

In the early 1980s the Getty Museum was known chiefly for its collections of Greek and Roman antiquities, eighteenth-century French decorative arts, and European paintings. In the spring of 1984 John Walsh, then director of the Museum, proposed to Harold Williams, then president of the Getty Trust, and to the Board of Trustees a plan to form a new curatorial department through the simultaneous acquisition of several major American and European collections of photographs. This required a bold vision and good timing for the plan to succeed. Suddenly Los Angeles became a center for connoisseurship and study in the history of photography, from its experimental beginnings in England and France of the 1830s to the social documentary tradition of the twentieth century. By the end of 2003 the Museum had acquired about 35,000 individual prints, 1,500 daguerreotypes and other cased objects, 30,000 stereographs and cartes-de-visite, and 475 albums containing almost 40,000 mounted photographs.

As the Museum's curator of photographs, Weston Naef has guided the program of acquisitions, exhibitions, and publications with a discerning eye, driven by his abiding passion for the art of photography. Under his stewardship the collection has grown substantially, and the Department of Photographs has flourished as an educational and scholarly resource, with more than seventy exhibitions and thirty-five books to its credit.

The present undertaking, which commemorates the twentieth anniversary of the department, is dedicated to the vision and accomplishments of thirty-eight of the most important photographers represented in the Getty Museum's collection. Each of these artists possessed genius, as we are accustomed to defining it, in their extraordinary capacity for imaginative creation, invention, and discovery. Each created a body of work that exerted a profound influence, made a lasting contribution to art, and continues to resonate powerfully with us today.

I am indebted to William Griswold, associate director for collections, whose idea it was to prepare this exhibition and book, and above all to Weston Naef, whose own astute vision and significant achievements are reflected on these pages.

Deborah Gribbon
Director, The J. Paul Getty Museum
Vice President, The J. Paul Getty Trust

Introduction

This publication and the exhibition it accompanies have been created to celebrate the genius of more than three dozen photographers in the Getty Museum's collection whose pictures are exceptionally enduring in form and content. They are individuals whose daring experiments advanced the art of photography and changed the history of art in the process. This enterprise also marks twenty years of collecting rare photographs at the Getty Museum.

In 1984 the Museum's founding collections of photographs represented the deepest holdings in America of works by many master photographers of the nineteenth century. These included one hundred or more individual photographs each by Julia Margaret Cameron, Thomas Eakins, Roger Fenton, Hill and Adamson, Gustave Le Gray, Nadar, William Henry Fox Talbot, and Carleton Watkins. The fact that the strength of the collection originally lay in nineteenth-century photographs significantly influenced planning for the growth of the collection during the 1980s and 1990s. To complement these initial collections, the Museum's approach between 1984 and 1994 was to acquire groups of photographs by individual master photographers active in the first half of the twentieth century. Some notable acquisitions in this category were suites of photographs by Eugène Atget, Gertrude Käsebier, Charles Sheeler, Frederick Sommer, Alfred Stieglitz, Paul Strand, Doris Ulmann, and Edward Weston—all of whom are represented here.

Over the past decade it has become increasingly challenging to acquire bodies of work by many great photographers due to the shrinking supply. Our priority has therefore been to complement the strengths of the existing collection through the acquisition of small groups of photographs by very important makers along with exceptional individual photographs that contribute to the collection in various ways.

In considering which photographers to include here, it was not easy to select the few from the many extraordinary artists in the collection, although our criteria were clear: Each candidate must have exerted a strong formative influence on visual perception, whether during his or her lifetime or afterward; each needed to be represented by substantial holdings

in the Museum's collection; and each had to demonstrate great originality and artistic integrity.

As to the matter of influence, the work of many photographers can clearly be seen to have had a demonstrable impact. The effect of Nadar on portraiture, Carleton Watkins and Timothy O'Sullivan on landscape, Eadweard Muybridge on capturing motion, Lewis Hine on photography as an agent of social change, Alfred Stieglitz on penetrating the facade, Moholy-Nagy on experimentation, and Edward Weston on form versus content are but a few examples. Some relationships are more subtle, however, such as the influence of O'Sullivan on Walker Evans or that of August Sander on Diane Arbus.

Many important photographers of the nineteenth century lived and worked before it was possible to reproduce photographs mechanically on a printing press. Their influence was by necessity limited, and the impact of some of these pioneers is only beginning to be felt today. A few names here will be new even to experts. For example, early innovators Anna Atkins, Henry Bosse, Joseph-Philibert Girault de Prangey, the Langenheim brothers, and Camille Silvy have been rediscovered in recent years, bringing to light the importance of their particular contributions to the history of art and photography.

Among the inventory of more than eighteen hundred makers of photographs represented in the Getty Museum's collection, those with five or more photographs constitute 582 names, as listed in the back of this book (see page 171). A strong holding is defined as twenty-five or more photographs. A certain number of photographers were so experimental and ahead of their times, however, that the demand for their work during their lifetimes was low and the number of prints they made was therefore small. In such cases a dozen prints constitute a major holding, as is the case with Bosse and Sheeler.

The designation of genius, especially when considering the work of photographic artists, is clearly open to interpretation. Some individuals, however, because of their far-reaching imaginations and the inventive nature of their contributions, can wear that label without question. The paterfamilias and

WILLIAM HENRY FOX TALBOT
Wall in Melon Ground, Lacock Abbey, May 2, 1840
Photogenic drawing negative; 17.2 × 21.2 cm (6¹³⁄₁₆ × 8⅜ in.). 84.XM.260.6

perhaps greatest genius of the art was William Henry Fox Talbot (British, 1800–1877), who was active in photography between 1835 and 1855. Talbot's genius was to devise a two-step process by which multiple positive paper prints could be made from a single negative. He was also the first to recognize that multiple paper copies could be mounted onto or adjacent to a page of printed text to serve as illustrations. Photographs and books have been connected ever since. In addition, Talbot was the first person to articulate the great variety of ways a photograph could contribute to knowledge. The most seminal of Talbot's work in the Getty Museum was created before ways to make photographs permanent had been discovered. These crucial works are still in a sense alive in their sensitivity to light and must therefore be kept in the dark except for very brief appearances for scholarly study and

monitoring of their condition by conservators. They can be made known only through reproductions and not displayed even if shrouded. For this reason, Talbot's work—which is one of the strengths of the Museum's photographs collection—is represented in the exhibition only through facsimiles and not original photographs.

Talbot explained the charisma of photography in a single sentence long before it was truly possible to stop time with a camera: "The most transitory of things, a shadow, the proverbial emblem of all that is fleeting and momentary, may be fettered by the spells of our *natural magic*, and may be fixed forever in the position which it seemed only destined for a single instant to occupy."[1]

Photographers of genius understand instinctively that theirs is a "super-natural" medium of expression. Those who

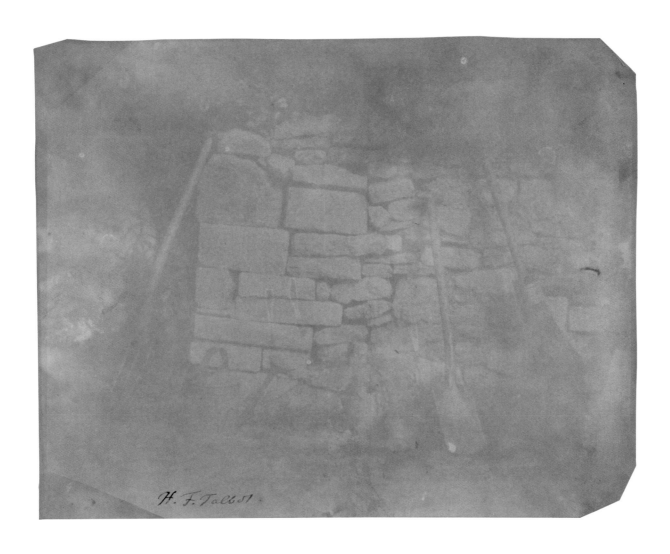

WILLIAM HENRY FOX TALBOT
Wall in Melon Ground, Lacock Abbey, May 2, 1840
Salt print from photogenic drawing negative; 17.2 × 21.7 cm (6¹³⁄₁₆ × 8⁷⁄₁₆ in.).
84.XZ.574.104

have earned the most general esteem are truth seekers as well and demonstrate Emanuel Kant's assertion that "*Genius is the innate mental aptitude* (*ingenium*) *through which nature gives the rule to art.*"[2] Truth is an element of genius, but genius reserves the privilege of imagining beyond the ordinary. The very best photographers express simultaneously the elements of both truth and beauty.

How photographers receive their education is a question that deserves consideration. Before about 1880 or 1890, when schools and academies of photography came into existence, photographers were either self-taught or trained as apprentices to already established photographers who, for the most part, operated portrait studios. The elements of portraiture could be more easily taught than landscape, urban views, and still-life photography; these required a special vision because

of the infinite number of choices available. Photographers of genius rarely learn to create from lessons that are taught but rather work instinctively from intuition, acting on impulses that come from deep within. The most consequential photographers manifest great soul and change the way we understand reality through their power to observe. We hope that this selection of work by the thirty-eight exceptional photographers represented here will offer inspiration to look further, delve deeper, and appreciate the genius of photography.

1. William Henry Fox Talbot, "Some Account of the Art of Photogenic Drawing," *History of Photography Monographs*, reel 174, no. 1928 (microfilm, Woodbridge, Conn.: Research Publications).

2. Emanuel Kant, in *Aesthetics: A Reader in Philosophy of the Arts*, ed. David Goldblatt and Lee B. Brown (New York: Prentice Hall, 1997), 494 (italics in the original).

Acknowledgments

Grateful acknowledgment is extended to Anne Lyden, assistant curator, and to Tami Philion, curatorial assistant, at the J. Paul Getty Museum's Department of Photographs, who contributed greatly to the form and structure of this book and the exhibition it accompanies. The content is greatly dependent on exhibitions held at the J. Paul Getty Museum in Malibu between 1986 and early 1997 and at the Getty Center in Los Angeles since late 1997. For these exhibitions and the publications that accompanied them, thanks are due to the remarkable team in the Museum's Department of Photographs, whose taste and knowledge were influential, including associate curators Gordon Baldwin, Julian Cox, and Judith Keller, as well as curatorial assistants Brett Abbott and Paul Martineau. My thanks are also due to departmental administrative support staff members Valerie Graham, Marisa Weintraub, and Edie Wu, and to long-term departmental volunteer Ann MaGee. Michael Hargraves, research associate in the Department of Photographs, and Carole Campbell, associate registrar for Collections Management, documented all the makers whose photographs are held by the department.

Special exhibitions require diverse talents to ensure that the audience is informed as well as delighted and that the objects presented for display achieve their maximum visual potential. Among the other persons who have contributed significantly to this project are Marc Harnly, Lynne Kaneshiro, Ernest Mack, and Martín Salazar of the Paper Conservation Department, who prepared the photographs for installation in the exhibition.

All aspects of the exhibition were coordinated by Quincy Houghton, exhibitions manager, with the assistance of Amber Keller. The Museum's special exhibition galleries were designed for the installation by Reid Hoffman and Nicole Trudeau under the direction of Merritt Price. The design team worked imaginatively and effectively to configure the galleries and the graphic design program for this purpose. The exhibition was efficiently installed by the skilled staff of the Preparations Department under the direction of Kevin Marshall and Bruce Metro.

Viviane Meerbergen, education project specialist, created an interpretive scheme that adroitly meshes the processes of photography with its images. We acknowledge the adept work of Loretta Ayeroff, film consultant, and Laurel Kishi, performing arts manager, in planning a series of films on some of the photographers who are represented here.

For the production of this book, we are grateful to the staff of Getty Publications, particularly Christopher Hudson, publisher, and Mark Greenberg, editor in chief, and their talented publications team, including Dinah Berland, editor; Jim Drobka, designer; and Stacy Miyagawa, production coordinator, who together saw the book through its editing, design, and production phases, aided by Cecily Gardner, senior staff assistant, who secured reproduction rights. Nomi Kleinmuntz, freelance editor, edited the texts and offered valuable suggestions; Karen Stough proofread the book; and Coughlin Indexing Services prepared the index. Christopher Foster and Jack Ross of the Photo Services Department, with the aid of Susan Logoreci and Susanne Winterhawk, worked to ensure copy photography of the highest quality for reproduction.

Robert Hennessey skillfully made the digital separations for the illustrations. We are also grateful to Diane Franco, typesetter; Sue Medlicott, production consultant; and Dr. Cantz'sche Druckerei, printer.

This book is dedicated to the memory of Margaret Meanor Crawford.

13

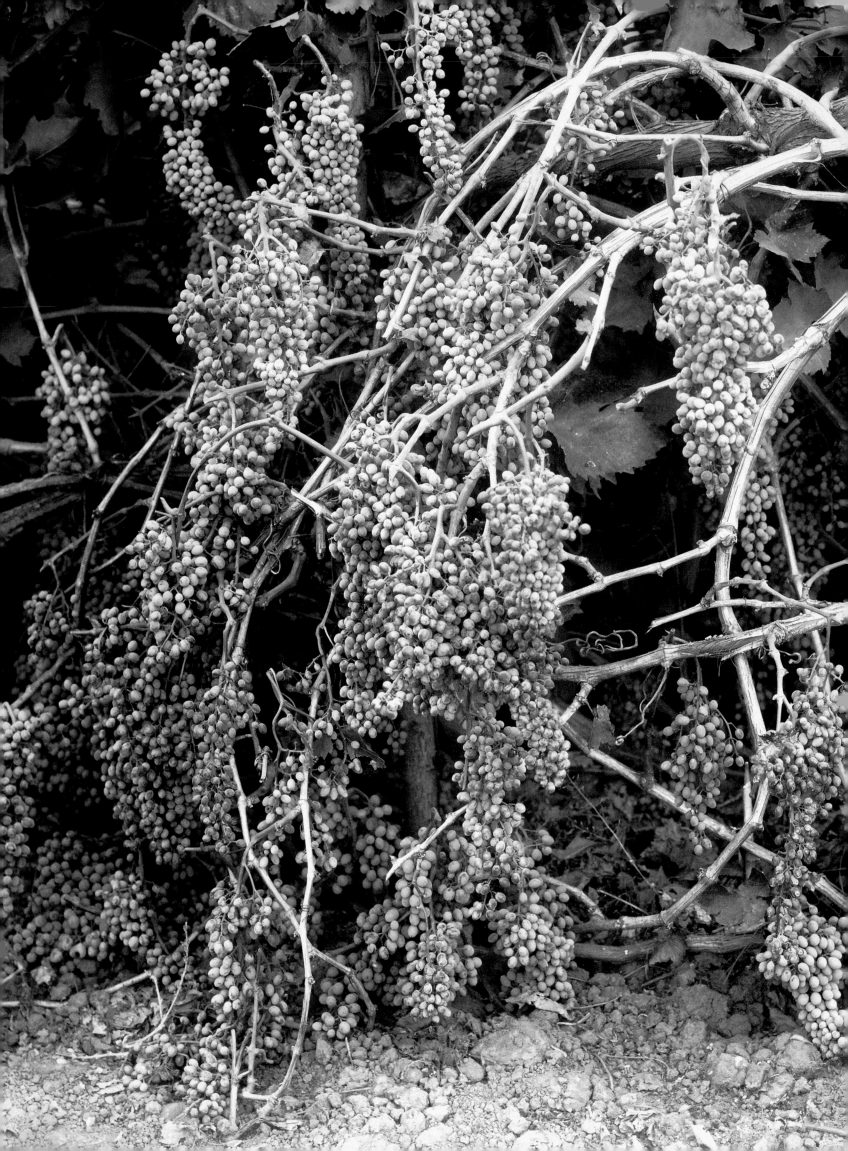

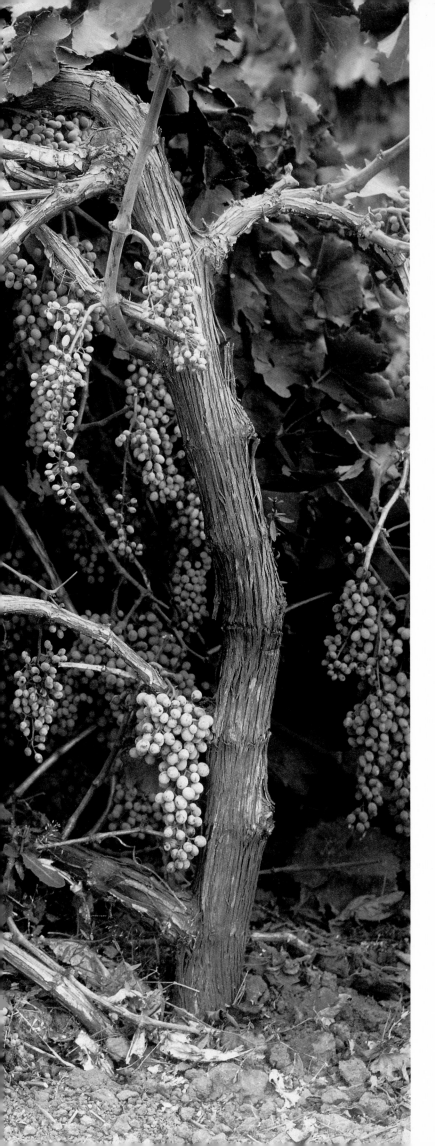

*Photographers of Genius
at the Getty*

While studying in Paris, the idea came to [Bayard], in his attic studio, of exposing at the back of a camera obscura a sheet of paper colored with the most fugitive vegetable colors and thus obtain the silhouette of the chimneys, attic windows, weather vanes, lightning rods, and other common or unusual things of prominence on the skyline.
—JULES ZIEGLER[1]

Hippolyte Bayard

By the summer of 1839—six months after William Henry Fox Talbot had first displayed his photogenic drawings and a few weeks prior to the first public display by Louis Jacques Mandé Daguerre—Hippolyte Bayard (French, 1801–1887) had progressed far enough in his experiments with light-sensitive materials to exhibit in Paris thirty of his own pictures made by light. The way in which Talbot and Daguerre became inventors of a new art is well documented, although Bayard's methods were not. We do know from evidence of surviving examples that Bayard devised a way to create direct positive photographs on paper by using a combination of Talbot's and Daguerre's processes, although the technical details of those earlier methods were as yet unpublished. The 1839 Paris exhibition in which Bayard's direct positive prints were shown consisted of paintings, drawings, sculpture, and "curiosities"—the last being the category in which his work was placed. This was the first time photographs—or "sun pictures," as Bayard called them—were exhibited alongside drawing and lithography, the media of expression to which photography was most frequently compared in its early years. (Daguerre was represented in this exhibition by drawings and paintings only.)

The great majority of Bayard's earliest surviving photographs were created after 1842, when he was introduced to Talbot and Sir John Herschel by the British photographer Calvert Jones, who was Talbot's disciple. Some of Bayard's most visually arresting pictures were made with the cyanotype process, discovered by Herschel in the spring of 1842. This process is based on the light sensitivity of certain iron salts and is distinguishable by its characteristic bright blue color. Bayard used the cyanotype to create cameraless photograms, similar in technique to Talbot's photogenic drawings. Bayard's arrangement of flowers, plants, feathers, and textiles in *Arrangement of Specimens* (PLATE 1) focuses on the graphic quality of each element. Through his idiosyncratic choices—selecting a ruffled feather or boldly patterned textile—Bayard projected his own particular personality.

Bayard revealed even more of his personal preferences in his numerous self-portraits. In *Self-Portrait in the Garden* (PLATE 2) he forever changed photography by opening it up to specifically autobiographical content, an approach that had been available to painters for at least three hundred years. Bayard tells us about himself by showing how he dresses; he is neither bohemian nor aristocratic but rather solidly bourgeois. He associates himself with neither artifacts of political power nor symbols of material wealth but with commonplace objects—flowerpots, a watering can, a trellis, a vase, a barrel, a ladder. These objects appear to have been found as we see them here, and not arranged specifically for the camera.

Along with documenting his personal surroundings, Bayard turned his gaze to the world outside his garden and studio. In the process he became one of the first photographers to make the city and its construction his subject.[2] He was fascinated by the growth and change in Paris and its suburbs during the prosperity of Emperor Louis-Philippe in the 1840s. Bayard made many panoramic overviews and general street views of his city, as well as studies of individual buildings and monuments. Numerous photographers followed in Bayard's footsteps as chroniclers of Paris, the best known being Eugène Atget (see page 80). Bayard was most markedly ahead of his time in his interest in the process of urban change; scenes of actual work taking place were a rare subject in early photography. His study of a wall of a building under renovation—*Construction Worker, Paris*, about 1845–47 (PLATE 3), with a workman standing on a temporary scaffold—is exceptional as an early record of everyday life.

1. Jules Ziegler, quoted in Jean-Claude Gautrand, *Hippolyte Bayard: Naissance de l'image photographique*, exh. cat. (Paris: Trois Cailloux, 1986), 19. Translated by the author.
2. Nancy Keeler, "Hippolyte Bayard aux origines de la photographie et de la ville moderne," *La Recherche Photographique* (May 1987): 11–15.

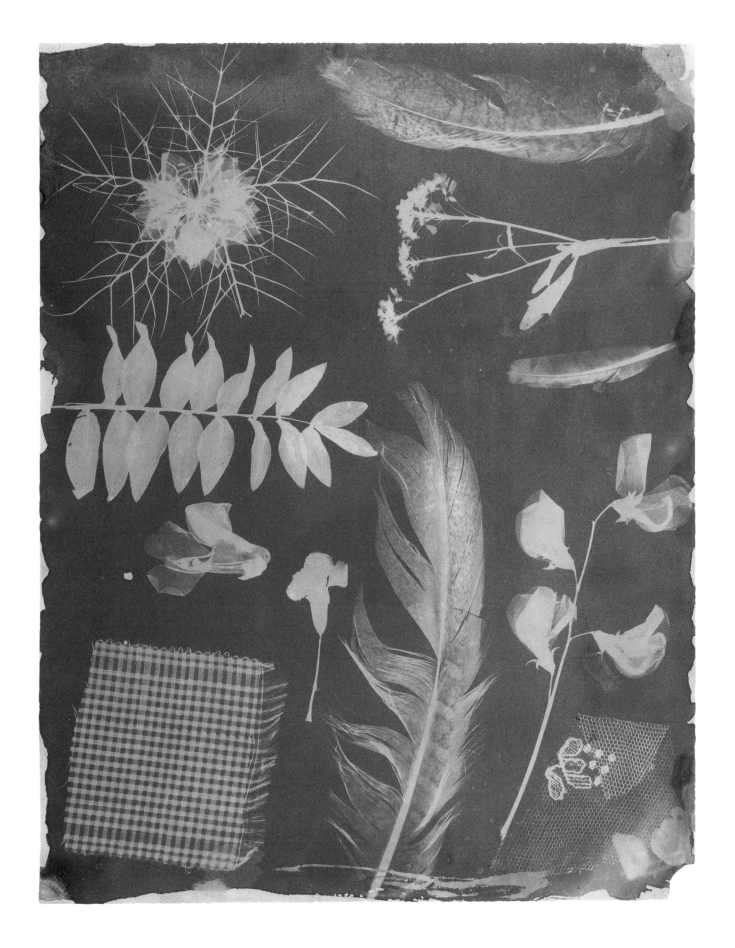

PLATE 1

Hippolyte Bayard

Arrangement of Specimens ca. 1842

Cyanotype (direct negative); 27.7 × 21.6 cm (10^{15}/$_{16}$ × 8^{1}/$_{2}$ in.). 84.XO.968.5

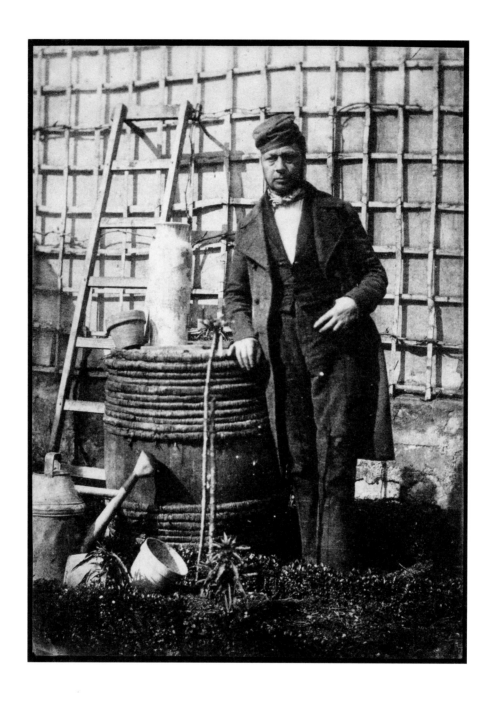

PLATE 2

HIPPOLYTE BAYARD

Self-Portrait in the Garden 1847

Salt print from paper negative; 16.5 × 12.3 cm (6 9/16 × 4 13/16 in.). 84.XO.968.166

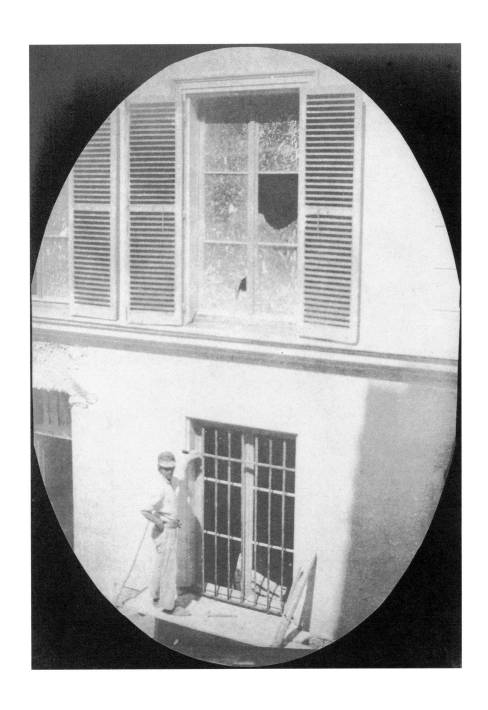

PLATE 3

HIPPOLYTE BAYARD

Construction Worker, Paris ca. 1845–47

Salt print from calotype negative; 16.6 × 11.7 cm (6⁹/₁₆ × 4⁵/₈ in.). 84.XO.968.82

Joseph-Philibert Girault de Prangey

Joseph-Philibert Girault de Prangey (French, 1804–1892) made his first "drawings with light" in 1841, the same year Louis Jacques Mandé Daguerre demonstrated his eponymous daguerreotype process in Paris.[2] Judging only from his results, Girault de Prangey must have learned to photograph from a very good teacher—someone like Daguerre or Hippolyte Bayard (see page 16), with whom he could have become acquainted through their mutual friend, the painter Jules Ziegler.[3]

Armed with a few hundred pounds of cameras, lenses, chemicals, and related hardware, Girault de Prangey embarked in 1842 on an extended tour proceeding from his home in Langres, France, to the port of Marseilles to Italy and then on to Greece, Egypt, Asia Minor, Turkey, Syria, and Palestine. During the course of these travels, Girault de Prangey created between eight and nine hundred daguerreotypes, representing Greek, Roman, Early Christian, and Islamic monuments.

In Rome he moved his camera audaciously close to the so-called Temple of Vesta (PLATE 4) and ingeniously exposed just the top half of the columned temple. The temple is viewed from an elevated perspective and fills the silver-coated copper plate edge to edge, to the daring exclusion of the stylobate and one-third of the column shaft. No photographer before him had created an equally revealing picture of a celebrated public monument.

In Greece Girault de Prangey was greatly inspired by the remains of Periclean Athens. He assigned a number to each plate he made, which is a slender clue to their order. At the Acropolis his method seems to have been to experiment with smaller plates and then to return to make full-plate exposures, possibly referring to the small images as aids in framing his compositions. One such half-plate study (PLATE 5) takes as its subject an arrangement of archaeological remains, one of which he believed to be a figure of Victory that had been removed from the Temple of Athena Nike. The photographer moved close to the grouping, which was washed in bright sunlight, and exposed one-half of a large plate. The deep shadows are translated into luscious, velvety tones; the translucent quality of the diaphanous drapery—the hallmark of the sculptor Phidias—is more faithful to the delicacy of the source than any drawing or engraving might have been.

After spending two or three weeks exposing fifty or more plates around Athens, Girault de Prangey appears to have returned to the Acropolis to create full-plate exposures of its main structures, including the Parthenon (PLATE 6). He approached the monument from the north corner, carefully positioning the camera to fill the entire plate. The structural swelling in the columns to correct distorted perspective is truthfully recorded for the first time here, as is the poignant reality of the fractured columns now seen as rubble at the monument's base.

In 1845 Girault de Prangey returned to his home in Langres with a veritable treasury of images. He used the daguerreotypes as sources for drawings transferred to paper by lithography, which he published in a very small edition under the title *Monuments arabes d'Égypte, de Syrie, et d'Asie Mineure dessinés et mesurés de 1842 à 1845* (Arab monuments of Egypt, Syria, and Asia Minor drawn and measured from 1842 to 1845) (Paris, 1845). It appears that he never exhibited or otherwise made known this extraordinary body of work, not even for the widely celebrated fiftieth anniversary of photography in 1889, when other pioneers of photography were remembered. Girault de Prangey took private pleasure in his epochal enterprise. He looked at every plate and marked the list "complete" in 1865 and again in 1880. In the 1920s the hoard was discovered, untouched, in a storeroom in Girault de Prangey's home in Langres by its new owner, the Count de Simony, in whose family the remarkable pictures remained until eighty-six items were sold at auction in London in 2003.

1. Joseph-Philibert Girault de Prangey, quoted in Jacques-Rémi Dahan, *Deux lettres d'un voyage en Orient: Girault de Prangey, 1804–1892* (Langres: Dominique Guéniot, 1998), 82–91. Translated by the author.

2. Bates Lowry and Isabel Barrett Lowry, *The Silver Canvas: Daguerreotype Masterpieces from the J. Paul Getty Museum* (Los Angeles: J. Paul Getty Museum, 1998), 21.

3. *Important Daguerreotypes by Joseph-Philibert Girault de Prangey from the Archive of the Artist*, auction cat., Christie's, London, May 20, 2003, 118.

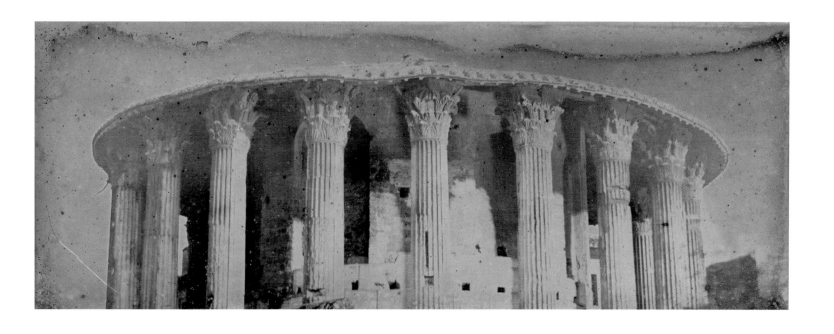

PLATE 4

Joseph-Philibert Girault de Prangey

Rome, So-Called Temple of Vesta 1842

Half-plate panoramic daguerreotype; 9.4 × 24 cm (3¹¹/₁₆ × 9⁷/₁₆ in.). 2003.82.1

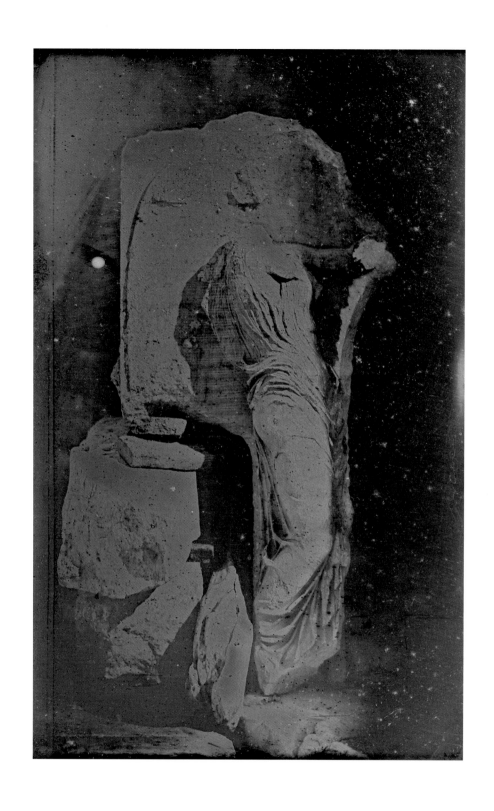

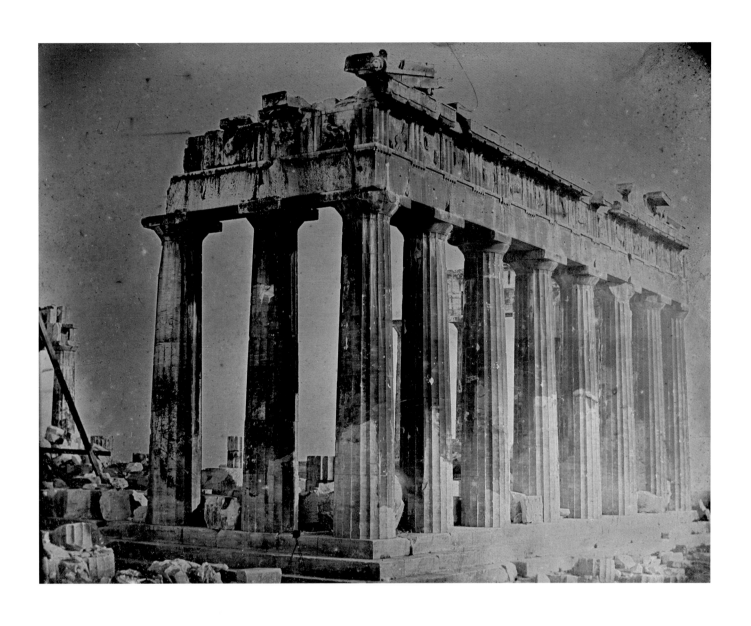

PLATE 6

JOSEPH-PHILIBERT GIRAULT DE PRANGEY

Facade and North Colonnade of the Parthenon, Athens 1842

Whole-plate daguerreotype; 18.8 × 24 cm (7⅜ × 9⁷⁄₁₆ in.). 2003.82.2

The difficulty of making accurate drawings of objects as minute as many of the Algae and Conferva, has induced me to avail myself of Sir John Herschel's beautiful process of Cyanotype, to obtain impressions of the plants themselves, which I have much pleasure in offering to my botanical friends. —ANNA ATKINS[1]

Anna Atkins

Anna Atkins (née Children, British, 1799–1871) was trained in drawing and attracted to the study of botany and natural history at an early age. By her mid-twenties she was a collector of seashells and aquatic plants. Atkins was introduced to the art of photography by her father, George Children, a leader in the Royal Society of London for Improving Natural Knowledge, an organization that published a journal titled *Philosophical Transactions.* During its early years, photography was embraced as a branch of philosophy as well as a method for making pictures.

At the January 25, 1839, meeting of the Royal Society, William Henry Fox Talbot first introduced his photogenic drawings, or "pictures made with light." In September 1841 he sent to Children a package of pictures produced through a process he had renamed calotype (from the Greek "beautiful picture"). Children acknowledged the gift saying, "My daughter and I shall set to work in good earnest 'till we succeed in practicing your invaluable process."[2] Atkins, however, became more interested in the cameraless cyanotype process discovered by Talbot's friend Sir John Herschel. Herschel named his process after *cyan*, the Greek word for "deep blue." He published his discovery in the August 1842 issue of *Philosophical Transactions* and sent an offprint to Children and Atkins.

For ten years, starting in 1842, Atkins employed the cyanotype process to create an inventory of plant specimens. Her collection of aquatic plant life, particularly seaweed, was one of the most comprehensive in England. Atkins thus became the first person in the history of photography to use light-sensitive materials to catalogue a collection of objects and gather that information into books.[3] She was also the first woman to create an extensive body of photographs. Her publication, *British Algae: Cyanotype Impressions*, was issued in individual parts beginning in 1843.

The process of presenting visual information in book form is so commonplace and familiar today that it is difficult to imagine a time when it had never been done. To better grasp Atkins's achievement, which like all great art appears to have been realized by an effortless creative action, we need to trace her process step by step. First was her decision to collect a class of objects—algae (seaweed)—something with no apparent commercial value in England at the time, nor obvious beauty. One aspect of Atkins's genius, therefore, was her decision to transform into a series of pictures a humble piece of nature that had never before been faithfully depicted.

Aquatic plants could be gathered directly from bodies of water or acquired by exchange with other plant collectors. Atkins probably did both. As a careful collector, she no doubt performed the work of documenting the specimens by assigning them their proper names from William Harvey's *Manual of British Algae* (1841), which was not illustrated. She also would have prepared and stored the specimens for future study. Her pictures were made by coating a sheet of high-quality writing paper with a solution of iron and potassium, drying the paper in the dark, and arranging a specimen on the dry paper along with an identifying label handwritten on transparent paper. The assemblage would then have been exposed to direct sunlight for several minutes. After removing the plant specimen, she would have washed the paper in water to develop the image and then allowed it to dry. Finally, the dried sheets would have been gathered into groups and the gathered sheets sewn together to form the finished part book. Atkins apparently did all this work herself at first and then, toward the end of the project, enlisted the assistance of her close friend Anne Dixon.

The resulting cameraless pictures (PLATES 7–9), called *photograms*, record the plants' shapes. With the cyanotype process, the areas shielded from the light appear in shades of off-white and blue gray against a bright blue background. Atkins achieved pictures of extraordinary beauty from the combination of strong color and the faithful recording of nature's designs. Her series of hundreds of cyanotypes thus advanced human knowledge by reconciling truth and beauty.

1. Anna Atkins, quoted in Larry J. Schaaf, *Sun Gardens: Victorian Photograms by Anna Atkins* (New York: Aperture, 1985), 8.
2. Schaaf, *Sun Gardens*, 26.
3. Schaaf, *Sun Gardens*, 40.

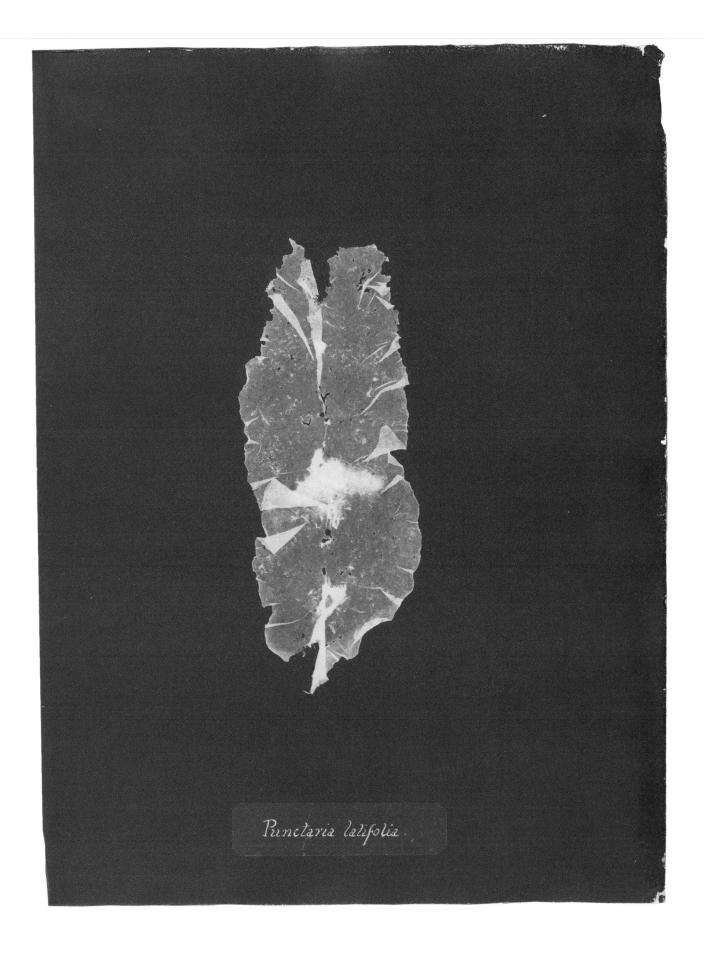

Punctaria latifolia.

PLATE 7

ANNA ATKINS

Punctaria Latifolia 1846–47

Cyanotype; 26.4 × 21.3 cm (10⅜ × 8⅜ in.). 84.XA.1107.3

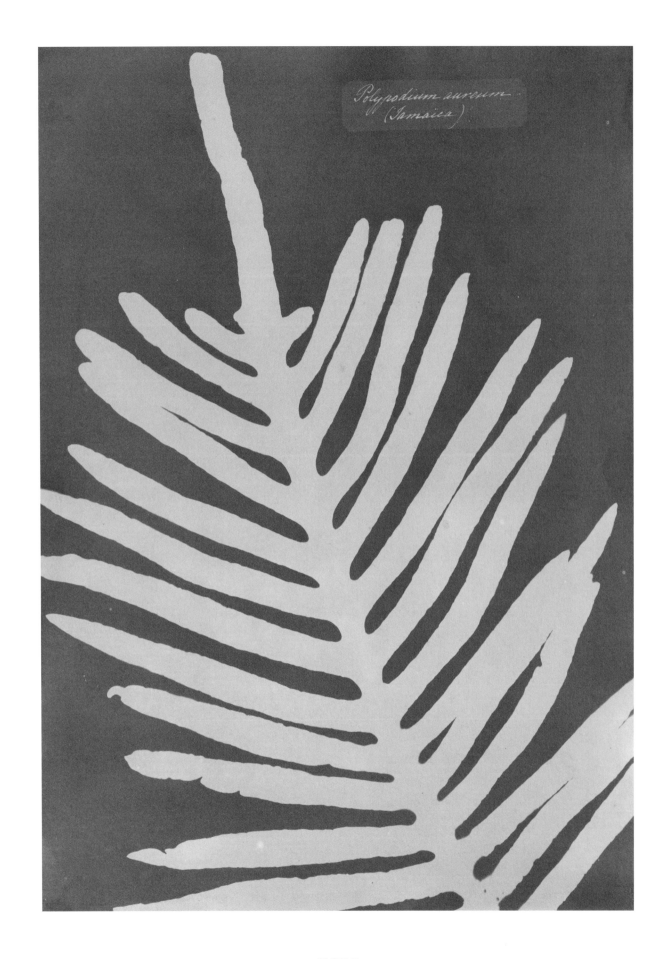

Polypodium aureum
(Jamaica)

PLATE 8

ANNA ATKINS AND ANNE DIXON
Polypodium Aureum (Jamaica) 1854

Cyanotype; 34.5 × 24.7 cm (13⅝ × 9¾ in.). 87.XM.115

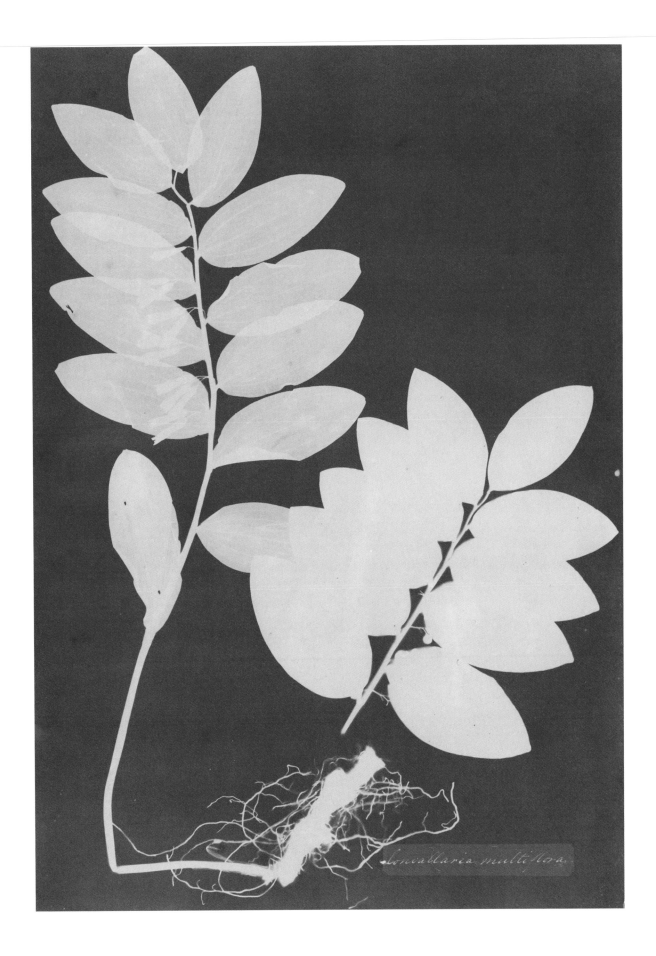

PLATE 9

ANNA ATKINS AND ANNE DIXON

Convalaria Multiflora 1854

Cyanotype; 34.8 × 24.8 cm (13¹¹⁄₁₆ × 9¾ in.). 84.XP.467.7

The rough surface & unequal texture throughout of the paper is the main cause of the calotype failing in details before the process [precision?] of Daguerrotypy [sic] — & this is the very life of it. They look like the imperfect work of a man — and not the much diminished perfect work of God. —DAVID OCTAVIUS HILL[1]

Hill and Adamson

As early as 1843/44 David Octavius Hill and Robert Adamson (Scottish, 1802–1870 and 1821–1848, respectively) began to experiment with a working method that has become commonplace today: the study of a community of people through a sequence of photographs. Hill and Adamson carried their primitive equipment to the seaside hamlet of Newhaven, one mile outside Edinburgh on the Firth of Forth, to photograph the inhabitants, both individually and in groups, in situations of daily life.

Between about 1800 and 1825 Scotland went through a dramatic social change as country people, dislodged from their traditional homelands by changes in agriculture and the rise of industrial opportunities, migrated to the cities. While property-owning city dwellers had grown prosperous from the industrial revolution and moved into affluent new neighborhoods, their old neighborhoods became some of the worst slums in 1830s Britain.

In 1849 the social theorist George Bell proposed the creation of new communities modeled on ones like the fishing village of Newhaven, with its inhabitants' lifestyle held up as a moral example. Hill and Adamson's intention in photographing Newhaven was to document the way in which this village had survived—both morally and physically—the Industrial Revolution and its ensuing social dislocation.[2]

The men of Newhaven, most of whom were fishermen by trade, fished from open dories fifteen to twenty feet long, which they propelled with oars by the strength of their backs. They would row as far as two hundred miles north to Wick, where they would fish for six to eight weeks before rowing back home. A fisherman's life was dangerous; one storm in 1848 drowned a hundred or more men, who left behind 47 widows and 161 orphans.[3]

The social structure of the Newhaven fisherfolk and the dangerous nature of the men's work may provide insight into a photograph Hill titled *The Letter* (PLATE 10). In this composition that recalls seventeenth-century Dutch painting, three women, dressed in boldly striped cotton skirts have

stopped what they are doing to read a letter. We can imagine that the letter bears news from or about a loved one who is away on the annual northward migration. At a time in the history of photography when capturing spontaneity was impossible for technical reasons, *The Letter* looks deceptively unplanned. One woman leans over the shoulder of the one reading, while a third holds an apparently casual contrapposto position. Contrary to the impromptu appearance of the captured moment, the three women are locked firmly into position by three-legged posing stands, two legs of which can be seen retouched at the feet of the figure at the right.[4]

Mrs. Elizabeth (Johnstone) Hall (PLATE 11) is formally posed in bright sunlight that casts deep shadows, obscuring half of the subject's face while also expressing the beauty of her nose, lips, and brow. Her wedding band clearly visible, she firmly grasps a fish basket, which is the emblem of her work.

Newhaven Fishermen (PLATE 12)—a picture that captures a gathering of eleven fishermen dressed in natural denim trousers, dark wool jackets, and top hats—invites us to imagine what it was like for a photographer to work with a group of men who had never before seen a photograph. In contrast to the women in *The Letter*, the fishermen are shown as they would naturally array themselves, gathered around a beached dory. Some lean on its gunwales, while others, apparently unmindful of the photographers' presence, appear blurred because they moved during the exposure. The figure in the center foreground stands in profile and appears to ignore the camera, while the figure to his right has his back to the camera. This unusual view is the kind of casual element that would not often be seen in photography for another fifty years.

1. David Octavius Hill, quoted in Sara Stevenson, *Facing the Light: The Photography of Hill and Adamson*, exh. cat. (Edinburgh: Trustees of the National Galleries of Scotland, 2002), 53.
2. Stevenson, *Facing the Light*, 105.
3. Stevenson, *Facing the Light*, 106.

4. Anne M. Lyden, *In Focus: Hill and Adamson*, Photographs from the J. Paul Getty Museum (Los Angeles: J. Paul Getty Museum, 1999), 78.

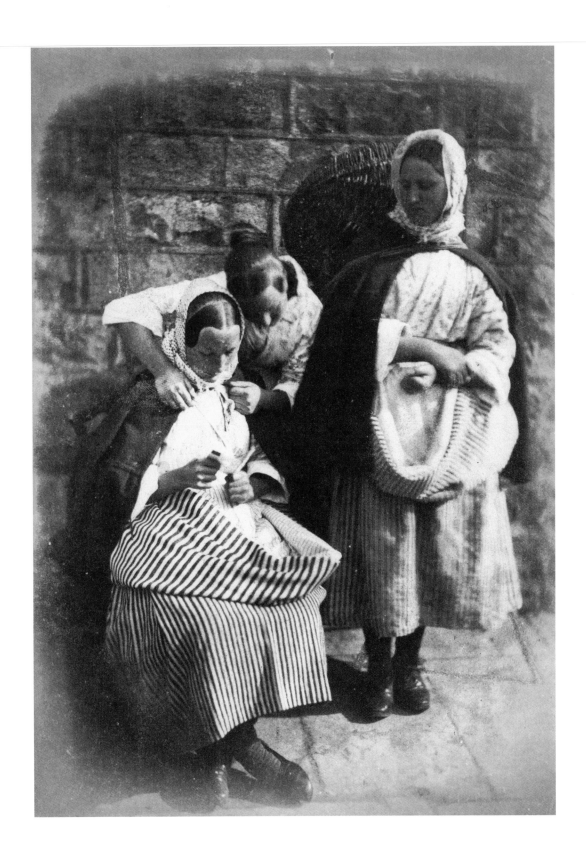

PLATE 10

HILL AND ADAMSON

The Letter (Marion Finlay, Margaret Dryburgh Lyall, and Grace Finlay Ramsay) 1843–47

Salt print from calotype negative; 20.4 × 14.3 cm (8 × 5⅝ in.). 84.XM.966.10

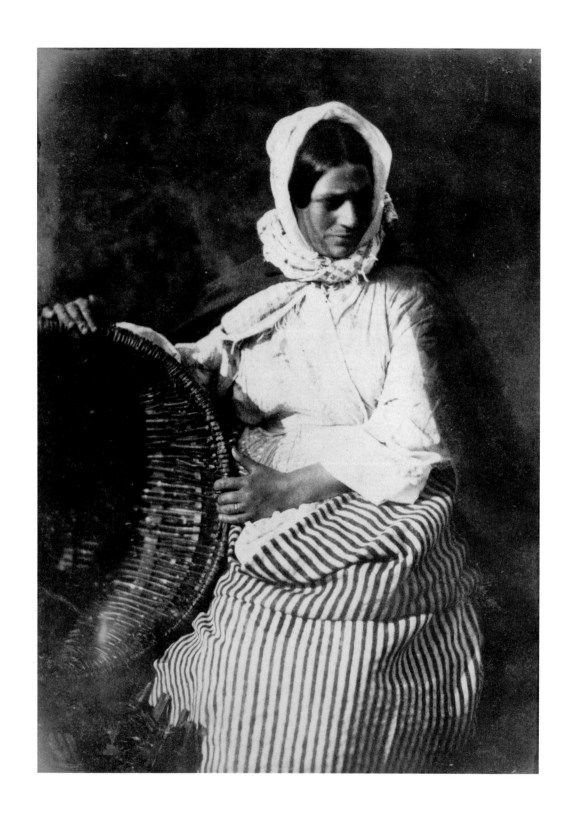

PLATE 11

HILL AND ADAMSON

Mrs. Elizabeth (Johnstone) Hall ca. 1846

Salt print from calotype negative; 19.2 × 13.8 cm (7½ × 5⁷/₁₆ in.). 84.xo.734.4.5.2

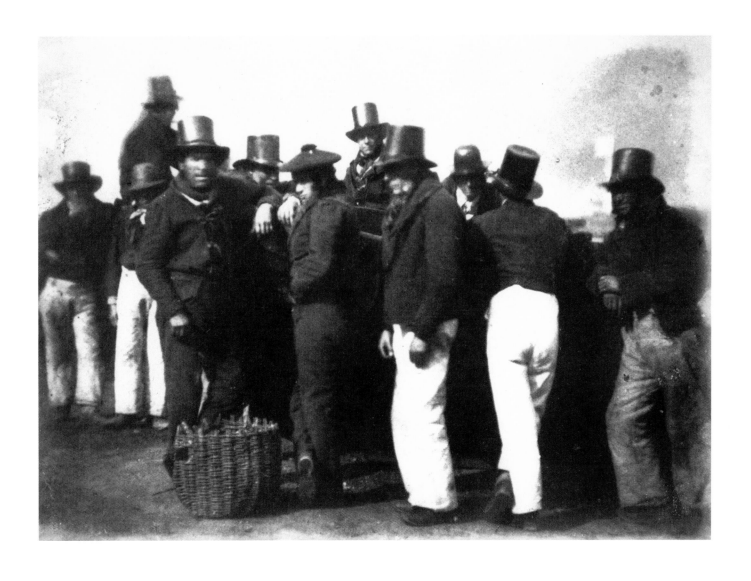

HILL AND ADAMSON

Newhaven Fishermen 1845

Salt print from calotype negative; 14.1 × 19.4 cm (5⁹⁄₁₆ × 7¹¹⁄₁₆ in.). 84.XM.445.12

It is my deepest wish that photography, instead of falling within the domain of industry, or commerce, will be included among the arts. That is its sole, true place, and it is in that direction that I shall always endeavor to guide it. —GUSTAVE LE GRAY[1]

Gustave Le Gray

Gustave Le Gray (French, 1820–1884) was first introduced to photography as a student of the painter Paul Delaroche, one of the first academically trained artists to encourage his students to use photographs as an aid for drawing. Le Gray quickly recognized the creative possibilities of photography, to which he fully devoted himself by 1848. His experiments in depicting light and atmosphere paralleled concerns of Barbizon painters and anticipated the Impressionist movement. He also developed new photographic processes and techniques, including the waxed-paper negative, which, before the advent of negatives on glass, improved the clarity and resolution of prints.

Between the years 1848 (when Hill and Adamson's studio in Edinburgh closed) and 1855 (when Le Gray opened his portrait studio on the boulevard des Capucines in the heart of Paris), photography as an art, as a profession, and as a business changed dramatically. Paris, London, and New York witnessed a genuine mania for photography by a public that had a seemingly insatiable appetite for being pictured. The financial potential of portraiture enticed artists and entrepreneurs. With money provided by investors, Le Gray designed an opulent portrait studio, and by 1855 his talent had propelled him into becoming the most celebrated photographer in Paris. His extravagant studio was operated by a team of at least six assistants, whom he directed. Le Gray's dream-come-true soon turned into a nightmare, however, as intense competition caused income to be short of expenses.

Around 1856, at the very time he was suffering from the adverse financial situation at boulevard des Capucines, Le Gray began a self-assigned series of photographs that had light and form as their chief subjects. *The Beech Tree* (PLATE 13), one of the first of these studies, takes as its subject a mature but insignificant beech. Yet it is bathed in glorious light. Le Gray positioned the camera low and close to the tree, omitting much of the foliage and instead focusing attention on the pools of light and tapestry of reflections on the

leaves. The negative was exposed with a wide aperture, causing the background to be out of focus and thus drawing us to the lighted foreground. The effervescent light vivifies and animates the tree.

During the summer of 1856, and possibly the summer of 1857, Le Gray made an epochal series of nearly two dozen seascapes on the northwest coast of France and the Mediterranean. Although his personal and financial life at the time was in turmoil, this series of pictures was supremely tranquil. He focused his attention on the transcendental nature of light as it passed through clouds and was reflected off the water, and he also experimented with the way light and the movement of water can express emotional states. His *Seascape with a Ship Leaving Port* (PLATE 14) was achieved by combining two negatives—one capturing a dark and dramatic sky and another showing a small sailboat leaving port and venturing out onto a choppy sea. The print Le Gray realized from the combined negatives calls to mind the emotion of fear and apprehension.

In 1860, in the face of mounting debt, Le Gray left Paris, and his name was seldom mentioned in print until a decade after his death in Cairo in 1884. A constant experimenter and innovator, Le Gray saw the chemical and mechanical limitations of photography as a challenge to overcome. Subjects such as a moving boat and a wave breaking on the rocks (PLATE 15), thought unphotographable because exposures were so slow, were successfully captured by Le Gray. No one in Paris predicted that a century after his death, Le Gray would be idolized for his exquisite power to observe and for the exalted beauty of his compositions. He was clearly ahead of his time in giving form to light.

1. Gustave Le Gray, quoted in Sylvie Aubenas, *Gustave Le Gray, 1820–1884* (Los Angeles: J. Paul Getty Museum, 2002), 44.

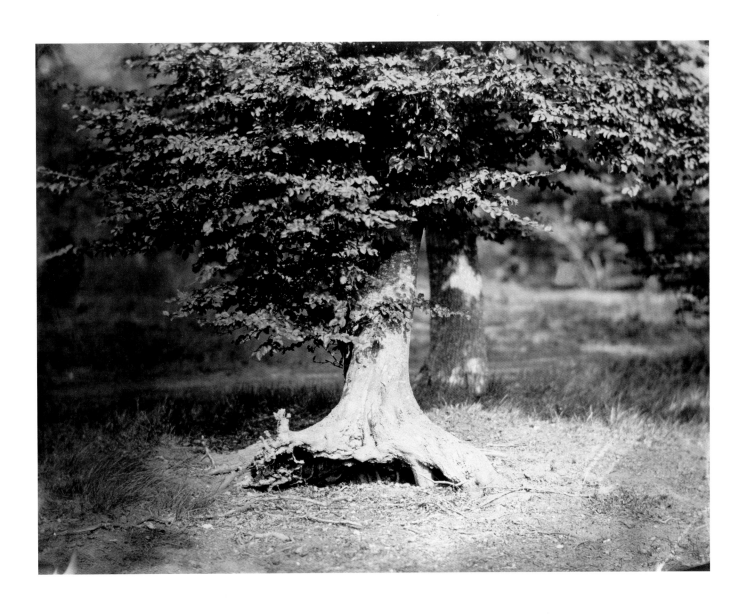

PLATE 13

GUSTAVE LE GRAY

The Beech Tree ca. 1856

Albumen silver print; 31.6 × 41.3 cm (12⁷⁄₁₆ × 16¼ in.). 84.XM.637.22

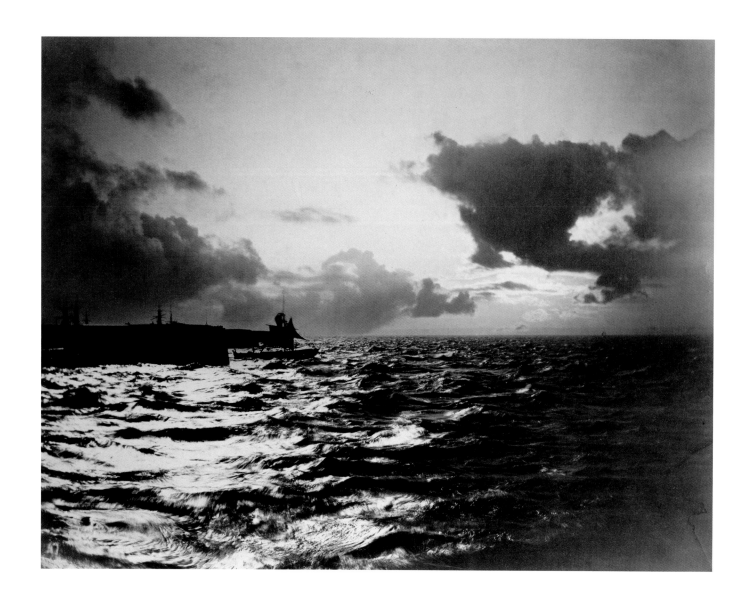

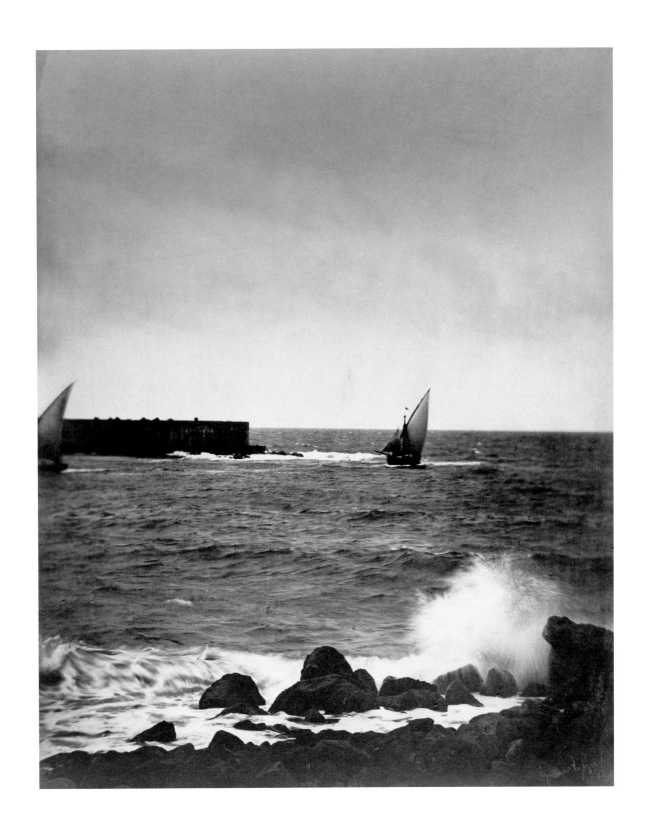

GUSTAVE LE GRAY

The Breaking Wave 1857

Albumen silver print; 41.4 × 33.5 cm (16⁵⁄₁₆ × 13³⁄₁₆ in.). 84.XM.347.11

What can't be learned, I will tell you: it's the sense of light. —NADAR[1]

Nadar

Gaspard Félix Tournachon (French, 1820–1910) adopted the pseudonym Nadar in the 1840s while writing rousing satires and drawing caricatures for Paris newspapers, for which he became known in literary and artistic circles. A self-described social gadfly, Nadar numbered among his friends many painters, sculptors, writers, and intellectuals who often became subjects for his work. In fact, the reproduction and display of Nadar's drawings, and later his photographs, brought fame to the artist as well as to his subjects.[2]

By the early 1850s Nadar had turned to portrait photography. To promote himself, he created numerous self-portraits in various characterizations, including one as an American Indian and another as an aeronaut seated in the basket of a hot air balloon. In a more demure self-portrait (PLATE 16), Nadar gazes beyond the camera, slightly hunched. The fingers of his left hand grasp an object under a dark cloth while he leans his chin against his right hand, his fingers and bent wrist echoing the shape of his thick, unruly hair. The neutral setting and monochromatic backdrop set his work apart from that of most portrait studios, where elaborate backdrops and distinctive furniture were the norm.

Nadar's early portrait of the Romantic poet Marceline Desbordes-Valmore (PLATE 17) is one of his first portraits not of a family member. The poet's reflections on adoration, devotion, idolatry, love, passion, and their opposites brought her considerable fame in the Romantic era. Having borne a child out of wedlock, she was considered an archetype of the bohemian spirit. On Nadar's invitation, she visited the rue Saint Lazare studio before the photographer had decided on the formula of a neutral background and before he began to carefully orchestrate the sitters' hands. From the very beginning he showed an instinctive ability to achieve a natural resemblance while simultaneously drawing out a subject's spirit.[3]

One of Nadar's most important friendships was with the widely known, prolific French critic and writer Théophile Gautier. They had been acquainted for almost twenty years when the portrait shown here (PLATE 18) was made in 1855. Nadar surely waited until he was completely secure in the technical aspects of photography and had fully shaped his guiding visual ideas before calling to his studio the man he referred to as "the good Gautier" and "the faultless Théo."[4] Nadar sometimes posed his subjects in the courtyard at rue Saint-Lazare, where plentiful indirect light poured in from above. This explains why many of his sitters look dressed for the outdoors, as Gautier does here. With his long, dark hair and uncoiffed beard, Gautier is a model of the creative vagabond. In Nadar's picture Gautier seems to tower heroically, an effect resulting from a low vantage point with the camera positioned close to the subject. In this portrait Nadar has hit his stride, having reduced the composition to its most essential elements: neutral space, understated clothing, and unseen hands. We are presented quite literally with the face of one genius observed by another.

By the 1860s the name Nadar was audaciously emblazoned in large, red, three-dimensional letters on the facade of an opulent studio on the fashionable boulevard des Capucines in Paris (where Gustave Le Gray's studio had also been located; see page 32). Even after Nadar had turned over the day-to-day operation of his successful business to assistants in the 1870s, his signature trademark was highly sought after. It was Nadar who had invented the idea that a photograph made by a famous photographer could serve as a valuable tool for a sitter who aspired to fame.

1. Nadar, quoted in John Updike, "Nadar's Swift Tact," *The New York Review*, May 25, 1995, 18–19.
2. Gordon Baldwin and Judith Keller, *Nadar/Warhol:Paris/New York: Photography and Fame*, exh. cat. (Los Angeles: J. Paul Getty Museum, 1999), 36–38.
3. Baldwin and Keller, *Nadar/Warhol*, 61.
4. Baldwin and Keller, *Nadar/Warhol*, 63.

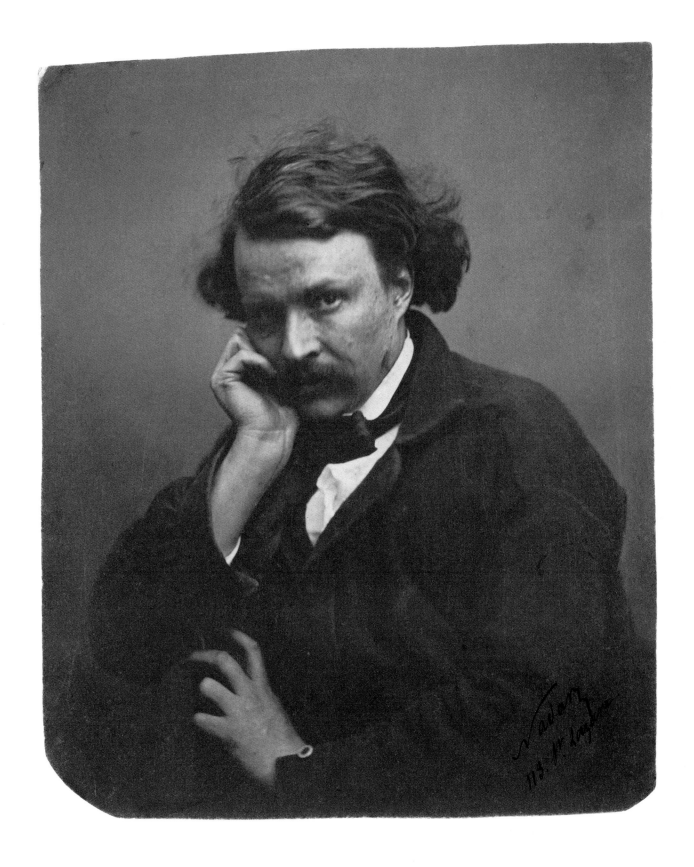

PLATE 16

NADAR

Self-Portrait ca. 1855

Salt print; 20.5 × 17.0 cm (8¹⁄₁₆ × 6¹¹⁄₁₆ in.). 84.XM.436.2

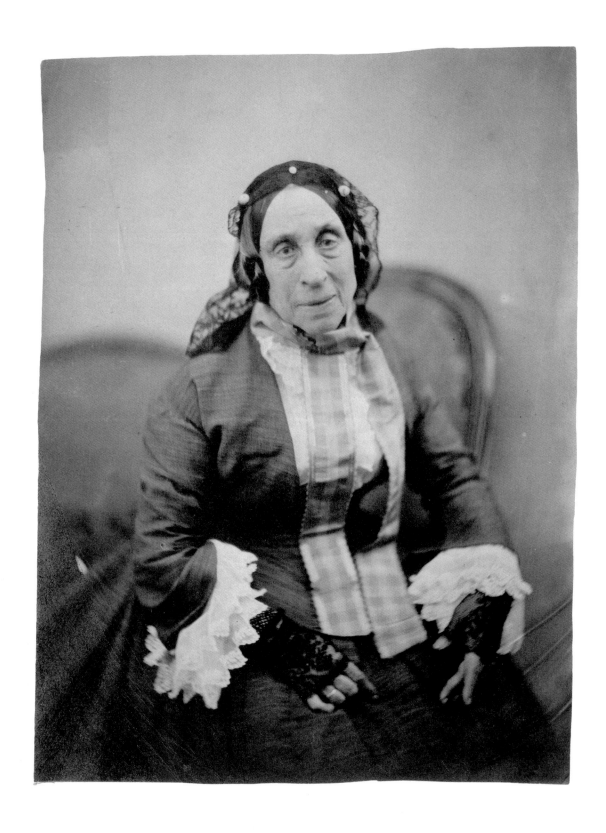

PLATE 17

NADAR

Mme Desbordes-Valmore 1854

Salt print; 19.6 × 14.9 cm (7 ²³/₃₂ × 5 ⅞ in.). 84.XM.436.141

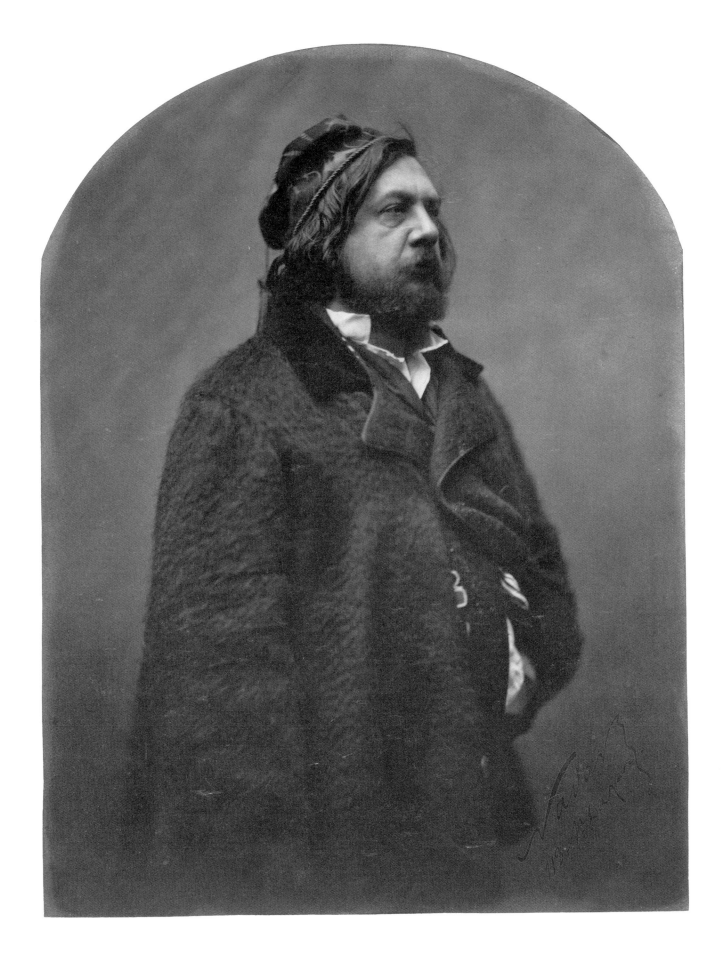

PLATE 18

NADAR

Théophile Gautier 1855

Salt print; 25.6 × 19.6 cm (10⅛ × 7¾ in.). 84.XM.436.127

The water, the foliage, the figures, the distance, the sky, are all perfect.... It is the most exquisite landscape we have seen in photography. —EDINBURGH EVENING COURANT[1]

Camille Silvy

In 1858 Camille Silvy (French, 1834–1910) was a young aristocrat, whose ancestors could be traced back many generations to Provence, France, and Sienna, Italy. He was born in the picturesque village of Nogent-le-Rotrou on the river Huisne, north of Paris, where his family was well established.[2] Silvy was, like most amateurs of his day, mostly self-taught in photography. By his early twenties he had worked with the French photographer Count Olympia-Clemente Aguado de Las Marismas, who was famous for using painted backdrops in portraits to create the illusion that the sitter is in an idyllic landscape. Silvy learned from Aguado that a photograph could be a skillfully contrived illusion as well as a truthful report. He took the creation of visual illusion to a new level and guarded the secrets of these remarkable effects.

The facility with which Silvy could fabricate artificial reality for his sitters is evident in the cartes-de-visite portraits he created of socially prominent individuals in London, where he emigrated from Paris for political reasons around 1859/60. In sharp contrast to the style and technique of Nadar's portrait subjects, who were usually attired in their everyday clothes and posed against a neutral background in soft light (see PLATES 16–18), Silvy photographed his clients in their very finest evening gowns and dinner jackets and posed them in fictional, opulent surroundings, showered with light. His enormous, well-staffed studio in London's Bayswater district was a veritable warehouse full of furniture, paintings, and decorative objects that were deployed as props. The mirrors were reserved for beautiful young women, two of whom are seen here in front of the same mirror (PLATES 19, 20), which is positioned on a bureau in one photograph and on a draped table in the other. The magic of these portraits is that, in each case, the reflection in the mirror was not recorded on the same negative as the full-length figure but rather was taken from a second negative that was skillfully combined with the master image. This graceful artifice was Silvy's genius.

Before immigrating to England, Silvy had made an international reputation for himself as a landscape photographer. His magnificent *River Scene, France* (PLATE 21), depicting the Huisne river valley, was first displayed in Edinburgh in 1858, where it was noted by a contemporary writer that he had achieved perfection. Six prints of Silvy's *River Scene*, all different, are known to exist. The prints differ chiefly in their toning and the effect of light in the sky. Our eyes, however, are drawn to the ten or eleven figures positioned alongside the river, eight or nine on the right bank and two on the left. The perfection of their placement seems too good to be true. Is it possible that Silvy contrived the setting of his *River Scene*, employing methods like those he used to achieve *Twilight* of 1859–60 (PLATE 22), one of a planned sequence he called *Studies on Light*?

In *Twilight*, unlike any street view yet created in photography, we are invited to believe the distant figure is disappearing into the background fog and that the boy is really leaning against the lamppost. The arrangement could not have been realized on a single negative, however, and is the product of skillful manipulation. One negative was required for the street lamp, another for the foggy background, a third for the architecture at the right, and a fourth for the two standing figures. Clues to the artifice abound. We see moisture at the feet of the two figures reflecting light differently than do the surrounding surfaces. The join of one negative is along a line in the street to the right of the man, and a lump of black along the boy's back as it meets the lamppost betrays the join of another negative. In defense of his illusionistic methods, Silvy wrote, "Fine arts create. Photography copies."[3]

1. Review of Silvy's *River Scene* in *Edinburgh Evening Courant*, December 21, 1858, reprinted in Mark Haworth-Booth, *Camille Silvy: River Scene, France*, Getty Museum Studies on Art (Malibu: J. Paul Getty Museum, 1992), 15–16.
2. Haworth-Booth, *Camille Silvy*, 38.
3. Haworth-Booth, *Camille Silvy*, 83.

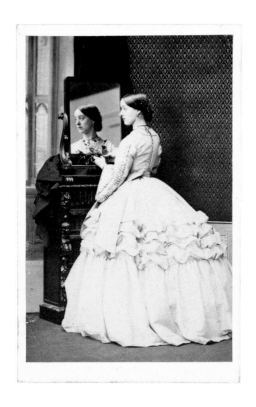

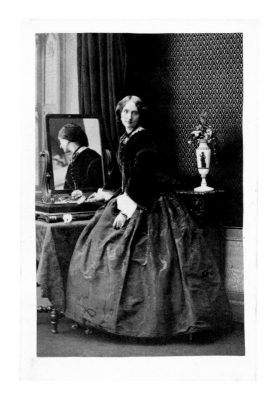

PLATE 19

CAMILLE SILVY

Lady Florence Paget ca. 1862

Albumen silver print; 8.6 × 5.6 cm (3⅜ × 2³⁄₁₆ in.). 84.XD.600.58

PLATE 20

CAMILLE SILVY

Miss West ca. 1862

Albumen silver print; 8.4 × 5.6 cm (3⁵⁄₁₆ × 2³⁄₁₆ in.). 84.XD.600.101

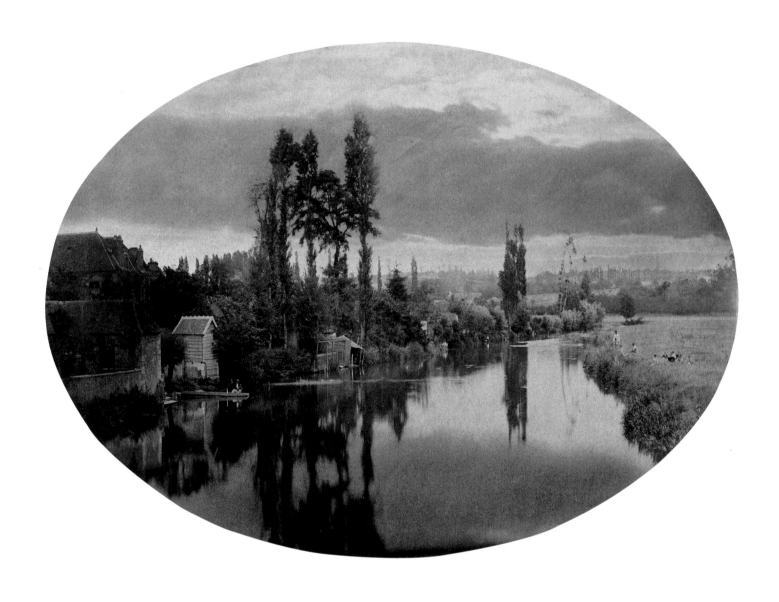

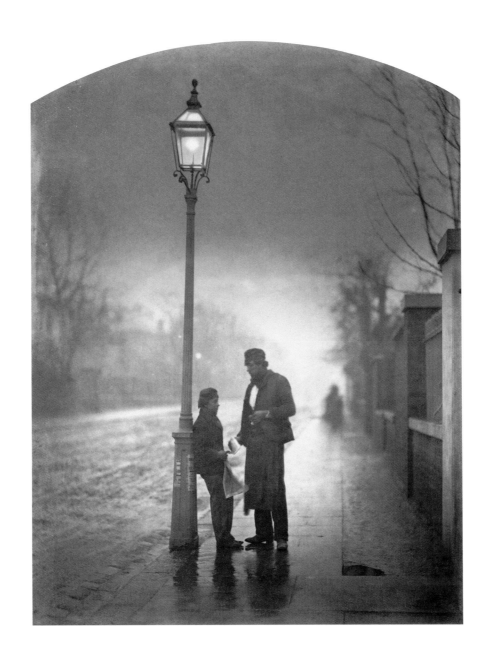

PLATE 22

CAMILLE SILVY

Twilight 1859–60

Albumen silver print; 27.4 × 22 cm (10^{25}/$_{32}$ × 8^{21}/$_{32}$ in.). 2002.11

I aim always in the production of negatives at the attainment of that kind of artistic result, the beauty of which I feel most strongly & as I have never yet succeeded in completely attaining that perfect result that I seek, I then seek in the positive print to compensate for any defect in the negative. —ROGER FENTON[1]

Roger Fenton

Roger Fenton (British, 1819–1869) was active in photography for a total span of less than a decade; however, his body of work, more so than that of any other photographer of the 1850s, demonstrates the differences in style and content between work made indoors and that made outdoors. He is most often recorded in history as the first war photographer, having made several hundred portraits and landscape photographs behind the scenes of the Crimean conflict. However, his true genius was for other accomplishments in the new art.

Fenton became recognized for his adventuresome travels to sometimes remote sites to photograph on location. Whereas the vast majority of his work was created in exterior environments, his most imaginative photographs were made indoors. One of his most startlingly original architectural works, *The Billiard Room, Mentmore House* (PLATE 23), was made inside a Rothschild estate in Buckinghamshire. This study was unusual for its depiction of leisure activity in a grand interior. Even with tall windows running down one side of the room, there was barely enough light for an exposure short enough to arrest the motion of the two figures playing the game of billiards and the four spectators. The sunlight pouring through the windows bathes part of the subject with intensely bright light, leaving the rest of the scene in shadow.

Fenton photographed the skeleton of an extinct giant ostrich (PLATE 24) at the British Museum, where exciting discoveries of the fossils of ancient creatures were on display. To visually isolate the specimen from the brick wall behind it, Fenton was obliged to improvise. He did so by arranging for a textile to be stretched over a framework positioned behind the object, with the excess material bunched on either side. Fenton probably imagined that once the negative was printed he could decide how he should trim the print to eliminate any extraneous content. However, only one print was made from the negative—this one—which leads us to ask whether Fenton may have been as fascinated by how the camera records the expected as by how it records the unexpected.

In 1855 Fenton sailed from England to Balaklava in the Crimea to document the war; he never got his camera to the line of battle but returned from his travels to the East with an awareness of Islamic culture. He borrowed souvenirs from friends in the form of textiles, musical instruments, and decorative objects obtained in Near East bazaars and incorporated them into a series of photographs made in what appears to be an artist's studio.[2] In *Pasha and Bayadère* (PLATE 25), Fenton has posed his model, who is outfitted in the free-flowing costume of a Turkish dancer, with her arms reaching overhead; her torso seems to undulate to music from an Egyptian-style spike fiddle. On her hands the dancer wears *zils*, or finger cymbals, which are of Arabic origin. Other musical instruments, such as an upside-down Arabic goblet drum and the tambourine that rests against it, are found in the background. The only typically Turkish instrument in this constructed scene is a *saz*, a lute, partially hidden on the floor between the fiddler and the pasha.[3]

Very little is authentic in this picture. The dancer's arms are held aloft by wires, the "pasha" is European, and the instruments come from several cultures. Here we have the product of the photographer's imagination, a Eurocentric fantasy of life in the Orient.

1. Roger Fenton to British Museum, June 9, 1859, letter no. 4995, British Museum.
2. Gordon Baldwin, *Pasha and Bayadère* (Malibu: J. Paul Getty Museum, 1996), 100.
3. Ken Moore, letter to author, April 27, 1988.

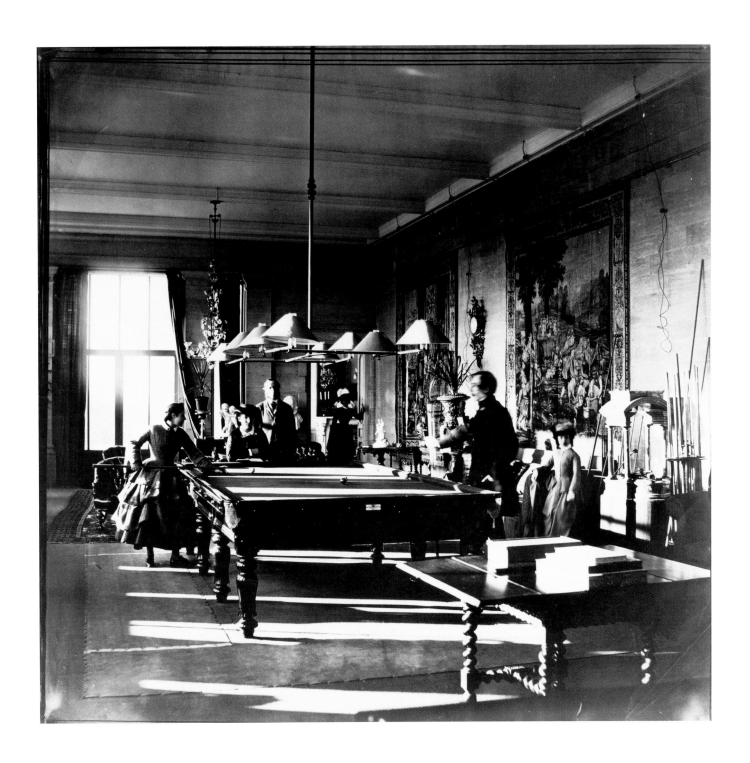

PLATE 23

Roger Fenton

The Billiard Room, Mentmore House ca. 1858

Albumen silver print; 30.3 × 30.6 cm (11 15/16 × 12 1/16 in.). 2001.27

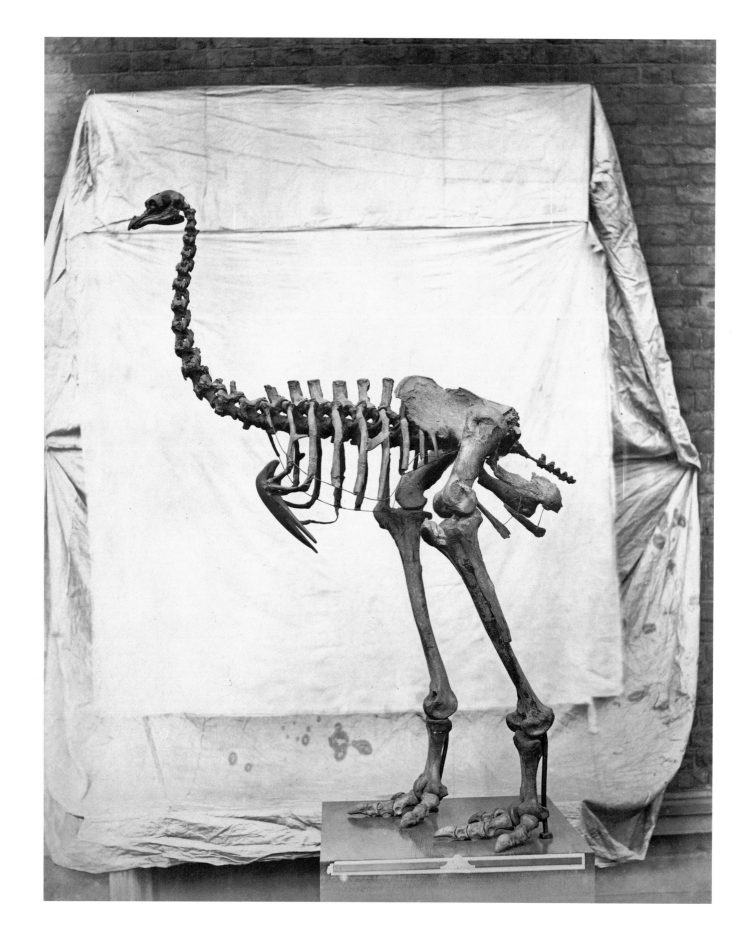

PLATE 24

ROGER FENTON

Dinornis Elephantopus ca. 1855

Salt print; 38.1 × 30.3 cm (15 × 11 $^{15}/_{16}$ in.). 84.XP.452.3

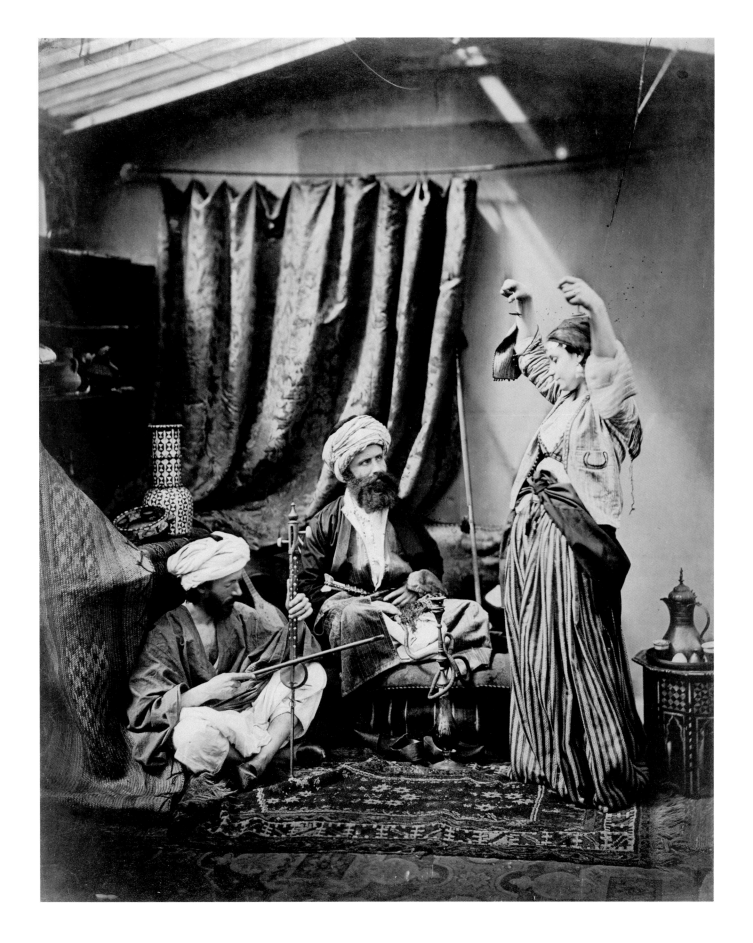

My aspirations are to ennoble Photography and to secure for it the character and uses of High Art by combining the real and Ideal and sacrificing nothing of the Truth by all possible devotion to Poetry and beauty. —JULIA MARGARET CAMERON[1]

Julia Margaret Cameron

Julia Margaret Cameron (British, born India, 1815–1879) was not the first woman photographer (see "Anna Atkins," page 24), but she was the first woman to earn international recognition for the practice of photography. She was also the first woman to change the history of photography through the impact of her work. Astonishingly, Cameron's photographs were not seriously collected by people outside her family and circle of friends until almost a century after her death.

Cameron looked chiefly to two sources for inspiration. One was literature in the form of poetry, fiction, and the Bible, and the other was her family, friends, and neighbors on the Isle of Wight. Inspired by Percy Bysshe Shelley's 1819 play *The Cenci*, Cameron posed Kate Keown, one of her young neighbors on the Isle of Wight, as the teenage Beatrice Cenci. The tragic story of Beatrice, who plotted with her stepmother and brother to assassinate her father as revenge for his violation of her, was seen by Cameron as an opportunity to embrace transcendent moral and social absolutes. Cameron's *A Study of the Cenci* (PLATE 26) mixes the ideal and the real. Kate Keown is swathed in a striped textile headdress and gazes despondently into space, her eyes expressing an all-knowing acceptance of the punishment she will receive. The pose resembles the graceful simplicity of Madonna and child paintings by Raphael and Guido Reni.[2]

In *Florence—Study of St. John the Baptist* (PLATE 27), Cameron's great-niece, Florence Fisher, dutifully performs her role as model. She cleverly has been posed against a leafy background like the ones frequently seen in paintings by Pre-Raphaelite artists such as John Everett Millais and Dante Gabriel Rosetti. Young Florence does not seem to have her heart in what she is doing, although her expression effectively conveys the sense of innocence and humility. In casting a girl as Saint John, Cameron manifests an audacious reversal of gender roles.

By 1875 Cameron realized that her heroic and strategic attempt to secure a meaningful supplement to the family income through photography was a failure. Over the fourteen years she was active in photography, Cameron dutifully had registered more than five hundred of her works for copyright protection, an action born of a belief in the commercial potential of her talent. However, expenses continuously exceeded income from print sales.[3] Financially in need and dispirited by the death of her vivacious adult daughter, Julia Norman (from whom the gift of a camera in 1863 launched her photography career), Cameron abandoned the idea of selling her photographs as a source of income. As if to admit defeat, in the fall of 1875 she and her husband departed for Ceylon to spend their last years on the family coffee plantations.

One of Cameron's last great photographs, created when she was over sixty years old, portrays a preteen Ceylonese girl seated on the floor with her legs gracefully tucked beneath her (PLATE 28). She wears a white cotton blouse and several pieces of jewelry—earrings, a necklace, two bracelets, and a ring on her little finger. We are left in the dark as to whether the valuable jewelry signifies that this is, indeed, a young princess or a household servant dressed and ornamented by Cameron for the picture. The tenderness of Cameron's visual caress suggests they are not strangers. The handling—selective focus (sharp in the eyes and soft in the foreground) and careful attention to the tilt of the head—marks this as pure Cameron. She surprises us by the persistence of her quest for beauty in a foreign culture and her sensitivity to her youthful subjects.

1. Julia Margaret Cameron, quoted in Julian Cox and Colin Ford, *Julia Margaret Cameron: The Complete Photographs* (Los Angeles: J. Paul Getty Museum, 2003), 41.
2. Cox and Ford, *Julia Margaret Cameron*, 57.
3. Mike Weaver, *Whisper of the Muse: The Overstone Album and Other Photographs by Julia Margaret Cameron* (Malibu: J. Paul Getty Museum, 1986), 18–21.

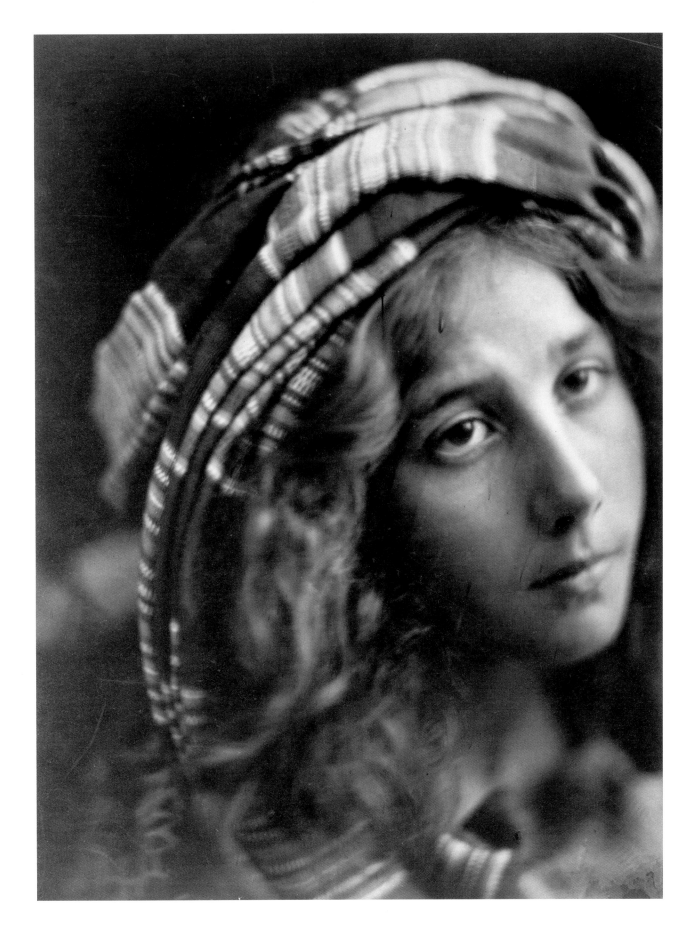

JULIA MARGARET CAMERON
A Study of the Cenci 1868

Albumen silver print; 32.7 × 24.6 cm (12⅞ × 8¾ in.). 84.XM.443.15

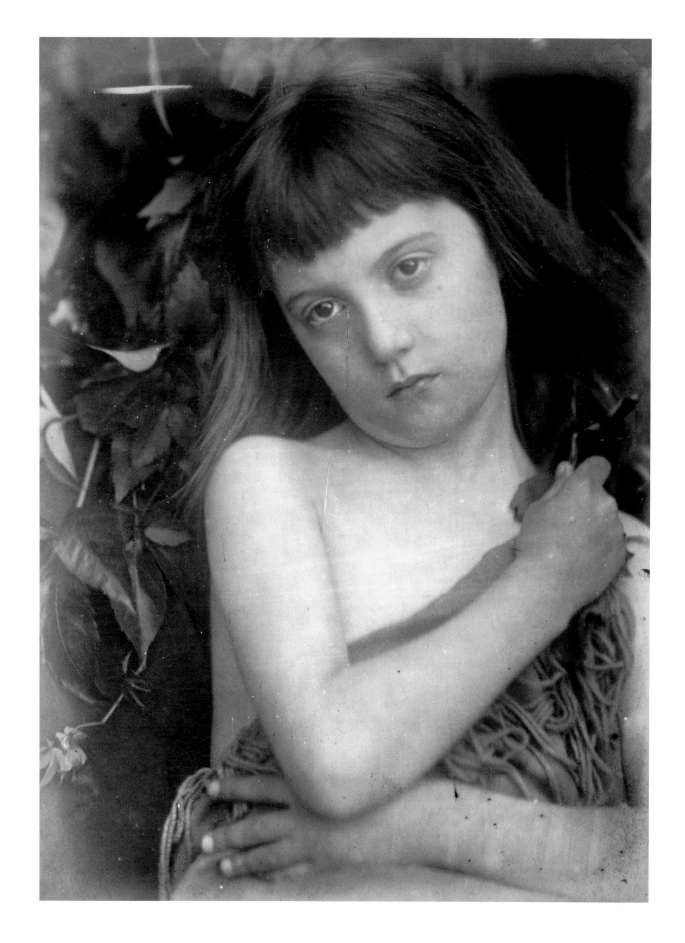

PLATE 27

JULIA MARGARET CAMERON
Florence—Study of St. John the Baptist 1872

Albumen silver print; 34.7 × 25.3 cm (13⅝ × 9¹⁵⁄₁₆ in.). 84.XM.443.67

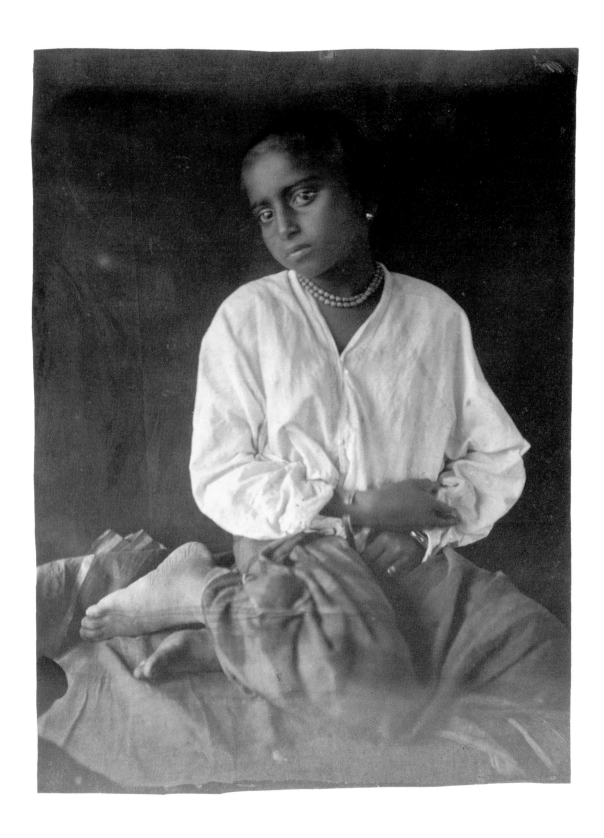

PLATE 28

JULIA MARGARET CAMERON

Girl, Ceylon 1875–79

Albumen silver print; 25.3 × 18.9 cm (9⅞ × 7⅜ in.). 86.XM.636.2

> *The more evidently accidental their introduction, the more trivial they are in themselves, the more*
> *[the stereographs] take hold of the imagination.* —OLIVER WENDELL HOLMES[1]

Langenheim Brothers

Among the first successful entrepreneurs of American outdoor photographs were the Langenheim brothers of Philadelphia, William and Frederick (American, born Germany, 1807–1874 and 1809–1879, respectively). With William as the business manager and Frederick operating the camera and producing the pictures, the genius in their partnership was in seeing the commercial potential in the new technology of photography.

With the idea of exploiting views of the American landscape, they initially set out to make a spectacular photograph of Niagara Falls and cleverly devised a method of producing a panorama by making a sequence of daguerreotypes to be displayed side by side. Frederick quickly realized the limitations of the one-of-a-kind, silver-on-copper process, however, and in 1848 purchased the American rights to William Henry Fox Talbot's calotype method at a then-lofty cost of one thousand dollars. Frederick also learned the albumen-on-glass process devised by Claude-Félix-Abel Niépce de Saint-Victor, which allowed them to produce lantern slides (transparent positives for projection) and also led to their invention of glass plate stereographs.

Equipped with these methods the Langenheim brothers became the first photographers to exploit the allure of the American landscape and the latent demand for travel.[2] Their camera was fitted with two side-by-side lenses that simultaneously exposed two nearly identical images on a single glass plate. When the glass negative was transformed into an albumen-on-glass positive—which was delicately hand colored—and viewed through a twin-lens stereoscope, the two images replicated binocular vision and magically transported the viewer into the scene. The Langenheim brothers' stereographs enabled anyone with a dollar to spare to visit Washington, Baltimore, Philadelphia, New York, Boston, and sites in between.

The fraternal partners concentrated on scenes from everyday life, making their work a cornerstone of the journalistic tradition in American photography. Traveling southeast from Philadelphia to Baltimore, Frederick recorded an African American man standing on a street corner with the new Roman Catholic cathedral in the distance (PLATE 29).

Attired in a coachman's uniform, the man stands with his hands in his pockets, gazing confidently at the camera. A multiplicity of details are revealed, ranging from the gas street lamp to the paving stones to the man's clothing.

Moving northwest by train and then steamer, Frederick arrived at the U.S. Military Academy at West Point on the Hudson River to capture a day in the life of a cadet (PLATE 30). A squad is at attention beside the enormous artillery intended to protect access to the upper Hudson River. Frederick eventually reached the Niagara River, where he recorded the celebrated railroad suspension bridge designed by John A. Roebling that spanned the river near Niagara Falls (PLATE 31). A number of important choices resulted in an extraordinarily dynamic composition. The vantage point is perpendicular to the bridge, with the river vanishing into the distance. The image is composed with just one-third of the span visible and a single locomotive in the center.

The principal market for the Langenheim lantern slides and stereographs was an unexpected one. Thomas Story Kirkbride, one of the first psychiatrists in America, was director of the Pennsylvania Hospital for the Insane. Starting in 1844 Kirkbride began to project drawings on glass for the education and amusement of his patients. By 1850, when the first experimental Langenheim photographic transparencies were available, Kirkbride immediately recognized their greater economy and visual effectiveness, and their use became commonplace at large mental hospitals across America and elsewhere. The Langenheim brothers created and sold hundreds, if not thousands, of stereographs and lantern slides to these institutional clients, establishing a defined market for their work.[3]

The Langenheim brothers created the foundation for a new specialty in camera art—taking the camera outdoors to depict landscape and urban views. A generation of younger photographers, such as Carleton Watkins (see page 56), followed their lead to achieve a stereographic encyclopedia of America.

1. Oliver Wendell Holmes, quoted in James Borcoman, *Eugène Atget: 1857–1927* (Ottawa: National Gallery of Art, 1984), 72.
2. Anne M. Lyden, *Railroad Vision: Photography, Travel, and Perception* (Los Angeles: J. Paul Getty Museum, 2003), 7.
3. George S. Layne, "The Langenheims of Philadelphia," *History of Photography* 11, no. 1 (1987): 39–46.

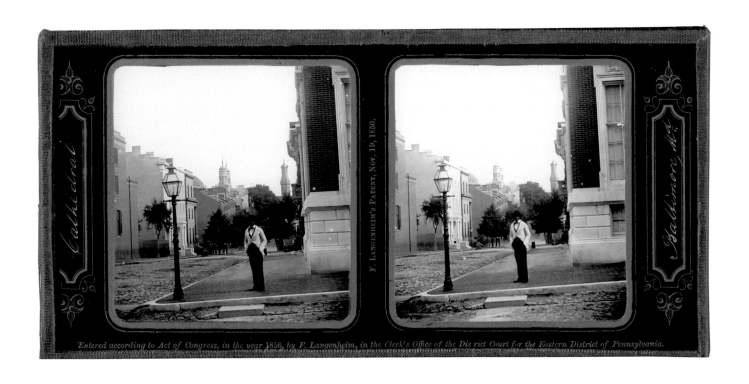

Glass stereograph inscriptions: "Cathedral" / "F. LANGENHEIM'S PATENT, NOV. 19, 1850." / "Baltimore Md" / "Entered according to Act of Congress, in the year 1856, by F. Langenheim, in the Clerk's Office of the District Court for the Eastern District of Pennsylvania."

PLATE 29

LANGENHEIM BROTHERS

Cathedral, Baltimore, Md. 1856

Glass stereograph; 8.3 × 17.3 cm (3¼ × 6¹³⁄₁₆ in.). 2000.10.255

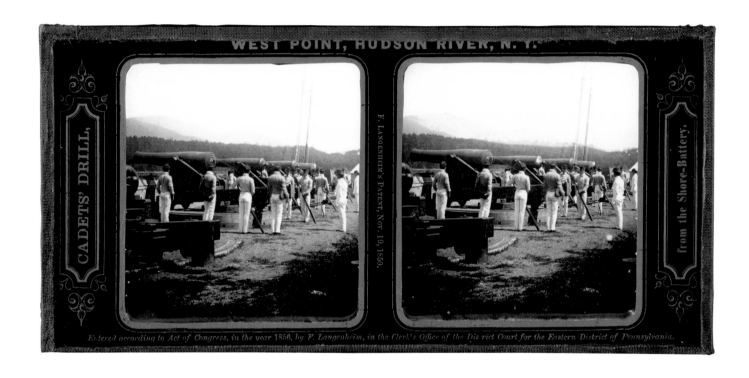

PLATE 30

LANGENHEIM BROTHERS

West Point, Hudson River, N.Y., Cadets' Drill, from the Shore-Battery 1856

Glass stereograph; 8.3 × 17.1 cm (3¼ × 6¾ in.). 2000.10.213

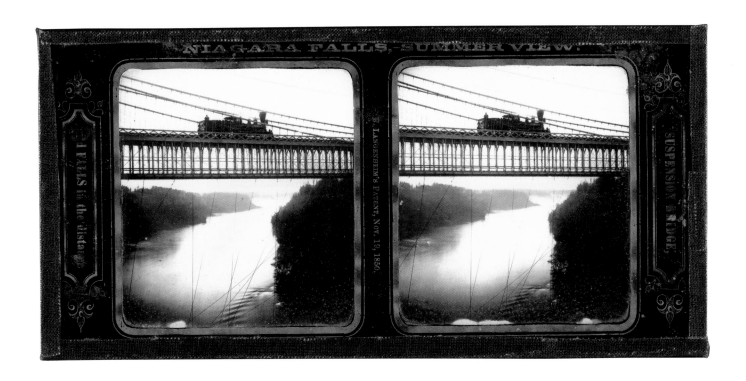

Just think of carrying such huge baths, glasses, etc. [for mammoth plate negatives], on muleback, and you can form some idea of the difficulties in the way of producing such magnificent results. —CHARLES H. SAVAGE[1]

Carleton Watkins

Carleton Watkins (American, 1829–1916), who is best known today for his photographs of landscape, architecture, industry, and still lifes, began his career in photography by chance as a portraitist. Legend has it that a lucky opportunity in San Francisco in the early 1850s landed him a job in the portrait studio of Robert H. Vance. Watkins was a skilled portraitist, but he quickly recognized that his calling was for outdoor work. By 1858 he had begun accepting commissions to make documentary photographs to be used as evidence in courts of law.[2]

In 1859 Watkins began using glass plate stereographs, a process made public in 1850 by Frederick and William Langenheim. The ambition of the Langenheim brothers (see page 52) to visually record the most notable sites of the natural and built environments throughout the Northeast influenced Watkins, who set about doing the same for the Pacific Coast. Although he gave up making stereos on glass by about 1863, his eye was forever informed by the subtlety of light and shadow that the transparency process was capable of achieving.

Watkins developed the amazing ability to choose the best point from which to view any subject and the talent to structure his photographs as an interconnected web of visual relationships driven by the act of perception.[3] Watkins had a great sensitivity to the built environment as well as for nature, a subject for which he became famous in 1862 with his views of Yosemite. In 1863 he began systematically photographing the landmarks of San Francisco. In *Russian Hill Observatory* (PLATE 32) the dark, erratically sloping earth defines the foreground, the fence and tower define the middle ground, and Alcatraz Island and Mount Tamalpais define the background. The time of day has been carefully chosen for the dynamics of light and shadow. When *Russian Hill Observatory* is viewed through a stereoscope, an ingenious interplay of spatial and planar, negative and positive elements captivates the eye, and a figure comes into focus at the top. Simultaneously applying logic and intuition, Watkins proves that photography is an art of the mind and the soul.

A few years later Watkins applied the same intentionality to mammoth-plate photographs, such as *Multnomah Falls, Columbia River, Oregon* (PLATE 33). The falls descended the face of the Columbia Gorge a short distance from the banks of the Columbia River, as they do now, but the dense forest made finding a viewpoint that could best incorporate both the upper and the lower cascades problematic. The camera was positioned almost directly opposite the lower falls at a spot where a trio of trees—one young and alive, the other two dead—framed the falls. The picture poetically invokes universal themes—the past in the form of the dead trees, the present in the form of the falling water, and the future in the form of the healthy young fir tree.

Watkins produced more than eleven hundred mammoth-plate photographs over thirty-five years, constituting one of the longest and most productive careers in nineteenth-century American photography. All the work Watkins produced before 1880 seems to have been a prelude to his remarkable late style. The lessons he learned along the way, from one exposure to the next, culminate in his last hundred large-plate photographs, the majority of which survive in only a single print each. Such is the case with his study of the mother vine of all table grapes planted in California, *Thompson's Seedless Grapes* of 1880 (PLATE 34). The very large camera used to make this image is positioned just above ground level and so close to the subject that a tangle of branches bountiful with fruit forms an edge-to-edge tapestry of intertwined elements. This archetype of abundant fertility melds decorative simplicity with a sensual treatment of nature not seen again until the twentieth century.

1. Charles H. Savage, quoted in Amy Rule, *Carleton Watkins: Selected Texts and Bibliography* (Oxford, England: Clio, 1993), 71.
2. Peter E. Palmquist, *In Focus: Carleton Watkins*, Photographs from the J. Paul Getty Museum (Malibu: J. Paul Getty Museum, 1997), 138.

3. Weston Naef and Margaret Stuffman, *Pioneers of Landscape Photography: Gustave Le Gray, Carleton E. Watkins—Photographs from the Collection of the J. Paul Getty Museum, Malibu*, exh. cat. (Frankfurt: Städtische Galerie; Malibu: J. Paul Getty Museum, 1993), 82.

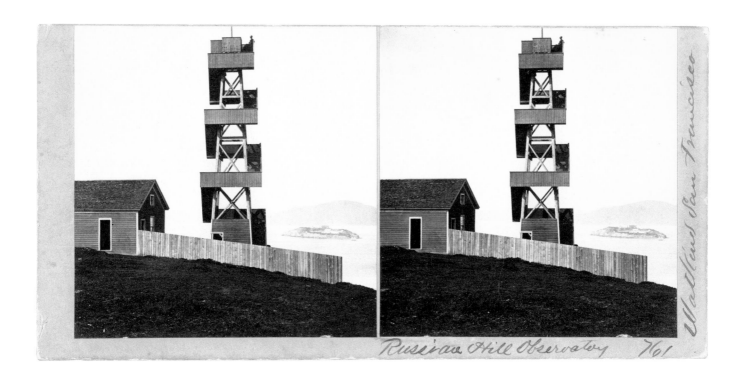

Russian Hill Observatory 761

Watkins San Francisco

PLATE 32

CARLETON WATKINS

Russian Hill Observatory 1863

Albumen silver print stereograph; 8.3 × 17 cm (3¼ × 6¹¹⁄₁₆ in.). 2000.78
Gift of Daniel Wolf in honor of John Walsh

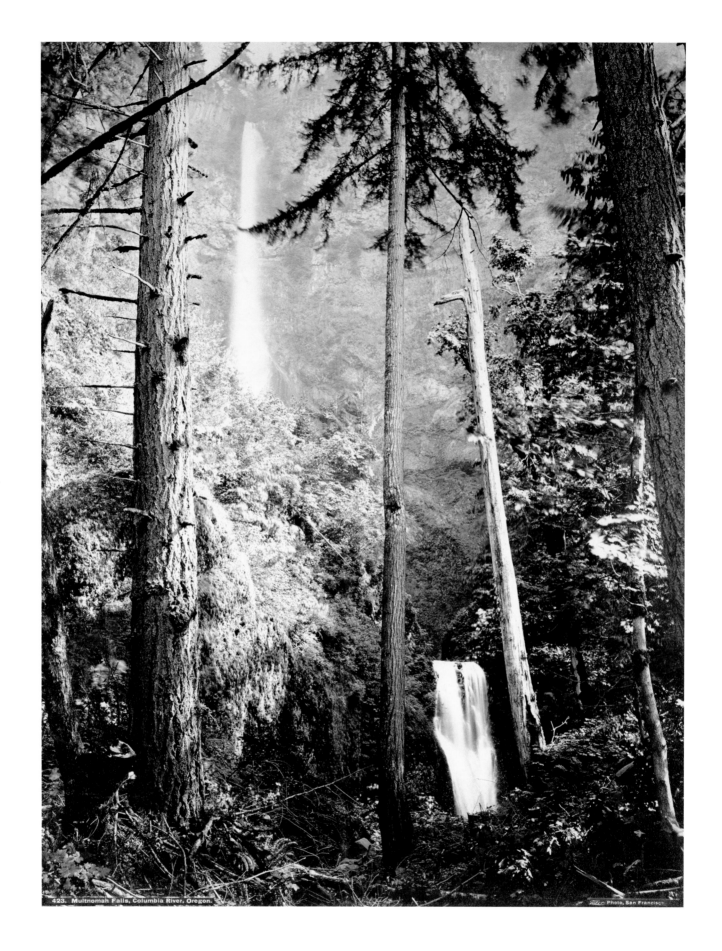

423. Multnomah Falls, Columbia River, Oregon.

PLATE 33

CARLETON WATKINS

Multnomah Falls, Columbia River, Oregon negative 1867, print by Isaiah Taber 1881–85

Albumen silver print; 55.1 × 40.3 cm (21 11/16 × 15 7/8 in.). 85.XM.11.31

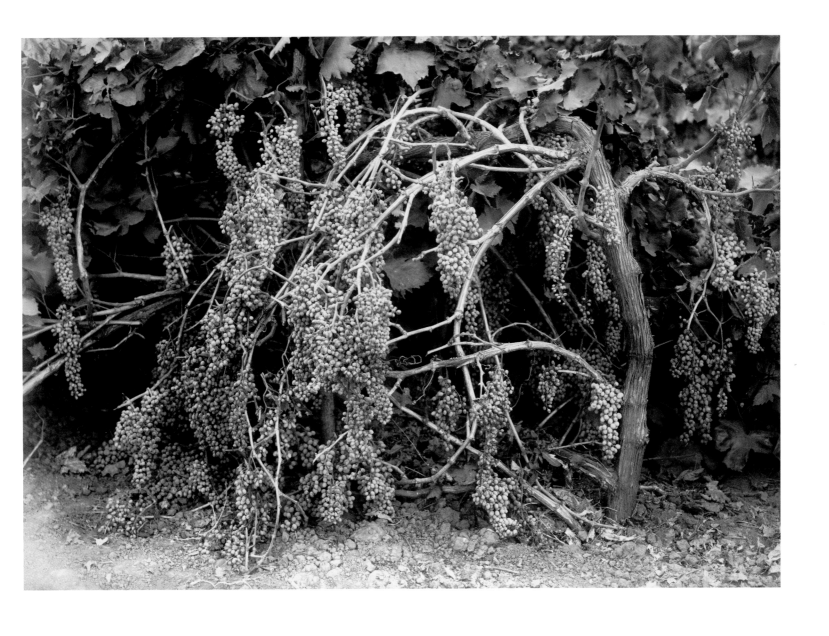

PLATE 34

CARLETON WATKINS

Thompson's Seedless Grapes 1880

Albumen silver print; 37.6 × 55.7 cm (14¹³/₁₆ × 21¹⁵/₁₆ in.). 98.XM.21.1

Spread out below us lay the desert, stark and glaring, its rigid hill chains lying in disordered groupings, in attributes of the dead. The bare hills are cut out with sharp gorges, and over their stone skeletons scanty earth clings in folds, like shrunken flesh: they are emaciated corpses of once noble ranges now lifeless outstretched as in a long sleep.
—CLARENCE KING[1]

Timothy H. O'Sullivan

In 1862 Timothy H. O'Sullivan (American, 1840–1882) quit the employment of the celebrated portrait photographer and Civil War picture merchant Matthew Brady and went to work in Washington, D.C., for Alexander Gardner, another photographer who had worked for Brady. While employed by Gardner—whose portraits of Abraham Lincoln are among the best that survive—O'Sullivan witnessed most of the chief military engagements of the Civil War from the Second Battle of Bull Run to Appomattox. When Gardner created the monumental *Photographic Sketch Book of the War* in 1865, no fewer than forty-four of the one hundred hand-mounted photographs were by O'Sullivan.

On September 22, 1862, Abraham Lincoln issued his preliminary Emancipation Proclamation and instructed his armies to implement its mandate as their lines advanced into the Confederate states. Among the first black slaves to be liberated were those on the cotton plantation of J. J. Smith, near Beaufort, South Carolina (PLATE 35). Because the freeing of the slaves took place in contested areas at the front lines of the war, where photographers were unwelcome, photographs of slaves being freed are rare. O'Sullivan happened to be in the vicinity of the Smith plantation and was able to make this remarkable picture. One hundred or more people are shown with their belongings packed in burlap bundles, ready, for the first time in their lives, to walk in any direction they pleased and to travel as far as they might wish to go.[2]

O'Sullivan left Gardner's establishment in 1867 to accept Clarence King's invitation to join his newly formed Fortieth Parallel Survey, which became the first federal exploring party in the American West after the Civil War. O'Sullivan's war experience proved to be excellent preparation for this endeavor and for the powerful landscape images that would influence twentieth-century perspectives. O'Sullivan was allowed to roam the wilderness apart from the main surveying party to prospect for subjects that would fulfill King's scientific agenda. *Desert Sand Hills near Sink of Carson, Nevada* (PLATE 36) presents a kind of self-portrait, showing

the wagon that served as O'Sullivan's rolling darkroom, pulled by four mules, positioned on a hill of windblown sand. The wagon has just made a U-turn, and footprints lead from the vehicle to the spot where O'Sullivan has set up his camera to compose this heroic image of exploration and discovery.[3]

At the conclusion of the West Coast expedition, in September 1869, O'Sullivan returned to the East Coast, where he remained until 1871, when he joined the Geological Surveys West of the One-Hundredth Meridian (1871–75) under the command of Lieutenant George M. Wheeler of the U.S. Army Corps of Engineers. In contrast with King, Wheeler was a graduate of West Point and a career military officer with little of King's interest in the arts or the philosophical controversies surrounding contemporary science that had informed O'Sullivan's 1868 series of western views.

In 1873 O'Sullivan led a small group, independent of the main survey party, to the Cañon de Chelle in the Arizona territory, where they visited its unoccupied cliff dwellings. The so-called White House Ruins are shown in the context of the surrounding cliffs, which are flooded by a bold, raking light that delineates the textures and striations of the massive cliff walls (PLATE 37). The sweeping thrust of the surface stains on the rock and the physical scale and asymmetry of the geology are dynamic elements to which the eye travels first. O'Sullivan's photograph is affecting because it forces us to ponder the limitations of human time versus the vastness of geologic time, successfully combining two aesthetic positions that are often in conflict: humanism and formalism.

1. Clarence King, quoted in Joel Snyder, *American Frontiers: the Photographs of Timothy O'Sullivan*, exh. cat. (Philadelphia: Philadelphia Museum of Art in association with Aperture, 1982), 32.
2. Jackie Napolean Wilson and Weston Naef, *Hidden Witness: African Americans in Early Photography*, exh. brochure, February 28–June 18, 1995, J. Paul Getty Museum, Malibu, iii.

3. James N. Wood, in Weston J. Naef and James N. Wood, *Era of Exploration: The Rise of Landscape Photography in the American West, 1860–1885* (New York: Albright-Knox Art Gallery / The Metropolitan Museum of Art, 1975), 136.

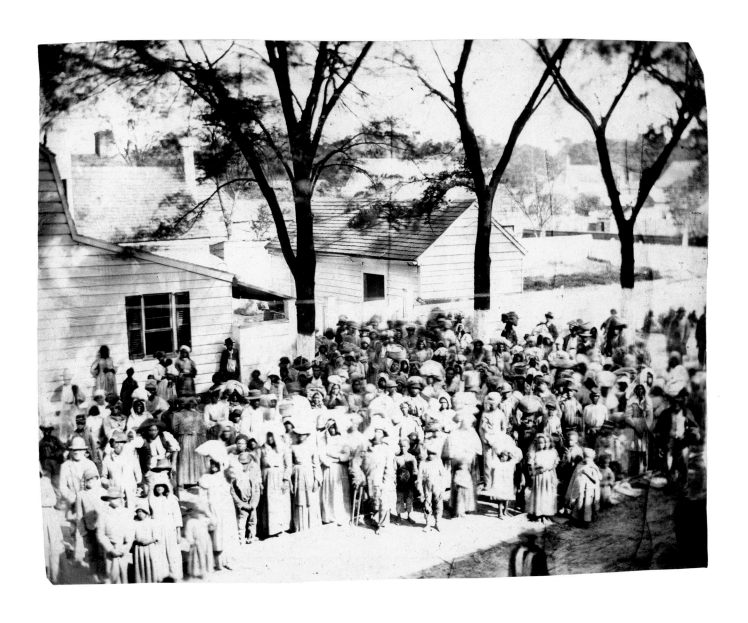

PLATE 35

TIMOTHY H. O'SULLIVAN

Slaves, J. J. Smith's Plantation, near Beaufort, South Carolina 1862

Albumen silver print; 21.4 × 27.3 cm (8⁷⁄₁₆ × 10³⁄₄ in.). 84.XM.484.39

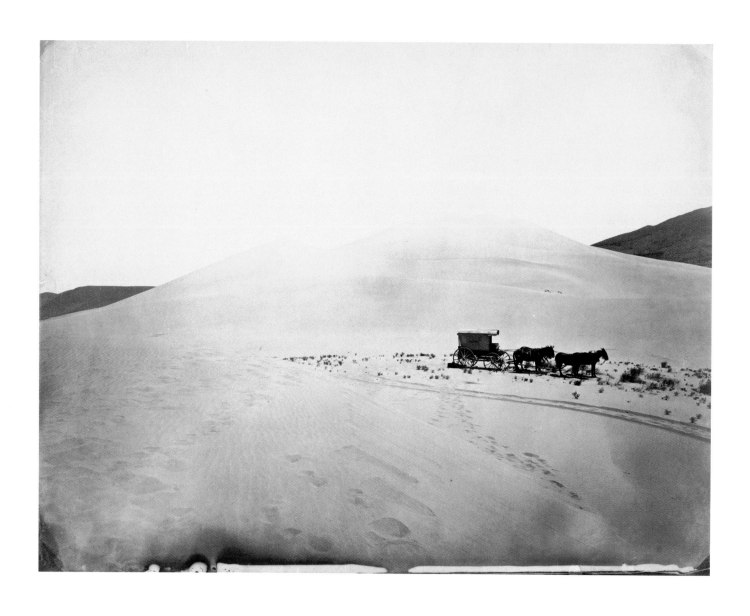

PLATE 36

TIMOTHY H. O'SULLIVAN

Desert Sand Hills near Sink of Carson, Nevada 1867

Albumen silver print; 22.4 × 29 cm (8¹³⁄₁₆ × 11⁷⁄₁₆ in.). 84.XM.484.42

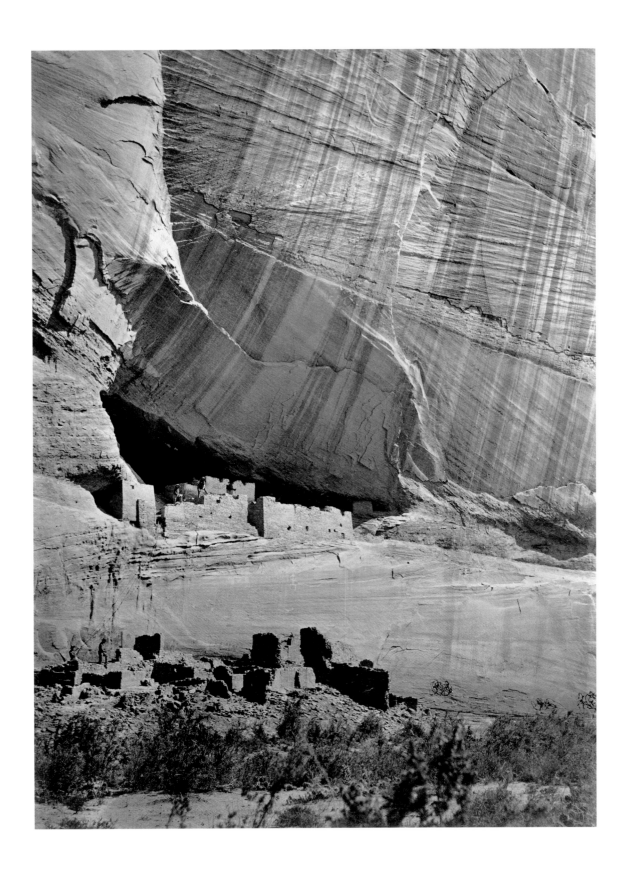

TIMOTHY H. O'SULLIVAN

Ancient Ruins in the Cañon de Chelle 1873

Albumen silver print; 27.6 × 20.6 cm (10⅞ × 8⅛ in.). 84.XO.1371.41

The Mississippi River will always have its own way; no engineering skill can persuade it to do otherwise.
—MARK TWAIN[1]

Henry P. Bosse

Many photographers in the 1860s and 1870s were inspired by the dramatic and challenging landscape of the far west, but the relatively flat heartland of America resisted the picturesque imagination. In producing photographs, Henry P. Bosse (American, 1844–1903) was the first to use a camera to harness the beauty and power of what Mark Twain called "that lawless stream"—the Mississippi River.[2] In 1863, the same year large photographs of Yosemite valley by Carleton Watkins (see page 56) were first seen by Abraham Lincoln, inspiring him to sign a decree causing the valley to be forever protected, the Mississippi was described in a headline of *Harper's Magazine* as "The Body of the Nation." The unidentified *Harper's* editor wrote that as "a dwelling-place for civilized man it is by far the first upon our globe."[3]

Bosse took up the challenge of giving visual shape to a landscape with significant human alterations extending along 850 miles and touching six states. Trained as a draftsman, mapmaker, painter, and engineer, Bosse brought diverse interests to his photographs. He utilized the cyanotype process exclusively, materials for which had just become commercially available, making it vastly more convenient for Bosse than it had been for Hippolyte Bayard (see page 16), Anna Atkins (see page 24), and Sir John Herschel, the inventor of the cyanotype. The cyanotype process had just begun to be used to duplicate maps and architects' drawings because they could be processed in subdued room light and they cost less than silver-based photographic materials. The blue color, however, brings to Bosse's photographs a melancholy, dreamlike aura.

Mechanic's Rock, Low Water of 1889 (PLATE 38) is emblematic of Bosse's entire Mississippi River series. With his camera positioned nearly at water level, Bosse recorded the riverbank and a figure holding a staff, which is marked with the graduations on a surveyor's transit, used to measure river depth. A line chipped into the rock—which at the time was located two miles downstream from Montrose, Iowa— indicates the low-water mark of 1864.[4] Light falling from

behind and to the right of the camera results in deep shadow on the bank and bright reflections off the water, a precise yet painterly approach to the subject.

If not at water's edge, Bosse frequently positioned himself on a bluff overlooking the view to be recorded. The perspective of his 1885 *Fort Madison, Iowa* (PLATE 39) conveys a brooding, industrial atmosphere. A lumber mill figures prominently in the foreground, with row upon row of stacked and drying milled lumber. The logs from which this material was produced constituted one of the chief commodities transported on the Mississippi River.

Bosse traveled on the riverboat *General Barnard*, owned by the U.S. Army Corps of Engineers; it was the same vessel on which Twain had traveled at about the same time. *Boatyard of Kahlke Brothers, Rock Island, Illinois* (PLATE 40) depicts a facility that opened just after the Civil War and continued into the twentieth century as a supplier and repair plant for riverboats. Bosse's view into the forest of smokestacks is like a still-life arrangement assembled from industrial components, foreshadowing twentieth-century artistic concerns.

Bosse invariably trimmed his prints to an oval shape that greatly complements their dreamy blue color. The color and shape also relate to the carefully chosen viewpoints that achieve simultaneously solid yet gentle compositions. Through his photographs Bosse illuminated the physical beauty of the great river and its surrounding landscape. He showed how human beings attempt to control nature and how nature resists being controlled. Bosse anticipated the widespread use of photography as a tool for natural resource planning.

1. Mark Twain, *Mark Twain in Eruption: Hitherto Unpublished Pages about Men and Events*, ed. Bernard DeVoto (New York: Harper and Brothers, 1940), 18.
2. Mark Twain, quoted in "Hands Across the Mississippi River," *Mayo Magazine*, Fall/Winter 1999, 8.
3. "The Body of a Nation," *Harper's Magazine*, February 1863, reprinted in Charles Wehrenberg, *Mississippi Blue: Henry P. Bosse and His Views on the Mississippi River between Minneapolis, Minn., and St. Louis, Mo., 1883–1891* (San Francisco: Solo Zone, 2001), 140.
4. Mark Neuzil, *Views on the Mississippi: The Photographs of Henry Peter Bosse* (Minneapolis: Univ. of Minnesota Press, 2001), 166.

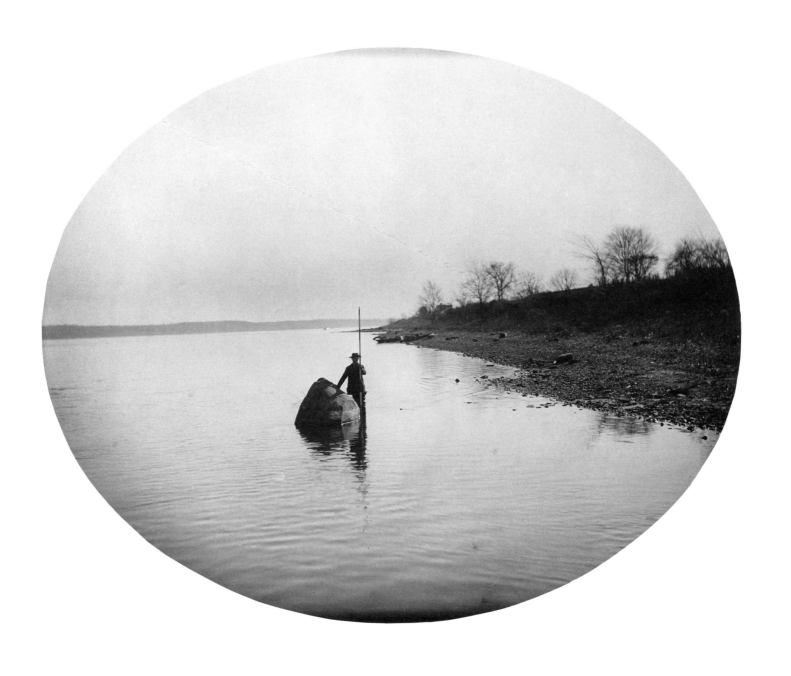

PLATE 38

HENRY P. BOSSE

Mechanic's Rock, Low Water 1889

Cyanotype; 26.5 × 33.2 cm (10⁷⁄₁₆ × 13¹⁄₁₆ in.). 2002.32.4

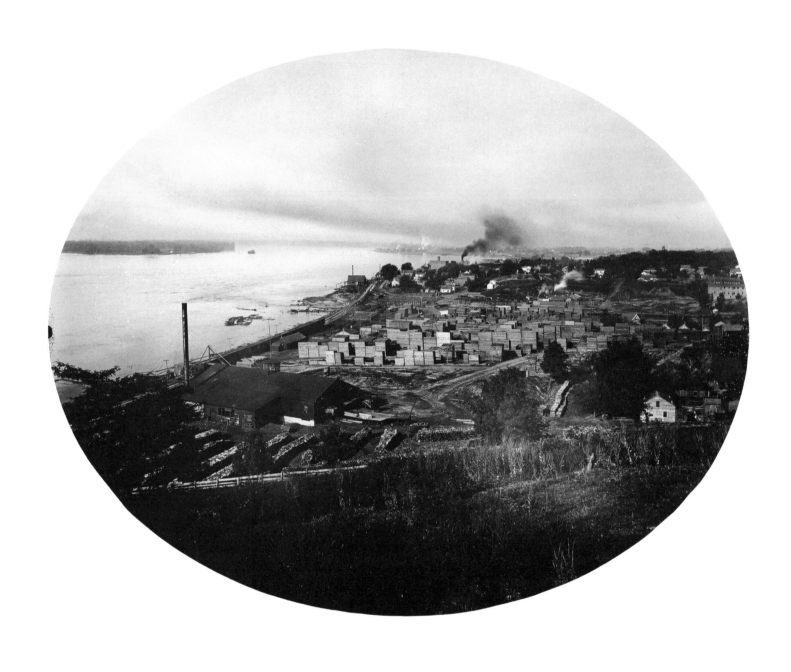

PLATE 39

HENRY P. BOSSE

Fort Madison, Iowa 1885

Cyanotype; 26.7 × 34.3 cm (10½ × 13½ in.). 2002.32.3

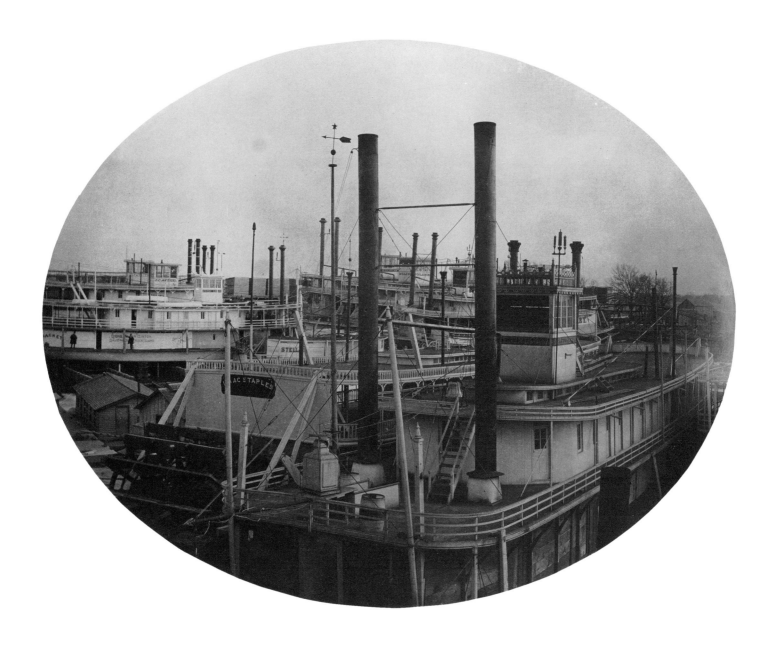

It is the artist who is truthful and photography which lies, for in reality time does not stop. —AUGUSTE RODIN[1]

Eadweard J. Muybridge

Time is an integral element of photography. A photograph seems to stop the clock by arresting an ephemeral moment, by fixing forever the appearance of any subject at any given point in time. Time is fundamental to all existence in that it is simultaneously the most controlling and the most uncontrollable force experienced by living things. Time cannot be seen or touched but only represented symbolically. Nevertheless, for centuries artists have tried to depict it. Not until the advent of photography, however, was there a medium of visual expression in which time joined light as one of the elements an artist must handle to give form and content to a picture.

Photography has dramatically changed the way we perceive and understand time and space. One photographer who contributed much to this shift in perspective was Eadweard J. Muybridge (American, born England, 1830–1904). Muybridge's chief contribution to the theoretical underpinnings of photography was the understanding—through purely visual language—that the value of a collective sequence of photographs could be greater than any single image. Muybridge thus paved the way for sequential photographs of all types, including motion pictures.

In May 1872 Muybridge took on the challenge of answering the question of whether a trotting horse lifts all four feet off the ground at any point during its gait. The purpose of the endeavor was to settle a wager between Leland Stanford and Frederick MacCrellish, two Californians, wealthy from post–gold rush prosperity, who could afford the expense of a grand experiment. Muybridge proved with his pictures in 1872, to the satisfaction of his patrons, that a trotting horse does indeed raise all four feet off the ground at one point in its gait. However, he mysteriously failed to identify for posterity specifically which of his thousands of exposures of trotting horses made between 1872 and 1881 (PLATE 41) were the very ones he used to settle the wager. Muybridge left but one

cryptic paragraph of description about the decisive pictures, written a decade after the fact: "Thus far the photographs have been made with a single camera, requiring a separate trotting for each exposure. The horse being of a dark color and the background white, the pictures were little better than silhouettes, and it was difficult to distinguish, except by inference, the right feet from the left."[2] We know that his first experiments were made with a single camera and repeated passes by the horse, but none of Muybridge's existing photographs quite conform to these parameters. What survives was apparently made after 1872. History is time and, ironically, the first person to stop time with a camera suppressed key facts that would have documented, for the sake of history, the beginning of his enterprise.

Backed by Leland Stanford between 1872 and 1878, Muybridge used a bank of twenty-four twin-lens cameras, making exhaustive studies of different species in motion that led to the monumental 1887 publication *Animal Locomotion*, which contained 781 collotype plates. The printed announcement for the set of plates promises "more than twenty thousand figures of Men, Women, and Children, Animals and Birds, all actively engaged in walking, galloping, flying, working, jumping, fighting, dancing, playing at base-ball, cricket, and other athletic games, or other actions incidental to everyday life, which illustrate motion and the play of muscles."[3] Nearly twenty-five years had elapsed between the advent of photography and the moment when photographic hardware and chemistry were capable of arresting the motion of a man chasing a goat (PLATE 42) or a running greyhound (PLATE 43).

1. Auguste Rodin, quoted in Hollis Frampton, "Eadweard Muybridge: Fragments of a Tesseract," *Artforum* 11, no. 7 (March 1973): 43–52.
2. Eadweard Muybridge, *Descriptive Zoopraxography or the Science of Animal Locomotion* (Chicago: Lakeside Press with Univ. of Pennsylvania, 1893), 5.
3. Edward J. Nygren and Francis Fralin, *Eadweard Muybridge: Extraordinary Motion* (Washington, D.C.: Cocoran Gallery of Art, 1986), 5.

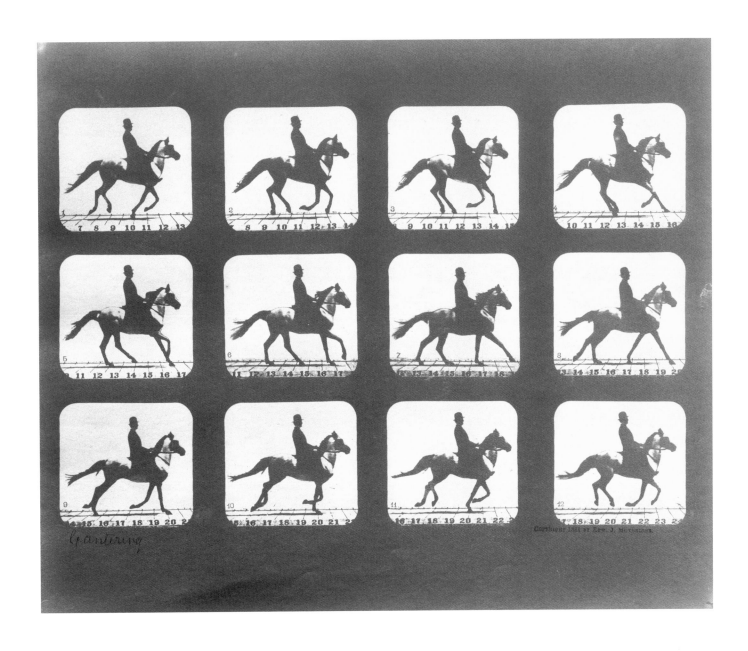

PLATE 41

EADWEARD J. MUYBRIDGE

Cantering 1878–81

Iron salt process print; 18.9 × 22.6 cm (7⁷⁄₁₆ × 8¹⁵⁄₁₆ in.). 85.XO.362.24

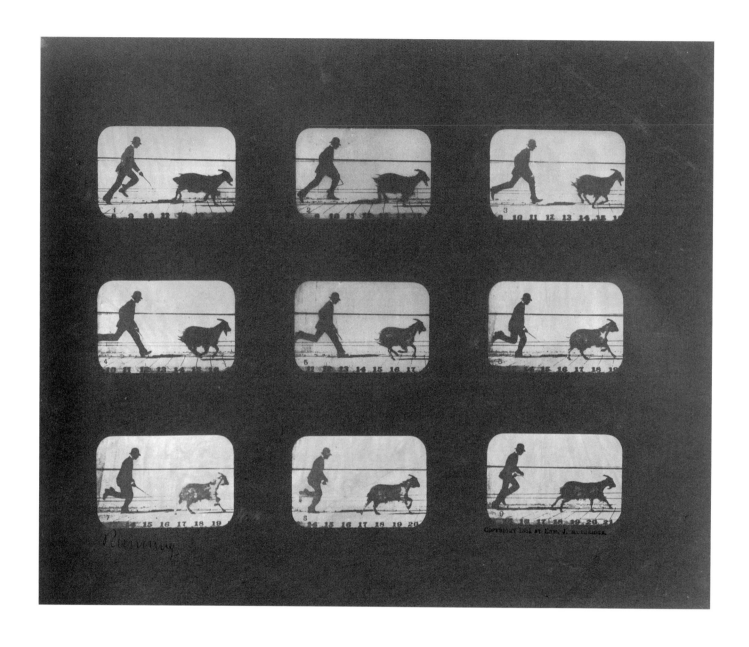

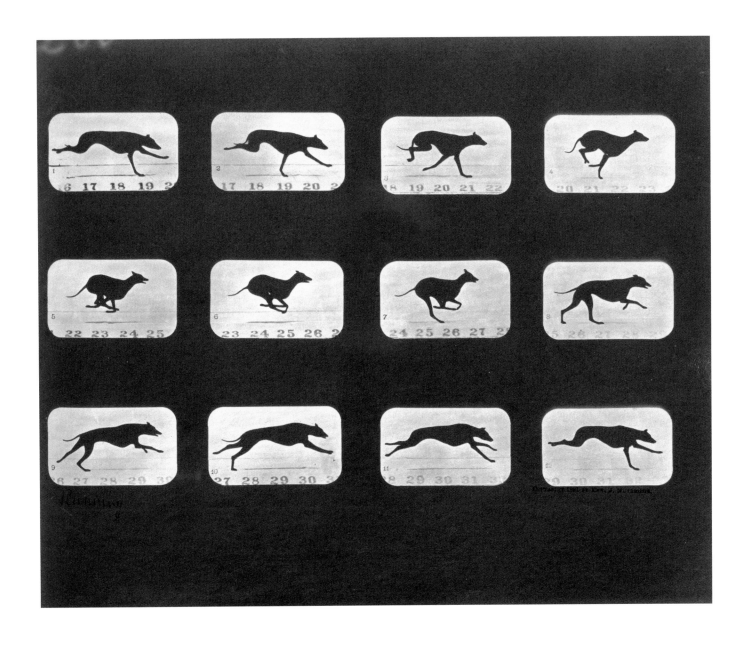

PLATE 43

EADWEARD J. MUYBRIDGE

Running 1878–81

Iron salt process print; 18.9 × 22.6 cm (7⁷⁄₁₆ × 8¹⁵⁄₁₆ in.). 85.XO.362.82

The photograph ... has opened our eyes and forced us to gaze on that which we have never before seen, an important and inestimable service it has rendered to Art. Thanks to [the photographer], truth has finally emerged from its well. It will never go back again. —JEAN-LÉON GÉRÔME[1]

Thomas Eakins

The earliest documented involvement that painter Thomas Eakins (American, 1844–1916) had with photography was in 1872, when he used a photograph made by his friend Henry Schreiber as the source for an oil-on-canvas portrait of Schreiber's dog Grouse.

In 1878 Eakins studied some photographs by Eadweard Muybridge (see page 68) and became aware of how useful photographs could be to the painter. In late 1879 Eakins was named professor of drawing and painting at the Pennsylvania Academy of Fine Arts in Philadelphia, where the cornerstone of the curriculum was the study of the nude, a discipline that would inform his future work.[2]

In 1880 Eakins acquired his first camera. It is possible that Eakins learned photography from his wife, Susan, or from Schreiber, who specialized in photographing animals owned by prominent Philadelphians. Schreiber and other photographers of the 1870s would have used the wet-collodion process, which required coating, sensitizing, and developing on location just prior to the exposure. In 1879 ready-to-use, factory-prepared glass plates became commercially available for the first time. This opened the door to a new era of photography, in which photographers could be more spontaneous and experimental in their approach.

The study of Eakins's dog Boyce (PLATE 44)—probably one of Eakins's early photographs—is an example of a snapshot before its time. In the era before handheld cameras, however, Eakins could not merely crouch to the same level as the sleeping dog but rather had to make the picture with the camera placed on the floor. The unusual perspective causes the picture to resemble a snapshot, but the photograph was made years before handheld cameras were commonplace.

Exactly when Eakins began to photograph nude figures is unknown; however, he and his students made a great many studies that were used as tools to understand anatomy. He presumably experimented first with models close at hand, such as his sister's young children, Margaret and Arthur Crowell (PLATE 45), who were photographed outdoors on the grass at the Crowell farm in Avon, Pennsylvania. Eakins was

a serious student of anatomy, and he seized the opportunity to observe young bodies in bright sunlight. He would later encounter controversy by photographing his female students in the nude.

One day in 1884 Eakins and a group of male students traveled, presumably by train and wagon, to the secluded site of an old sawmill on a small river near Bryn Mawr, a suburb of Philadelphia. Eakins, perhaps assisted by one of the students, created several carefully structured photographs of nude men posed beside a swimming hole along the river. These became photographic sketches for his celebrated oil painting titled *Swimming* (Amon Carter Museum, Fort Worth), which was first exhibited in 1886. In the painting, six young men are shown, including a diver in midair, plus Eakins himself in the water. The photographic study for this work, called *Male Nudes at the Site of "Swimming"* (PLATE 46), reveals that Eakins did not directly translate the photograph to the painting. Elements were added and subtracted. For example, Eakins does not appear in the photograph. In the painting, the figures are positioned differently, apparently to avoid frontal nudity, and the dog, who is not in the photograph, has been added.[3]

Eakins was the earliest American painter with an international reputation for producing photographs as aids for painting, and he encouraged his students to do likewise. Some of his photographs were highly structured, as in *Male Nudes at the Site of "Swimming,"* while others were more like snapshots. He was one of the first Americans to explore the interplay between visual truth and narrative fiction using photographs as an analytic tool.

1. Jean-Léon Gérôme, quoted in Darrell Sewell, ed., *Thomas Eakins*, exh. cat. (Philadelphia: Philadelphia Museum of Art, 2001), 255.
2. The academy devoted sixty hours of teaching per week to working from the nude model, reportedly more than at any other art school in the world. See W. Douglas Paschall, "The Camera Artist," in Sewell, *Thomas Eakins*, 248.
3. Doreen Bolger and Sara Cash, eds., *Thomas Eakins and the Swimming Picture*, exh. cat. (Fort Worth: Amon Carter Museum, 1996), 189–91.

PLATE 44

THOMAS EAKINS

Boyce, Portrait of a Setter Dog 1880–90

Albumen silver print; 6.2 × 9.5 cm (2⁷⁄₁₆ × 3¾ in.). 84.XM.155.5

PLATE 45

THOMAS EAKINS

Margaret and Artie Crowell September 18, 1883

Albumen silver print; 9.1 × 6.8 cm (3¹⁹⁄₃₂ × 2¹¹⁄₁₆ in.). 84.XM.201.15

PLATE 46

THOMAS EAKINS

Male Nudes at the Site of "Swimming" 1884

Albumen silver print; 9.3 × 12.1 cm (3²¹/₃₂ × 4²⁵/₃₂ in.). 84.XM.811.1

Gertrude Käsebier

Between the 1880s, when Thomas Eakins (see page 72) was active, and the 1890s, when Gertrude Käsebier (American, 1852–1934) began to make photographs, a new relationship between painting and photography was being established. In 1889, when Käsebier was thirty-seven and the mother of three teenage children, she enrolled in Brooklyn's Pratt Institute to study art. Photography was not included in the Pratt curriculum, nor was it embraced as an adjunct to painting, unlike at the Pennsylvania Academy of Fine Arts, where Eakins had urged his students to pick up the camera. However, Käsebier had already learned the essentials of photography on her own, and by the time she had finished her art school studies in 1894 she was ready to devote herself to the new art. Käsebier appropriated Eakins's snapshot-like approach, but her style of printing was exactly the opposite of his. Eakins favored simple albumen and sometimes platinum papers, whereas Käsebier preferred exotic materials such as gum-bichromate on Japanese tissue or watercolor paper.

Whereas Eakins saw veracity as the chief virtue of a photograph, Käsebier pioneered the new relationship between reality and fiction in American photography. She created pictures that were naturalistic but driven by ideas. *The Manger* (PLATE 47), which was created in the barn at Käsebier's summer rental near Newport, Rhode Island, in the summer of 1899, is an experiment in artificiality. Only the rustic setting is authentic, and the eye is drawn to the aged wood in the background. The costume, however, is complete artifice, and since there were no infant children available, a prop was used instead. Käsebier enlisted artist Frances Delehanty to pose as the Madonna in a nativity scene in keeping with her later series of photographs of mothers and children. This subject, coupled with her artistic spirit, her continuous experimentation, and her ability to combine candid elements within a solid formal structure, brought Käsebier fame.

Inspired by *The Manger*'s success, she opened a portrait studio in the New York City Women's Exchange building, a gathering place for affluent ladies.[2] Käsebier's studio was situated a short walk from the Camera Club of New York, where Alfred Stieglitz (see page 92) was editor of its journal, *Camera Notes*, through which he promoted the idea of photography as a fine art. Käsebier soon joined this group and in 1899 was granted a one-person exhibition in the club gallery, organized by Stieglitz. The prevailing style in studio portrait photography at the time was to furnish the room with an elaborate artificial setting that would include gilt furniture, potted plants, a fur throw, and other superfluous decorations. Käsebier took the opposite approach, influenced by the new American Arts and Crafts movement that emphasized elegance, simplicity, and authenticity.

By the summer of 1903, when her first grandchild, Charles O'Malley, was born, Käsebier had already photographed with considerable originality many socialite ladies with their children. Consequently, the subject of mother and child was established as a central theme of her art. The birth of her grandson presented Käsebier an opportunity to pursue this theme close to home. One of her best works in this genre is a sequence of three photographs of her daughter (also named Gertrude) and grandson outdoors (PLATE 48). The sequence was inspired by the three-year-old's apparent devotion to his mother. Käsebier trimmed the outer two of the platinum prints to matching rounded shapes and fitted the three into a specially made frame to create a triptych. She took her candid approach to its extreme in *Happy Days* (PLATE 49).

Käsebier no doubt knew the work of Julia Margaret Cameron (see page 48). She probably learned about Cameron from Ellen Terry, who had been photographed by Cameron at the age of sixteen and who later, in 1899, purchased a print of Käsebier's *The Manger*.[3] Cameron was the first great photographer to make women and children a central subject. Käsebier was one of the first to pick up the stylistic baton from a female precursor and take it to a new level of form and content.

1. Gertrude Käsebier, quoted in Barbara L. Michaels, *Gertrude Käsebier: The Photographer and Her Photographs* (New York: Harry N. Abrams, 1992), 28.

2. Michaels, *Gertrude Käsebier*, 28.

3. Michaels, *Gertrude Käsebier*, 74.

PLATE 47

GERTRUDE KÄSEBIER

The Manger 1899

Platinum print; 32.5 × 23.7 cm (12¹³/₁₆ × 9⁵/₁₆ in.). 84.XM.160.1

GERTRUDE KÄSEBIER

Gertrude and Charles O'Malley: A Triptych summer 1903

Platinum print; 19.7 × 49.1 cm (7³⁄₄ × 19¹⁄₄ in.). 87.XM.59.1.1-3

GERTRUDE KÄSEBIER

Happy Days 1903

Platinum print on tissue; 32 × 25 cm (12⁹/16 × 9⁷/8 in.). 87.XM.59.4

Eugène Atget

Like many other great makers, Eugène Atget (French, 1857–1927) did not achieve a fresh manner of expression until the final years of his career. His body of work thus can be divided stylistically between what he created before about 1913 and what he made between 1920 and his death in 1927. (He was inactive between about 1914 and about 1919.) The work before 1913 deals chiefly with the outward reality of Paris and its environs. It emphasizes the most characteristic features of the subjects, whether a street or a tree, a tradesman or a transportation vehicle. Each was observed without apparent bias or prejudice. These early photographs tend to be precise, sometimes excessively regular, and always methodical.

Much of the work after about 1920 is nearly the opposite. Many pictures are private and introspective, expressing an individual, sometimes melancholy, mood. They seem to be phrased in the first-person *I*, in contrast with the third-person *it* of earlier work. Many of the late photographs are layered with significance and are of uncertain motivation. In them Atget seems to be exploring latent poetic concerns.

The Panthéon (PLATE 50), for example, was created on a damp, overcast day, which filled the scene with lyric atmosphere. It is baffling that Atget deferred photographing the Panthéon for so long, for he passed by it many times on the way from his Montparnasse apartment to the center city, where he photographed numerous subjects. For more than twenty years Atget avoided the touristic monuments of Paris. He never photographed the Paris Opéra, the Arc de Triomphe, or the Eiffel Tower. When he finally decided to focus on the Panthéon, he did so on a wet day, causing this burial place of Voltaire, Rousseau, Murat, Hugo, and Zola to be shrouded in mist. He chose a vantage point that looked across the Sainte-Geneviève square toward the north side

of the building. Most of the main subject is obscured by the church of Saint-Étienne-du-Mont. The foreground is cast in dramatic, deep shadow as the light falls from behind. A clear description of the subject's main features is subordinate to Atget's distinct compositional choices.[2]

In 1924 Atget returned to the royal gardens at Saint-Cloud outside Paris, where he had made an earlier series of photographs between 1904 and 1907. This time he was especially drawn to a secluded area (PLATE 51) where nature had begun to encroach on the built environment, suggesting that man and nature were eternally in competition. This obscure subject, driven by uncertain motives and difficult to classify in his body of work, tells us more about Atget the person than it does about Saint-Cloud the place.

Atget's study of four female mannequins with frozen gestures in a storefront on the avenue des Gobelins (PLATE 52) is both ambiguous and private. It is not certain whether his main subject was the window display itself, the reflections of the trees and buildings in the glass, or the combination of the two. The composition is a picture within a picture and is a great departure from the explicit, formal, and affirmative work he created before 1913. His power to turn the ordinary material of everyday life into something extraordinary is a mark of Atget's genius as a photographer. Like the best experimental artists of the twentieth century, he always courted failure and apparently took satisfaction in risking being misunderstood by his audience.

1. André Calmettes to Berenice Abbott, quoted in John Szarkowski and Maria Morris Hambourg, *The Work of Atget*, vol. 2: *The Art of Old Paris* (New York: Museum of Modern Art, 1982), 19.

2. Gordon Baldwin, *In Focus: Eugène Atget*, Photographs from the J. Paul Getty Museum (Los Angeles: J. Paul Getty Museum, 2000), 78.

PLATE 50

Eugène Atget

The Panthéon 1924

Gelatin silver-chloride print; 17.8 × 22.6 cm (7 × 8⅞ in.). 90.XM.64.34

PLATE 52

EUGÈNE ATGET

Storefront, avenue des Gobelins 1925

Gelatin silver print; 23 × 16.8 cm (9¹⁄₁₆ × 6⅝ in.). 84.XM.1034.15

It should be plainly said that whatever happens in the sacrifice of adult workers, the public conscience inexorably demands that the children under twelve years of age shall not be touched; that childhood shall be sacred; that industrialism and commercialism shall not be allowed beyond this point to degrade humanity. —FELIX ADLER[1]

Lewis Hine

Over a period of twelve years—between 1906, at the beginning of his career, and 1918, when he was in full stride—Lewis Hine (American, 1874–1940) took child labor as his subject. He was employed for a decade as staff photographer, field researcher, and writer by the National Child Labor Committee (NCLC), for which he made more than five thousand negatives. Hine later recalled, "My first trips [for the NCLC in 1908] through West Virginia, the Carolinas & Georgia brought to light, in a visual way, the horrors of child labor and my photo-studies formed the backbone of much of the publicity and propaganda that followed for twenty years or more."[2] His photographs were ultimately the most reliable body of proof the committee gathered. "All along, I had to be doubly sure that my photo-data was 100% pure—no retouching or fakery of any kind," Hine stated in 1938. "This had its influence on my continued use of straight photography which I had preferred from the first."[3]

The NCLC was chartered by the U.S. Congress on February 27, 1907, with a mandate "to investigate and report the facts concerning child labor."[4] Although Hine was collecting visual evidence for the committee, he took an artist's pride in the quality of his pictures. Light was the most important of the variable elements in the composition of a picture, as we see in *Sadie Pfeiffer, Spinner in Cotton Mill, North Carolina* (PLATE 53). He chose a vantage point close to a row of tall windows that fill the space with soft light. The main subject—positioned in the middle ground—is in sharp focus, while the background and foreground are not. In making this enlarged exhibition print, Hine exposed the foreground longer to darken it and lightened the background behind the distant, softly focused figure of a girl, causing her blurry outline to stand out. The two girls represented here are not just exploited workers but individuals.

Perhaps more typical of Hine's child labor series is *Doffer Boys, Macon, Georgia* (PLATE 54), a contact print from the five-by-seven-inch glass plate negative of the spinning mill workers. Elucidating the unsuitability and inappropriate use of children as laborers, Hine inscribed the back of the photograph, "Some boys were so small they had to climb upon the spinning frame to mend broken threads and push back the empty bobbins."

Hundreds of children were employed as messengers and newspaper vendors, many of whom worked at night delivering alcohol and opium to and from gambling parlors and houses of prostitution. Addressing these moral issues, Hine communicates the dark side of life on the streets in his study of a newsboy in Mobile, Alabama (PLATE 55). The photographer's own shadow adds an element of mystery, as an emblem of unseen dangers, while elements such as the theater poster, the boy's dirty bare feet, and the cotton bale add texture and nuance to the visual story.

Hine's photographs helped change employment laws for children. By 1911 the eight-hour day for children was implemented in five states, night work was prohibited in seven states, and night messengers were required to be twenty-one or older in three states and eighteen or older in six states. With weekly news magazines such as *Life* and *Look* not yet in existence, Hine was ahead of his time in presenting photographs in revealing sequences, combined with words, to tell a story.

1. Felix Adler, Minutes from the first general meeting of the National Child Labor Committee, April 15, 1904, quoted in Verna Posever Curtis and Stanley Mallach, *Photography and Reform: Lewis Hine and the National Child Labor Committee* (Milwaukee: Milwaukee Art Museum, 1984), 1.
2. Lewis Hine, quoted in Daile Kaplan, ed., *Photo Story: Selected Letters and Photographs of Lewis W. Hine* (Washington and London: Smithsonian Institution Press, 1992), 179.
3. Lewis Hine, "Notes on Early Influence," recorded by Elizabeth McCausland, in Kaplan, *Photo Story*, 124.
4. National Child Labor Committee, *National Child Labor Committee Pamphlets 148–172* (New York: National Child Labor Comittee, 1911), pamphlet no. 148, 1.

PLATE 54

LEWIS HINE

Doffer Boys, Macon, Georgia **January 1909**

Gelatin silver print; 12.2 × 17.4 cm (4¹³⁄₁₆ × 6⅞ in.). 84.XM.221.7

PLATE 55

LEWIS HINE

Newsboy, Mobile, Alabama October 1914

Gelatin silver print; 11.8 × 16.8 cm (4¹¹/₁₆ × 6⅝ in.). 84.XM.132.33

*I did, I think, understand . . . what the principle was behind Picasso [in his] organization of the picture space, of the unity of what that organization contained, and the problem of making a two-dimensional area have a three-dimensional character. . . . Everything in that picture had [to be] really related to everything else. —*PAUL STRAND[1]

Paul Strand

Paul Strand (American, 1890–1976) came onto the scene just when two new impulses occurred in photography. One came from Cubism through Alfred Stieglitz (see page 92), and the other from the documentary tradition via Lewis Hine (see page 84). Strand reflected knowledge of Cubism in his still-life studies and simultaneously acknowledged the documentary tradition in his photographs made on the streets of New York.

Strand was introduced to photography in his late teens as a student at the Ethical Culture School in New York, where Hine was teaching one of the first high school courses on photography to be offered anywhere in the city. In the late fall of 1907 Hine accompanied a group of students, including Strand, on a field trip to Stieglitz's New York art gallery, called 291 after its street address on Fifth Avenue.[2]

With Hine's encouragement Strand looked beyond Stieglitz to other accomplished Pictorialists, including Gertrude Käsebier (see page 76), Clarence White, and advanced amateurs at the Camera Club of New York. Inspired by the painterly effects possible with soft-focus lenses and pigment printing, Strand's work from the years 1913–15 was closer to etching and lithography than it was to the tradition of documentary photography as exemplified by his teacher. Strand was influenced not only by his mentors but also by publications such as *Camera Work* and exhibitions of the paintings and drawings of the Modernists, most notably the 1913 International Exhibition of Modern Art at the Armory in New York. Strand's photographs from 1915–16 reflect all of these influences.

His 1916 study of a woman and child on stone steps, as observed from above (PLATE 56), mixes formal and lyrical elements—a combination not yet common in pho-tography. The soft tapestry of foliage contrasts with the hard edges of the tree and the angular shadow. Similarly, the tender human quality of motherhood contrasts with the brittle urban context. Urban motifs and pastoral ones are skillfully juxtaposed and represent a forward-looking homage to Pictorialism.

Strand was the first of a generation of American photographers who learned from Stieglitz that photography has a fascinating history and is well stocked with its own masters. Strand wrote about Hill and Adamson (see page 28) in an essay and later told interviewers that he admired their work. His 1916 study of a woman seated in Washington Square Park (PLATE 57) departed boldly from Pictorialism and was a daring attempt to bring Hill and Adamson's study of Elizabeth (Johnstone) Hall (see PLATE 11) into the twentieth century. Hill and Adamson's study appears to capture Elizabeth Hall in the midst of a thought, as her head turns away, but because spontaneity was impossible and the involvement of the subject was required to achieve this effect, we see fictional reverie. Strand, however—using a camera with a dummy lens that allowed him to face in one direction while the real lens pointed in another—was able to catch the subject unaware, conveying the woman's authentic look of reverie and resignation. Strand moves in closer to his subject than did Hill and Adamson, thus eliminating all suggestion of environment and focusing attention on the elements that describe the subject's rugged, yet noble, character.

If Strand's dozen or so street portraits are an archetype of realism, his still-life compositions from the summer of 1916 are the opposite. Enigmatically, in the spirit of Dadaism, he titled a study of a pear and bowls *Photograph* (PLATE 58). It appeared in Stieglitz's publication *Camera Work* in 1917 and reflects the collective influence of experimental painting from Fauvism to Cubism.[3] The vantage point here is close to the subject, unlike the distant high angles from which many of his New York views were made. Strand proved with his still lifes that he could master abstraction, but it was not to be his destiny.

1. Paul Strand, interview by William Innes Homer, June 25, 1974, quoted in Maria Morris Hambourg, *Paul Strand circa 1916*, exh. cat. (New York: Harry N. Abrams / The Metropolitan Museum of Art, 1998), 34.

2. Naomi Rosenblum, "The Early Years," in *Paul Strand: Essays on His Life and Work*, ed. Naomi Rosenblum (New York: Aperture, 1990), 33.

3. Milton W. Brown, "The Three Roads," in Rosenblum, *Paul Strand*, 23.

PLATE 56

PAUL STRAND

New York 1916

Platinum print; 25.2 × 32.1 cm (9 15/16 × 12 5/8 in.). 86.XM.687.1

PLATE 57

PAUL STRAND

Portrait—New York 1916

Platinum print; 33.3 × 23.7 cm (13⅛ × 9⁵⁄₁₆ in.). 89.XM.I.I

PLATE 58

PAUL STRAND

Photograph 1916

Gelatin silver-platinum print; 25.7 × 28.7 cm (10⅛ × 11⁵⁄₁₆ in.). 88.XM.15

Alfred Stieglitz

Alfred Stieglitz (American, 1864–1946) lived several lives as a photographer before he met Georgia O'Keeffe in 1916, at which point the form and content of his work was forever changed. He had traveled to Europe in 1883 to study with Hermann Wilhelm Vogel, a celebrated German teacher of photography. At the 1889 Jubilee exhibition in Vienna, celebrating the fiftieth anniversary of the public announcement of the new art, Stieglitz saw for the first time work by the old masters of the medium, Louis Jacques Mandé Daguerre, William Henry Fox Talbot, Hill and Adamson (see page 28), and Julia Margaret Cameron (see page 48).[2]

But the force that changed his life was Georgia O'Keeffe, whom Stieglitz met in the summer of 1916 when he included one of her watercolor drawings in a group exhibition. In mid-1917 O'Keeffe had a solo show at his gallery 291 in New York, and in 1918 she relocated to New York from Texas. O'Keeffe soon became Stieglitz's muse and chief subject, leading him into the most productive decade of his life.

Stieglitz and O'Keeffe became a couple in the summer of 1918 and were married in 1924. While he had created many stunning individual portraits, Stieglitz became dissatisfied with the limitation of concentrating on the face as the sole aspect of portraiture and had begun to experiment with studies that focused on other parts of the body.[3] He aggressively advanced this sequential approach in a series of photographs of O'Keeffe, collectively titled *Georgia O'Keeffe: A Portrait*, an innovative project that was intended to constitute a single, cumulative portrait in multiple images. The earliest of these (PLATE 59) is dated June 4, 1917, when O'Keeffe's solo show was on view at 291. The image was composed in the camera by cropping the subject to the shoulders. The gesture of one hand is graceful, while the other is somewhat awkward, yet expressive. Similar contrasts can be found elsewhere in the composition, where the dark mass of the dress is less formally organized than the graceful white lines of the V-shaped collar and the undulating outline of the triangle formed by the bent elbow. The model's gesture and the maker's composition are in complete harmony.

The summer of 1918 was exceptionally hot. "It was so hot that I usually sat around painting with nothing on," recalled O'Keeffe, whose various states of undress were seized upon by Stieglitz as an opportunity to photograph her.[4] For comfort in her studio O'Keeffe often wore a diaphanous white kimono, as shown in Stieglitz's 1918 study (PLATE 60). Here O'Keeffe gazes beyond the camera in a pose that recalls the Virgo Lactans Madonna figures in Christian iconography, as well as the Asian goddesses whose hands cup their breasts. Stieglitz no doubt intended the suggestion of sexuality as an expression of the sacred.

For one of his 1919 studies (PLATE 61), "I was asked [by Stieglitz] to move my hands in many different directions," recalled O'Keeffe in 1977.[5] Actively directing his model, Stieglitz posed her hands above her head in front of her own *Drawing No. 17*. Her thumb and index finger appear as if about to squeeze one of the suggestive shapes. O'Keefe's words, "No comments, please," were printed opposite a 1974 reproduction of the charcoal drawing, leaving no doubt as to the hidden message expressed in purely visual language.

In *Georgia O'Keeffe: A Portrait* Stieglitz shattered traditional notions about portraiture. His work from this series entered the collection of the Metropolitan Museum of Art in New York in 1928, becoming some of the first photographs collected as works of art by any museum and thus fulfilling Stieglitz's early prophecy about the potential cultural and artistic value of photography.

1. Alfred Stieglitz, *Alfred Stieglitz*, exh. cat. (Washington, D.C.: National Gallery of Art, 1983), 15.
2. Weston Naef, *In Focus: Alfred Stieglitz, Photographs from the J. Paul Getty Museum* (Malibu: J. Paul Getty Museum, 1995), 6.
3. Sarah Greenough, *Alfred Stieglitz: The Key Set: The Alfred Stieglitz Collection of Photographs*, vol. 1, 1886–1922 (Washington, D.C.: National Gallery of Art; New York: Harry N. Abrams, 2002), xxxvii, 310–14.
4. Georgia O'Keeffe, conversation with the author, May 16, 1977.
5. O'Keeffe, conversation with the author (see note 4).

PLATE 59

ALFRED STIEGLITZ

Georgia O'Keeffe: A Portrait June 4, 1917

Platinum-palladium print; 24.4 × 19.5 cm (9⅝ × 7¹¹⁄₁₆ in.). 91.XM.63.3

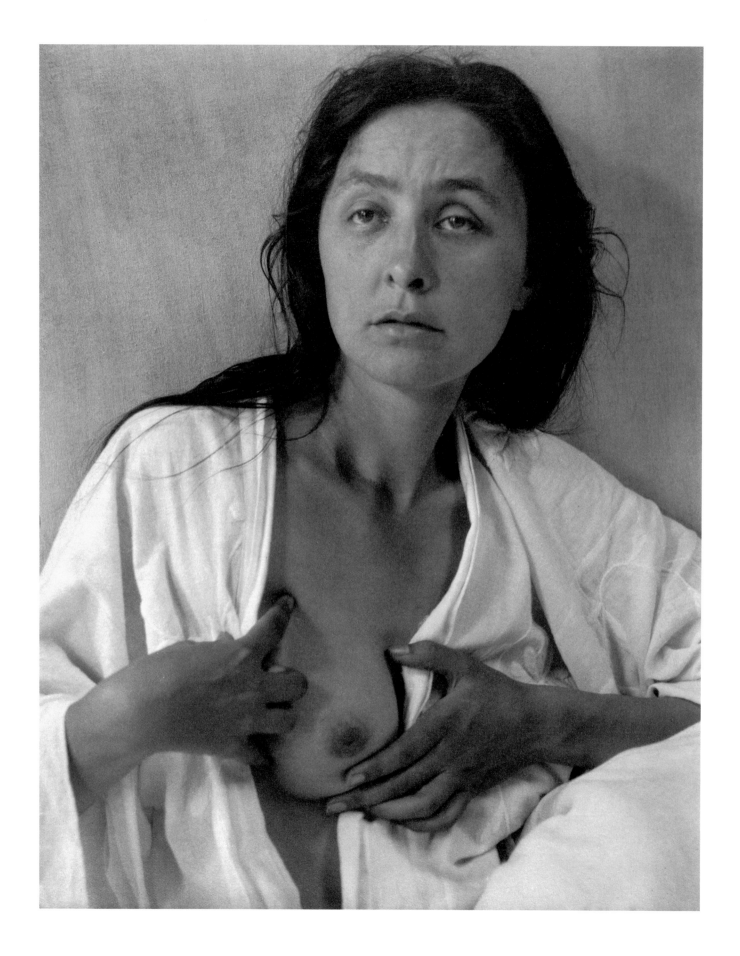

PLATE 60

ALFRED STIEGLITZ

Georgia O'Keeffe: A Portrait 1918

Platinum-palladium print; 24.3 × 19.4 cm (9⁹⁄₁₆ × 7⁵⁄₈ in.). 93.XM.25.53

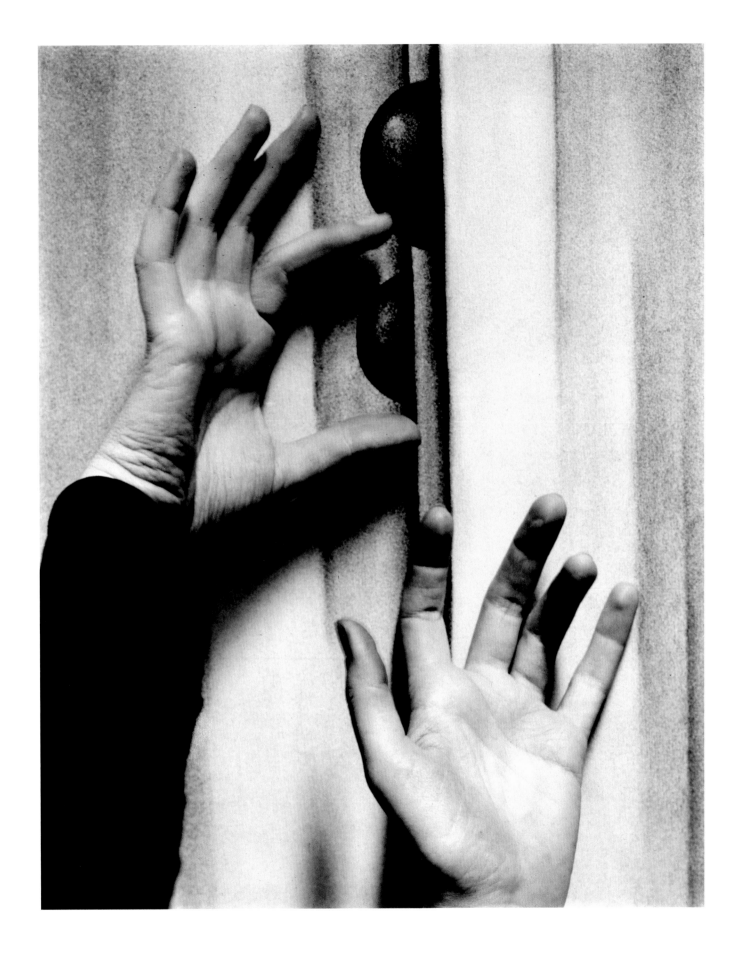

I classified all the types I encountered in relation to one basic type, who had all the characteristics of mankind in general. —AUGUST SANDER[1]

August Sander

ugust Sander (German, 1876–1964) was not a mainstream Modernist, as were Stieglitz (see page 92), Strand (see page 88), and Weston (see page 124). Sander held no reverence for speed or machinery, subjects that were idolized by many artists and photographers of the German avant-garde. Instead he became legendary for the enormous body of work he produced in the traditional genre of portraiture.

Sander operated a portrait studio in an upper-middle-class neighborhood in Cologne. When he was not working in his studio, he would set out by train to the nearby rural districts of Siegerland and the Westerwald, where he had spent his childhood, to make his pictures. His equipment packed on a bicycle, he prospected for clients along the country lanes, where he may have encountered the two men in *Dwarfs* (PLATE 62).[2] It is not known whether Sander found these subjects and persuaded them to pose for his camera or whether they commissioned him to do so. He photographed this pair outdoors and made the exposure at a very wide aperture, causing the background to be completely out of focus. Seeming at first glance to be twins, the two men do not actually look alike; however, their starched white shirts, bow ties, and dark three-piece suits, in addition to their physical stature, make them appear related.

In 1912, when he created the negative for *Dwarfs*, Sander had recently conceived the guiding idea for a grand project that would remain unrealized for a dozen years. In the mid-1920s, he revisited his earlier negatives (including *Dwarfs*) and made very fine enlargements. These were exhibited in Cologne in 1927 under the title *People of the Twentieth Century*. This ambitious project, which was life defining for Sander, took portraiture to a new universal level of expression.

About the time of the 1927 exhibition, in his quest for archetypes of the German people, Sander drafted a scheme that divided his portraits into seven broad categories—farm people, working people, women, men, creative people, city people, and people who were outside the mainstream of German society—and almost fifty subthemes.[3] *Dwarfs* was allocated to the last category, the outsiders.

Shortly after formulating this organizational scheme, Sander encountered two young women, apparently sisters, who fell into his first group, people of the farming class, and its first subtheme, teenage farmers. Sander identified them generically as *Farm Girls* (PLATE 63). Posed against the background of trees and bushes that Sander favored for his roadside portraits, the sisters have identical somber dresses, identical flowers in the same position at the waist, and identical large wristwatches. However, they wear different types of shoes, a detail that visibly sets them apart.

In 1930 Sander photographed two other young women of about the same age who have at least one chief attribute in common, their blindness (PLATE 64). The two are dressed quite differently; one wears a plain blouse and skirt, the other a boldly patterned tunic. One faces the camera, presumably without being able to see it, while the other stands with her eyes and head cast downward. Even though some of his subjects may not have paid to have their portraits made, Sander applied the same observant skills he did when working for clients. The images show a sensitivity to details of clothing and an appreciation of revealing gesture and facial expression. Historically, these are the skills used in the most successful pencil or oil portraits. In Sander's work, tradition and innovation are seamlessly interwoven. This unusual portrait combines empathy with objectivity. Sander weaves emotion into his photographs like threads in a tapestry, so it becomes integral to the work yet is not its primary focus.

1. Claudia Bohn-Spector, *In Focus: August Sander*, Photographs from the J. Paul Getty Museum (Los Angeles: J. Paul Getty Museum, 2000), 12.
2. Ulrich Keller, *August Sander: Citizens of the Twentieth Century*, ed. Gunther Sander; trans. Linda Keller (Cambridge: MIT Press, 1986), 14.
3. Keller, *August Sander*, 36, 63.

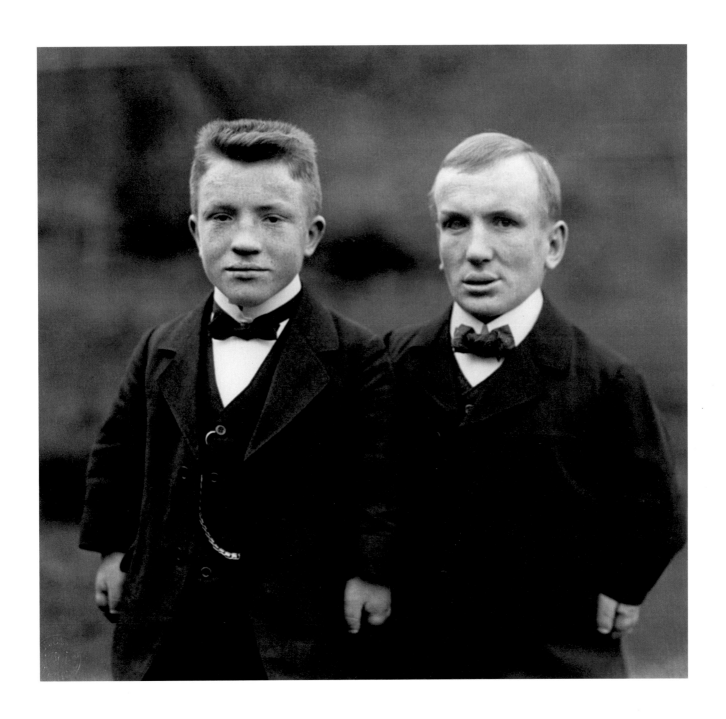

PLATE 62

AUGUST SANDER

Dwarfs negative 1912, print 1920s

Gelatin silver print; 16.8 × 17.7 cm (6⁹⁄₁₆ × 7 in.). 84.XM.126.83

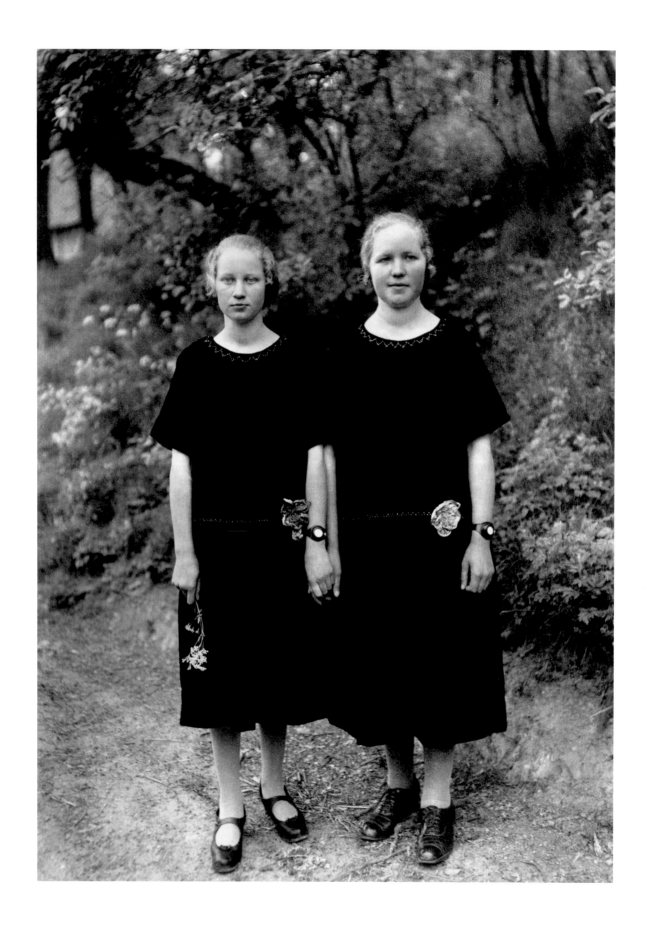

PLATE 63

August Sander

Farm Girls 1928

Gelatin silver print; 22 × 15.9 cm (8⅝ × 6¼ in.). 84.XM.126.534

PLATE 64

AUGUST SANDER

Blind Children ca. 1930

Gelatin silver print; 23.5 × 16.8 cm (9¼ × 6⅝ in.). 84.XM.126.107

My best pictures are always taken when I succeed in establishing a bond of sympathy with my sitter.
—Doris Ulmann[1]

Doris Ulmann

Doris Ulmann (American, 1882–1934) was trained in the very style of Pictorialism that Strand (see page 88), Stieglitz (see page 92), Sander (see page 96), and Weston (see page 124) had denunciated at various times before 1920. Ulmann graduated from the Ethical Culture School in New York, where she may have come into contact with Hine (see page 84), but her principal mentor in photography was the Pictorialist Clarence White. Ulmann used the oil-transfer and platinum methods favored by Pictorialists, and her work was shown in Los Angeles as early as 1920.[2]

From the beginning Ulmann pursued people untouched by modernity, an approach that had been pioneered in Germany by Sander. Ulmann sought out American fishermen, coopers, blacksmiths, weavers, cobblers, and dozens of workers in related trades. She also photographed people in preindustrial communities such as the Shakers, the Quakers, and the Mennonites, as well as the Cherokee and Lumbee Indians of North Carolina and various African American religious sects.[3] Just as Sander had recorded the archetypes of German society, Ulmann searched for American archetypes. She was motivated by despair over what she perceived as damage to social structures caused by industrialization.

Divorced from her physician-husband in 1921, Ulmann used her art, and inherited wealth, to advance a variety of social causes. She traveled through Pennsylvania, Virginia, Kentucky, and North Carolina making photographs, and in the summer of 1928 selections from her series *The Mountaineers of Kentucky* were published. As with Sander's enormous, multilevel project, Ulmann's work unfolded as a layering of themes and subthemes. Within the overarching topic of vanishing archetypes, Ulmann was particularly driven to find and express archetypes of the female.

In the study of a washerwoman (PLATE 65), Ulmann presents a Melungeon woman—a people believed by some to be of mixed Caucasian, African American, and Native American ancestry—whom she probably encountered in North Carolina. Dressed in a cotton smock with her shirtsleeves rolled up, the strong-featured woman gazes intently at Ulmann, who, in contrast to her subject, typically wore fine dresses, fancy hats, and stylish shoes.[4]

Although Ulmann was Jewish by birth, she eventually became agnostic. She was nonetheless greatly attracted to people who devoted their lives to spiritual callings. When visiting New Orleans she arranged to visit the convent of the Sisters of the Holy Family, an Augustinian order of the Roman Catholic Church whose members took vows of poverty. There she photographed Sister Mary Paul Lewis (PLATE 66). The nun's manifest strength, integrity, faith, and sacrifice were the same qualities Ulmann admired in Quaker and Mennonite believers.

From 1928 until her death in 1934, Ulmann worked at a furious pace, sometimes exposing three or four dozen six-by-eight-inch glass plate negatives per day while she was traveling. She usually photographed her subjects in their everyday clothes; however, in the case of Grace Combs (PLATE 67), the teenager is treated like a fashion model, posed with hat and gloves and a youthful, seductive gaze.[5] Although there is no surviving record of when Ulmann made each picture, we can speculate that she portrayed Grace Combs—whose father wrote on the subject of Appalachian folk songs—during the last two years of her life.

It was during these final years that Ulmann was assisted by music folklorist John Jacob Niles, with whom she was deeply in love and whose estate was the source for much of the Getty holding of Ulmann prints. Ulmann's devotion to Niles was not returned with equal fervor. After having created approximately forty-five hundred pigment and platinum prints, and a few gelatin silver prints, she died in 1934 from a series of self-destructive actions in the wake of her unrequited love.[6]

1. Doris Ulmann, quoted in David Featherstone, *Doris Ulmann: American Portraits* (Albuquerque: Univ. of New Mexico Press, 1985), 21.
2. Philip Walker Jacobs, *The Life and Photography of Doris Ulmann* (Lexington: Univ. Press of Kentucky, 2001), 37.
3. Jacobs, *Life and Photography*, 54–55.
4. Jacobs, *Life and Photography*, 78.
5. Judith Keller, *In Focus: Doris Ulmann, Photographs from the J. Paul Getty Museum* (Malibu: J. Paul Getty Museum, 1996), 72.
6. Jacobs, *Life and Photography*, 154–55.

PLATE 65

DORIS ULMANN

Monday (Melungeon Woman, Probably North Carolina) ca. 1929

Platinum print; 20.1 × 15.4 cm (7¹⁵⁄₁₆ × 6¹⁄₁₆ in.). 87.XM.89.73

PLATE 66

DORIS ULMANN

Sister Mary Paul Lewis, a Sister of the Order of the Holy Family, New Orleans December 1931

Platinum print; 20.5 × 15.6 cm (8¹⁄₁₆ × 6¹⁄₈ in.). 87.XM.89.80

PLATE 67

DORIS ULMANN

Grace Combs, Hindman, Kentucky 1928–34

Platinum print; 20.2 × 14.9 cm (7^{15}/$_{16}$ × 5^{7}/$_{8}$ in.). 87.XM.89.78

My work is inspired by my life. I express myself through my photographs. Everything that surrounds me provokes my feelings. —ANDRÉ KERTÉSZ[1]

André Kertész

André Kertész (American, born Hungary, 1894–1985) made his first photograph in 1912 as a self-taught amateur, pursuing this activity when he was not at his job as a clerk at the Budapest stock exchange. Drafted into the Austro-Hungarian army in 1914, he was wounded in Poland in 1916. The battlefield injury to his right arm left it partially paralyzed and required that he undergo daily physical therapy, which included swimming.[2]

The most remarkable of all the photographs from his war years, *Underwater Swimmer* (PLATE 68), was made while Kertész was seated along with a group of his buddies at the edge of a pool from where he observed the sunlight playing on the water above and around the swimmers.[3] Kertész made one print in 1917 and then, the following year, lent the negative for publication and never got it back. Therefore all later prints are copies of that first one. The water distorts the swimmer's arms and legs, and he appears to be almost headless. The figure is floating motionless in the water, yet the photograph is animated by many interacting elements, creating a dreamlike aura. Surrealism as a style in art had not yet been named in 1917, but when it did come into being a decade later in Paris, Kertész was among the original visionaries and referred to himself as a "naturalist surrealist."[4]

In September 1925, at the age of thirty-one, Kertész left Budapest for Paris, where his signature style evolved and where he hoped to earn his living by making photographs for reproduction in magazines and books. He prospected for subjects by walking the streets, riverbanks, and parks. He was a frequent guest at the Café du Dôme, a favorite haunt of an internationally diverse group of young painters, sculptors, photographers, and poets—among them aspiring Hungarian compatriots, such as Gyula Halász (later known as Brassaï; see page 132).[5]

Through contacts at the Café du Dôme, Kertész met Piet Mondrian and made a series of portraits of the painter, as well as photographs of his studio. Kertész had been photographing in Paris for almost a year when he made *Mondrian's Studio, Paris* (PLATE 69), a composition that echoes Mondrian's geometric painting style. It was the success of this image, perhaps more than any other, that launched his career. Kertész composed his photograph looking from inside the studio toward the stairwell through an open door, so the two spaces are made to seem as one. Light falls toward the camera from a window or skylight in the hallway, which casts a long shadow from the vase, which is essential to the composition. The inside and the outside of the room contrast yet balance each other, with light as the unifying element. Kertész was often asked whether he had repositioned the vase and flower on the table. He replied that his only intervention was to move a sofa in order to better position his camera.[6]

After five years in Paris, Kertész was earning his livelihood by making photographs with highly personal visual stories for picture magazines. He generated ideas for these by prowling the streets. As an old man he recalled how one day in 1932 he had wondered what was behind the imposing facade of the Académie française. Apparently without any formal introduction, Kertész presented himself to the director and was granted permission to photograph the interior.[7] He ascended to the attic, where he discovered and photographed rooms filled with graffiti and other strange sights. The only image from that series that has withstood the test of time is the one observed through the transparent face of a clock in the cupola (PLATE 70). Below, pedestrians can be seen on the Pont des Arts, with the Louvre museum in the background. The roman numerals and hand of the clock look as if they were collaged onto the scene.

1. Peter Adam, *Kertész on Kertész: A Self-Portrait* (New York: Abbeville Press, 1985), 29.
2. Weston Naef, *In Focus: André Kertész, Photographs from the J. Paul Getty Museum* (Malibu: J. Paul Getty Museum, 1994), 5.
3. Bela Ugrin, "Dialogues with Kertész," part 3, ed. Manuela Caravageli Ugrin (typescript, Department of Photographs, J. Paul Getty Museum, Los Angeles, 1985), 20.
4. André Kertész, conversation with author, May 25, 1981.
5. Sandra S. Phillips, "André Kertész: The Years in Paris," in Sandra S. Phillips, David Travis, and Weston Naef, *André Kertész: Of Paris and New York* (Chicago: Art Institute of Chicago; New York: The Metropolitan Museum of Art, 1985), 30–31.
6. Ugrin, "Dialogues with Kertész," 70.
7. Ugrin, "Dialogues with Kertész," 79.

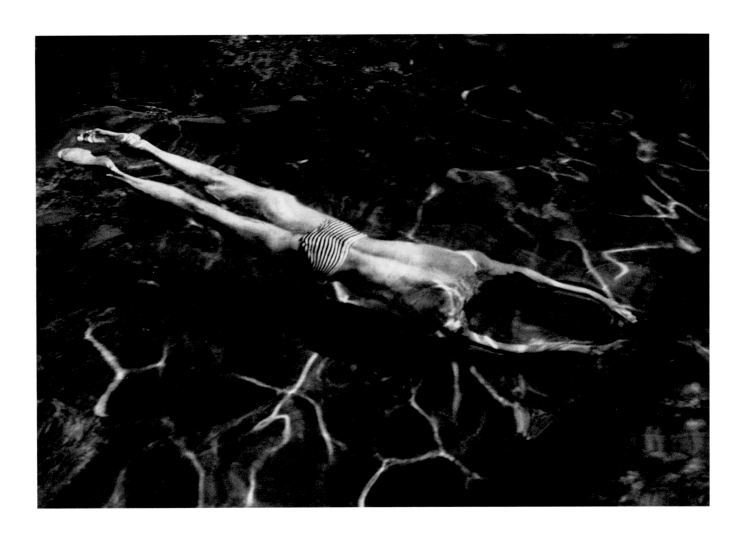

PLATE 68

ANDRÉ KERTÉSZ

Underwater Swimmer negative 1917, print 1970s

Gelatin silver print; 17 × 24.7 cm (6 ¹¹⁄₁₆ × 9¾ in.). 84.XM.193.11

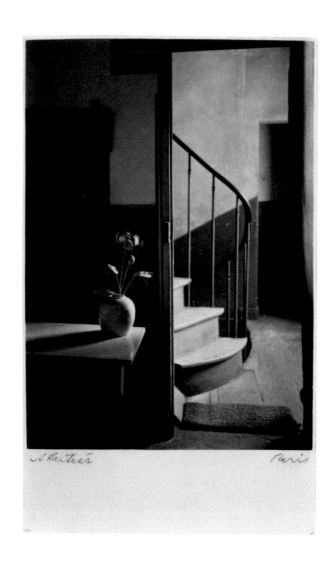

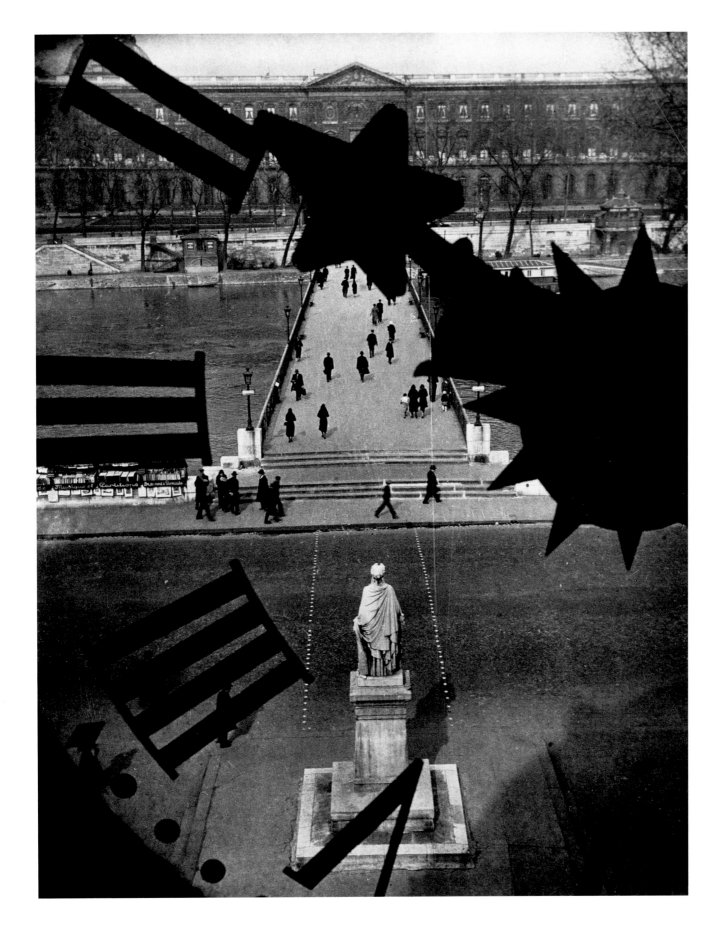

PLATE 70

ANDRÉ KERTÉSZ

Clock of the Académie Française, Paris negative 1932, print 1950s

Gelatin silver print; 25.1 × 19.7 cm (9⅞ × 7¾ in.). 84.XM.193.1

Charles Sheeler

Charles Sheeler (American, 1883–1965) was trained as a painter between 1903 and 1906 at the Pennsylvania Academy of Fine Arts in Philadelphia. His teacher was William Merritt Chase, a portrait painter to affluent clients who were flattered by his graceful brushstrokes and lively palette. In terms of style and subject matter, however, Sheeler had more in common with Chase's predecessor at the academy, Thomas Eakins (see page 72).

Sheeler struck up a lasting friendship with his classmate Morton L. Schamberg, a painter with whom he shared a studio in Philadelphia after graduation. Both artists took up photography around 1910, with Schamberg specializing in portraits and Sheeler concentrating on architecture and works of art. At first photography was just a source of revenue for both men. However, for Sheeler it soon became another form of drawing, as well as an important medium of expression.

Sheeler and Schamberg were invited to participate in the International Exhibition of Modern Art held at the New York Armory in 1913. The Armory show introduced important new works of European Modernism—including Marcel Duchamp's *Nude Descending a Staircase, No. 2*—to America for the first time,[2] and Duchamp's work brought Dadaism to the forefront in New York. Dadaism was an attitude that elevated irreverent, spontaneous, and humorous actions while diminishing the importance of the traditional materials of art and encouraging the use of new ones. The found object became a cornerstone of Dada expression, as exemplified by Duchamp's sculpture in the form of an appropriated urinal, displayed in New York at the First Annual Exhibition of the Society of Independent Artists in April 1917. Sheeler surely knew this work from seeing it on display or through Stieglitz's photograph of it.

In the spring of 1917 Sheeler suddenly took a bold new approach in a series of photographs inspired by eighteenth-century farm buildings located in Bucks County, north of Philadelphia. This series had been under way for several years and consisted at that point of barns observed and recorded in a documentary style as specimens of design and construction.

Then, in 1917, he began to shape tough, dramatic compositions with light and found objects as the key.[3] In *Doylestown House—the Stove, Pennsylvania* (PLATE 71) a nineteenth-century iron stove dominates the composition, with its sensuously curved finial and its sheet-metal chimney pipe extending to the ceiling. The stove stands in the center of the picture, radiating a profusion of light from a source other than the open firebox. Seen in the silhouette of bright light, Sheeler's stove is a powerful object that was not made as a work of art but, like Duchamp's urinal, is elevated to one by the photographer's bold appropriation and singular vision.

In *Side of a White Barn, Pennsylvania* (PLATE 72) Sheeler became even more deliberate. He moved his large camera close to the subject and made an exposure in strong, direct sunlight that describes precisely the texture of the weather-worn wood, the deteriorating, uneven stucco, and six panes of dirty glass. Two chickens are perched on a pile of hay below the double doors. All of these elements, when analyzed, represent individual found objects. The highly textured, irregularly milled wood, the crumbling stucco, and the pile of soiled hay constitute an image that is partly rectilinear, partly random. Taken together these objects are recontextualized as art.

Sheeler's study of the interior of a barn, titled *The Buggy, Pennsylvania* (PLATE 73), transforms found objects, in a single photograph, with a level of seeing equal to the best card-carrying Dadaists. Farm implements and tools, clothing, the barn's structural materials, dangling ropes or wires, and the elements of the buggy itself (spoked wheel, axles, suspension) are all photographed in silhouette with light from a single source. By using light in this way, Sheeler deliberately shapes our perception of found objects. No other artist of his time had employed photography so skillfully to create original works in the Dadaist spirit.

1. *New York World*, exh. review, 1917, quoted in Theodore E. Stebbins and Norman Keyes, *Charles Sheeler: The Photographs* (Boston: Little Brown, 1987), 8.

2. Milton W. Brown, *The Story of the Armory Show* (Greenwich, Conn.: Joseph H. Hirshorn Foundation, 1963), 240, 275–76.

3. Stebbins and Keyes, *Charles Sheeler*, 11.

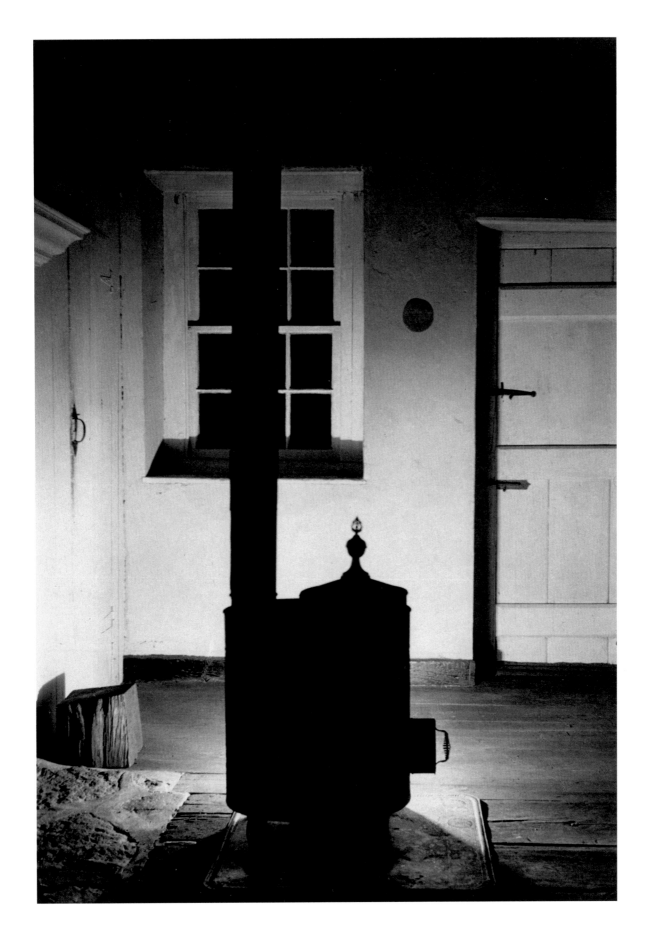

PLATE 71

CHARLES SHEELER

Doylestown House—the Stove, Pennsylvania 1917

Gelatin silver print (sepia-toned); 22.9 × 16.2 cm (9 × 6⅜ in.). 88.XM.22.1

PLATE 72

CHARLES SHEELER

Side of a White Barn, Pennsylvania 1917

Gelatin silver print; 19.4 × 24.4 cm (7 ⅝ × 9 ⅝ in.). 88.XM.22.4

PLATE 73

CHARLES SHEELER

The Buggy, Pennsylvania 1917

Gelatin silver print; 19.5 × 24.4 cm (7 ¹¹⁄₁₆ × 9 ⅝ in.). 88.XM.22.3

I suggested [to Duchamp] that there might be a photographic process that would expedite matters. Yes he replied, perhaps in the future photography would replace all art. —MAN RAY[1]

Man Ray

Throughout his life Man Ray (American, 1890–1976) enjoyed a succession of creative relationships, which started with his first wife, Adon Lacroix, whose love inspired him to write poetry. She was also his muse for drawings, photographs, and paintings. Around 1915, encouraged by meetings with Alfred Stieglitz (see page 92), Man Ray bought a tripod-mounted camera so he could photograph professionally. At about the same time, he met Marcel Duchamp, who had recently arrived in America.

In 1919 Man Ray left his wife and, starting around January 1920, became a constant companion of Duchamp in New York, where both men were invited to participate in the founding of the Société Anonyme, Inc., the first modern art museum in America. Their New York camaraderie continued through the summer of 1921, when both men departed separately for Paris, where their association resumed. The most astonishing piece they created together was Duchamp's female alter ego, produced in the form of *Rrose Sélavy* (PLATE 74). The name was derived from the phonetic pronunciation of the French phrase *Eros c'est la vie* (Eros is life). In a number of Man Ray photographs, Rrose Sélavy is brought to life by Duchamp dressed in women's clothing.[2]

Eros once again came into Man Ray's life in the form of Alice Prin, who was better known in Paris by the name Kiki of Montparnasse, after the Paris district inhabited by many foreign artists, including Pablo Picasso, Amedeo Modigliani, and Diego Rivera, as well as Man Ray. About the photographs of Kiki, Man Ray wrote in his autobiography that they "really looked like studies for paintings or might even be mistaken [at] a casual glance for reproductions of academic paintings."[3]

Le Violon d'Ingres (PLATE 75) was inspired by the languid nudes of Jean-Auguste-Dominique Ingres, whose drawings Man Ray first saw at the New York Armory show in 1913. The photograph shows Kiki from the back with only her head and torso visible, wearing a turban reminiscent of those on some of Ingres's subjects. The photograph was altered by drawing the sound holes of a violin in ink (on the print from which this one was copied), thus suggesting the female form as a musical instrument.

Lee Miller, a young American fashion model who made the shift from being in front of the camera to being behind one, became an apprentice to Man Ray in Paris. She followed Kiki as Man Ray's lover and became his indispensable studio assistant and muse. Working in his darkroom together in 1930, they discovered the solarization process that became a signature technique in Man Ray's portraiture. Miller also collaborated with him on a sequence of images based on the theme of electricity for the Paris electric utility company. Her influential role in his creative process went unnoticed until the mid-1990s.

Man Ray frequently served as the subject in his own work but never so successfully as in *Self-Portrait with Camera* (PLATE 76). It is unlikely that he created this work alone. The photographer is posed in profile with his left hand adjusting the aperture of a camera lens and his eyes focused in that direction. It would have been difficult to simultaneously operate the second camera required to realize this tightly composed picture. Man Ray and Miller frequently photographed each other, and it was she who preferred the close-in profile perspective. Moreover, the print is solarized, directly associating the image with the process they discovered together. While the photograph is prominently signed and dated by Man Ray, it is in all likelihood one of the last works Man Ray created in collaboration with Miller.

1. Man Ray, *Self-Portrait* (Boston: Atlantic Monthly Press and Little, Brown, and Company, 1963), 82.
2. Katherine C. Ware, *In Focus: Man Ray, Photographs from the J. Paul Getty Museum* (Malibu: J. Paul Getty Museum, 1998), 34.
3. Man Ray, *Self-Portrait*, 140–45.

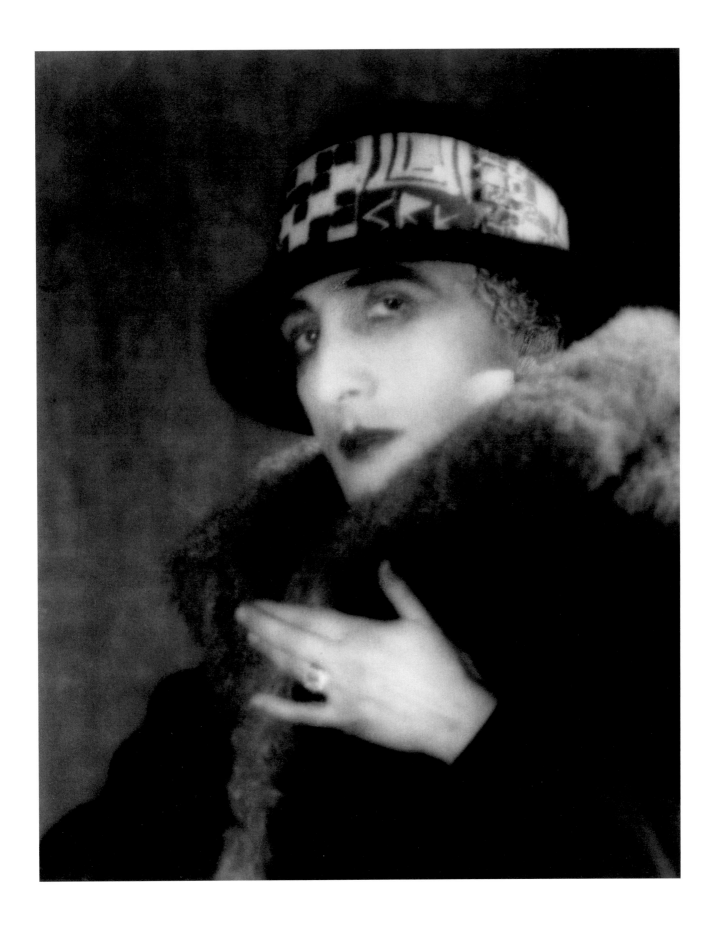

PLATE 74

MAN RAY

Rrose Sélavy (Marcel Duchamp) 1923

Gelatin silver print; 22 × 17.6 cm (8¹¹/₁₆ × 6¹⁵/₁₆ in.). 84.XM.1000.80

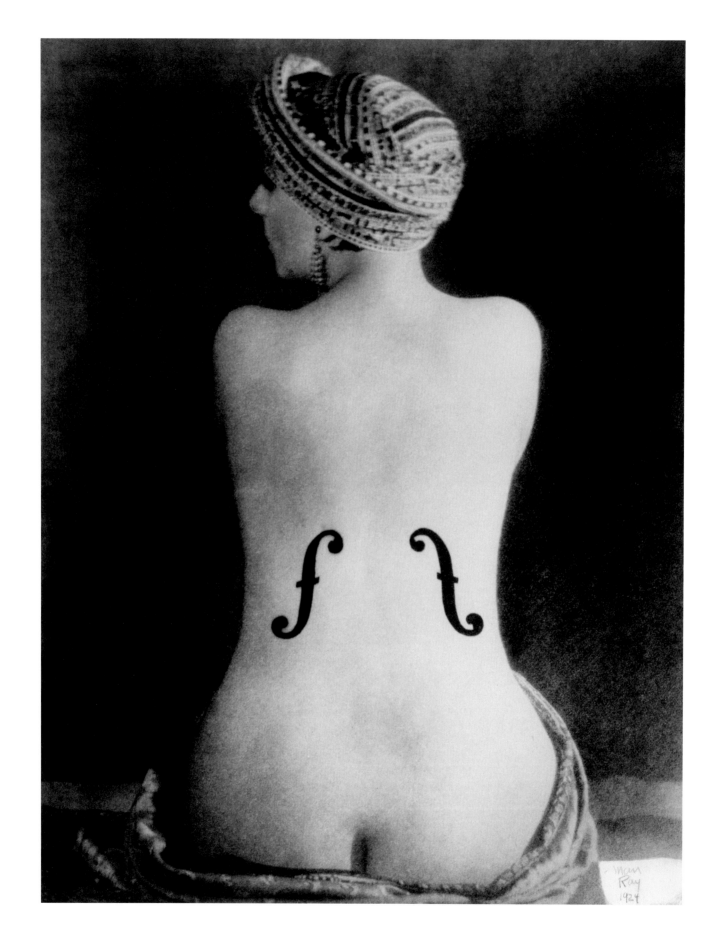

PLATE 75

MAN RAY

Le Violon d'Ingres 1924

Gelatin silver print; 29.6 × 22.7 cm (11⅝ × 8¹⁵⁄₁₆ in.). 86.XM.626.10

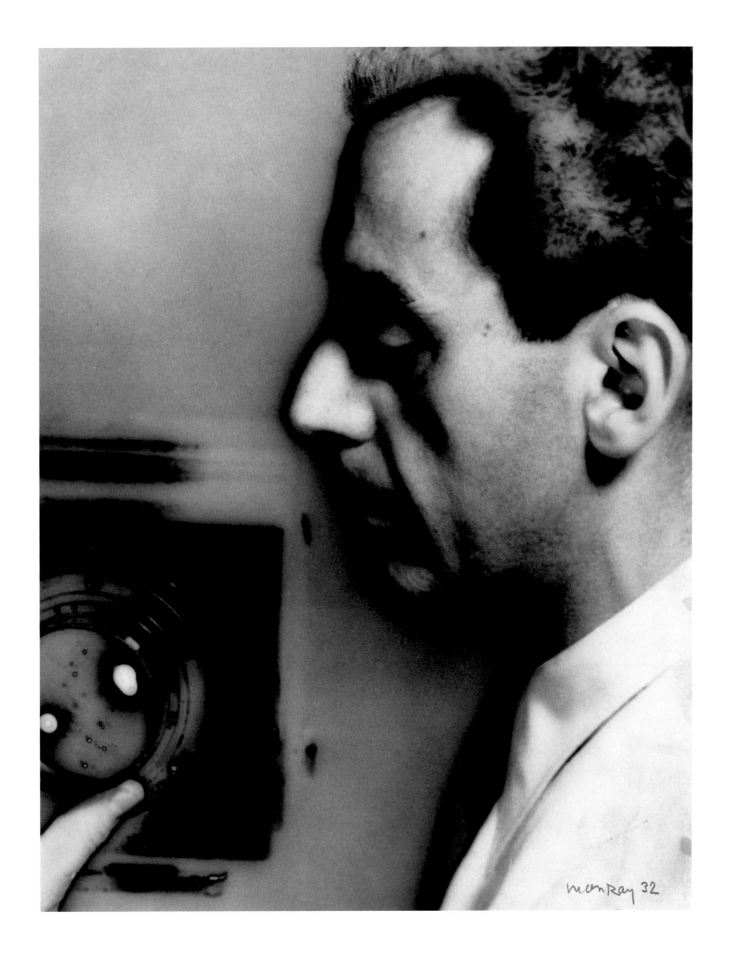

PLATE 76

MAN RAY

Self-Portrait with Camera 1932

Gelatin silver print (solarized); 29.2 × 22.8 cm (11½ × 9 in.). 84.XM.1000.14

The proletariat will create new houses, new streets, new objects of everyday life. —NIKOLAI PUNIN[1]

Alexander Rodchenko

Born in Saint Petersburg, Alexander Rodchenko (Russian, 1891–1956) grew up in Kazan, a city in eastern Russia, where he attended the local art academy. In 1914 he relocated to Moscow and enrolled in the Stroganoff School of Applied Arts to study graphic design. In Moscow he associated with Vladimir Tatlin and Kasimir Malevich, the patriarchs of Russian Constructivism, a style that advocated pure geometric abstraction in painting and the use of machine-made materials—such as wire, glass, and metal—in the industrial arts. Inspired by the politics of the October 1917 revolution, Rodchenko became a loyal communist. He and his wife—the painter Varvara Stepanova—used art to advance the political agendas of Vladimir Ilyich Lenin and Joseph Stalin.

Shortly after the revolution, under the auspices of Soviet political leaders, a trade union of artists was established with a section devoted to the applied arts. Rodchenko's involvement in this group led him to become one of the founding instructors at Vkhutemas, a state art academy modeled on Germany's first antiacademic art school, the Bauhaus. The academy formulated a new, proletarian approach to art, in which productivity was the chief objective. Inspired by this agenda, Rodchenko gave up painting in 1924 and devoted his creative energies to photography and graphic design.

One of Rodchenko's first published photographic works was his 1924 portrait of his friend Osip Brik (PLATE 77), the critic and theoretician whose 1926 essay "Photography versus Painting" was published in the second issue of *Sovetskoi Foto* (Soviet photography). It is unknown whether Rodchenko made the image of Brik with his own camera or whether he appropriated the image, but he altered it by adding Russian letters to one eyeglass lens. The letters read, in the Western alphabet, *LEF* (left), and the portrait was published on the cover of *Lef*, a Soviet art journal that disseminated the principles of Productivist design. Rodchenko was its chief graphic designer.[2] Soon after the Brik portrait was published, Rodchenko's work took another direction. He espoused the snapshot as the highest form of portraiture, "the first serious collision between art and photography, the battle between eternity and the moment."[3]

A turning point in Rodchenko's life came in the spring of 1925, when he spent several months in Paris supervising the Soviet installation of the International Exposition of Modern Decorative and Applied Arts held at the Grand Palais. While in Paris, Rodchenko purchased a handheld camera designed to expose 35 mm motion picture film, which he used to produce many important journalistic photographs, including his picture of a radio tower, *Sentry of Shukhov Tower* (PLATE 78), and a great many photographs devoted to the subject of sport.

In the radio tower image Rodchenko amalgamated the principles of Constructivism and Productivism. The image is "constructed" from the geometry of intersecting lines, while the subject is the result of Soviet "productivity" and technology. It shows a detail of a huge radio transmission tower and a uniformed guard whose bayonet rifle points to the sky. The industrial and the human, the Constructivist and the symbolic are fused into one image. The dynamic diagonal composition relates to Rodchenko's earlier paintings and drawings, while the linear element and the low angle are a signature style in his photographs.

The mobility of the 35 mm camera also made possible new vantage points, like that required to create *Pole Vault* (PLATE 79), in which Rodchenko created a drawing with light that consists of interlocking black lines. By 1930 Rodchenko had given up teaching in favor of photojournalism and, with his photographs reproduced in a dozen magazines and newspapers, embodied the true spirit of the Soviet Productivist artist.

1. Nikolai Punin, chief theorist of Productivist art, address at the Palace of Artists (Winter Palace), Saint Petersburg, November 24, 1918. See Nikolai Punin, quoted in German Karginov, *Rodchenko* (London: Thames and Hudson, 1979), 88.
2. David Elliott, ed., *Alexander Rodchenko*, exh. cat. (Oxford: Museum of Modern Art, 1979), 90.
3. Aleksandr M. Rodchenko and Varvara F. Stepanova, *The Future Is Our Only Goal: Alecksandr M. Rodchenko, Vavara F. Stepanova*, ed. Peter Noever; trans. Mathew Frost, Paul Kremmel, and Michael Robinson (Munich: Prestel; New York: Neues, 1991), 234.

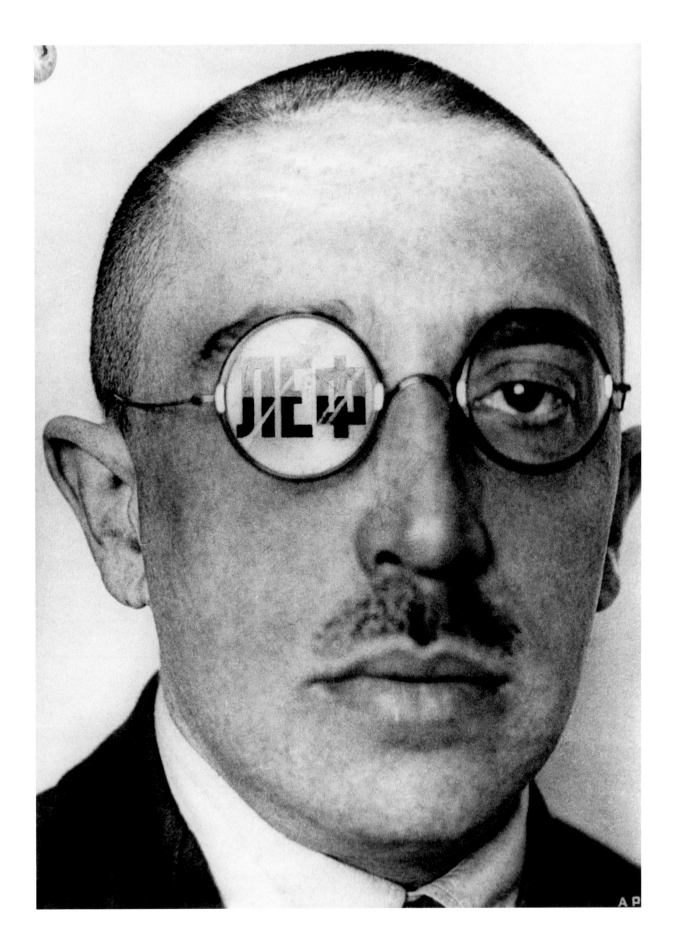

ALEXANDER RODCHENKO

The Critic Osip Brik 1924

Gelatin silver print; 28.6 × 20.8 cm (11¼ × 8³⁄₁₆ in.). 84.XM.258.30

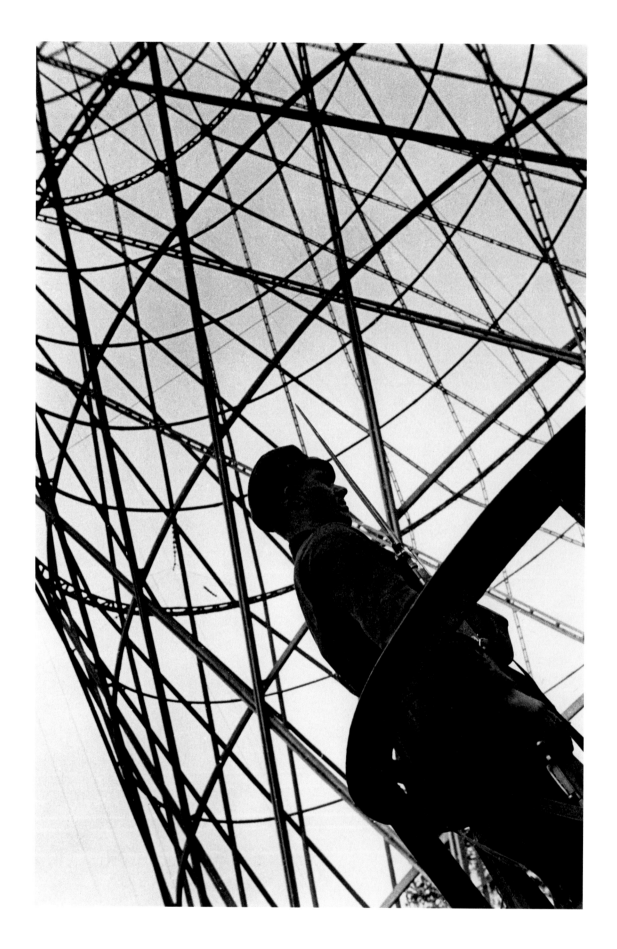

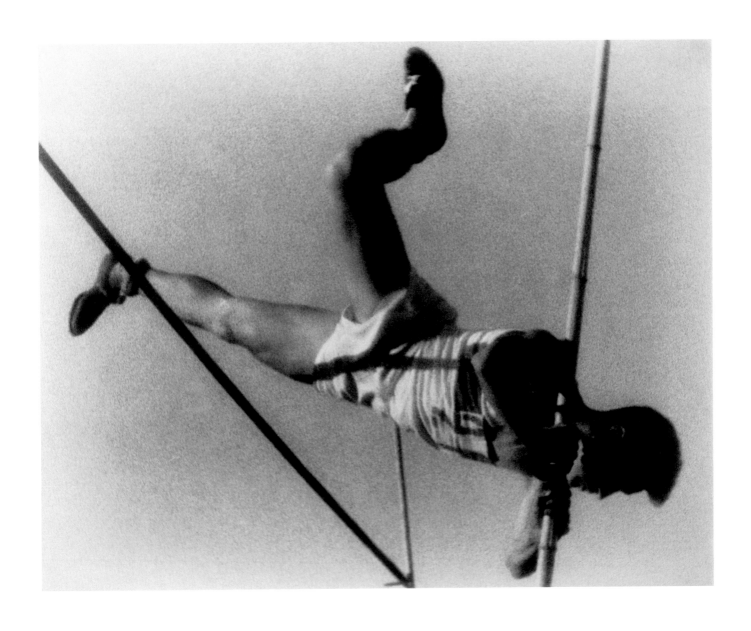

PLATE 79

ALEXANDER RODCHENKO

Pole Vault 1936

Gelatin silver print; 23.8 × 30.2 cm (9⅜ × 11⅞ in.). 84.XM.258.47

In photography we possess an extraordinary instrument for reproduction. But photography is much more than that. Today it is [a method for] bringing (optically) something entirely new into the world.
—László Moholy-Nagy[1]

László Moholy-Nagy

The strong anti-Semitic climate that prevailed in Eastern Europe following the First World War caused a migration of Jewish intelligentsia to Western Europe, particularly Germany and France, where many of them lived and worked until worsening circumstances drew them to America. André Kertész (see page 104) followed this diaspora, as did László Moholy-Nagy (American, 1895–1946), who was born in Hungary but spent most of his life in other countries.

Moholy-Nagy showed an appetite for information and a prodigious talent for transforming ideas first expressed by other artists. He had the capacity to produce a visual theory and make it comprehensible to others. In his essay "Production-Reproduction,"[2] published in 1922, he proposed that "the senses are insatiable.... they reach out for more new experience every time they take something in," which leads to "the perpetual need for new modes of creativity."[3] From 1923 to 1928 Moholy-Nagy taught at the Bauhaus, where the dissemination of his ideas provided fertile ground for many future artists.[4] He imaginatively used established materials to create an innovative visual syntax.

In a virtuoso advance on the photogram techniques developed by Christian Schad and Man Ray (see page 112), Moholy-Nagy created a number of completely abstract images based on Constructivist painting. These works were made chiefly by the projecting and scattering of light. An untitled photogram of around 1923 (PLATE 80) is closely related to his paintings of the same date in which Moholy-Nagy sought to explore the purely formal relationships of light, color, and shape by eliminating all references to natural forms.[5] The elements of the photogram—a white line, a small circle, and a lozenge—are literally streams of light and shadow that have been harnessed and composed.

Although Moholy-Nagy was deeply committed to abstraction, a tug of war appears to have been going on within him. Around 1924 he created an untitled photogram (PLATE 81) using identifiable found objects—wooden matchsticks and two napkin rings—arranged in a boldly diagonal pattern. On the back of the photograph, the artist identified the matches and napkin rings used to create the picture and then added the following note: "But is that [information] important in the end? How the light flows in tracks and what becomes of the whole has nothing to do anymore with the original material."[6]

Among the most masterful photographs created without the use of a camera is the enigmatically titled *Photogram Number 1—the Mirror* (PLATE 82). The dimensions are comparable to those of a medium-size painting (twenty-five by thirty-six inches), and the composition consists of bold geometric shapes set onto a variable gray background with lighter shadows of some of the darker shapes. The title word "Mirror" as well as when and how this work was realized have been the subject of much speculation. "Mirror" may refer to the method of enlargement. A photogram is usually a negative print no larger than eight by ten inches. The background is generally black with white or grayish shapes representing the reverse silhouettes of objects positioned on the paper. Here the background is just the opposite—white, or shades of light gray, with black or dark gray lines and shapes. None of these appear to be shadows and may instead represent reflections from a mirror or other translucent object.

For Moholy-Nagy, art was all about relationships between the parts of a picture, the way materials behave structurally, and the form that results. As he wrote in his essay "Production-Reproduction," "From this point of view creative endeavors are only valid if they produce new, as yet unfamiliar relationships."[7] Moholy-Nagy's inventive use of photography as a fine art continues to influence artists to this day.

1. László Moholy-Nagy, "A New Instrument of Vision," in Krisztina Passuth, *Moholy-Nagy* (London: Thames and Hudson, 1985), 326.
2. Moholy-Nagy, "Production-Reproduction," in *Photography in the Modern Era: European Documents and Critical Writings, 1913–1940*, ed. Christopher Phillips (New York: The Metropolitan Museum of Art / Aperture, 1989), 79–82.
3. Moholy-Nagy, "Production-Reproduction," 80.
4. Katherine Ware, *In Focus: László Moholy-Nagy*, Photographs from the J. Paul Getty Museum (Los Angeles: J. Paul Getty Museum, 1996), 6.
5. Ware, *In Focus*, 10–11.
6. Ware, *In Focus*, 12.
7. Moholy-Nagy, "Production-Reproduction," 80.

PLATE 80

László Moholy-Nagy

Untitled Photogram ca. 1923

Gelatin silver print; 17.6 × 12.2 cm (6^{15}/₁₆ × 4^{13}/₁₆ in.). 84.XM.997.62

LÁSZLÓ MOHOLY-NAGY

Photogram Number 1—the Mirror negative 1922–23, print ca. 1928

Gelatin silver print; 66.7 × 92.1 cm (25¼ × 36¼ in.). 84.XF.450

Recording the objective, the physical facts of things through photography does not preclude the communication in the finished work, of the primal.... Life is a coherent whole: rocks, clouds, trees, shells, torsos, smokestacks, peppers are interrelated, interdependent parts of the whole. Rhythms from one become symbols of all. —EDWARD WESTON[1]

Edward Weston

Edward Weston (American, 1886–1958) was born near Chicago to a family whose ancestors had settled in Maine a century before the American Revolution. With his midwestern upbringing and interest in writing, Weston had much in common with Walker Evans (see page 144), who pursued a purely American vision but who never photographed a nude. Unlike Evans and many other self-taught photographers, Weston was professionally trained in how to pose and light his subjects, how to expose negatives, and how to retouch them to improve the sitter's image. "Indeed, all these [skills]...must be so well known that they are as automatic as breathing," he said in 1922, expressing an unmitigated faith in technique as a springboard for quality in art.[2] The commissioned portraits he made between 1911 and 1923, when he operated a studio near Los Angeles, were professional but often unsatisfying to him emotionally.[3]

Portrait photography was Weston's main livelihood but not his passion. The nude female form was a subject that he pursued as early as 1909 when one day his young wife, Flora, undressed and positioned herself comfortably beside a flowing stream at a secluded canyon in the San Gabriel Mountains near Los Angeles. Between 1911 and 1924 he photographed various nude models in his studio, sometimes in evocative architectural settings. In 1924 Weston's life and art changed when he closed his Glendale, California, studio and voyaged by steamer to Mexico with Tina Modotti, an Italian American actress, political activist, and photographer. The photographs he made of her in Mexico, such as the one shown here (PLATE 83), allowed his skillful technique—his understanding of the subtleties of light and shade, his perception of the picture space, his sensitivity to textures—to be harnessed, permitting him to express with tactile physicality the complex human relationship he shared with Modotti. Seen from above, Modotti reclines outdoors on a stone floor, her curvaceous torso nearly filling the frame.

After his return from Mexico in the winter of 1927, Weston sat at his Glendale desk "recalling the past, reviewing the present" of a life in turmoil. "I worked for myself

Monday.... Two negatives, nudes of C. [Christel Gang], both well seen....A start has been made."[4] Weston distinguished between his commissioned photographs and his personal work. He used the phrase "well seen" to congratulate himself on the success and noted that "a start has been made" on the road to achieving a personal vision. The woman's back shown here (PLATE 84) may be that of Christel Gang. This photograph represents a female nude seen from an objective, formal point of view rather than an emotional, subjective one: "I am stimulated to work with the nude body, because of the infinite combinations of lines which are presented with every move," he wrote around the time this photograph was made.[5]

In the spring of 1934 Weston met Charis Wilson, who became a muse as powerful to him as O'Keeffe was to Stieglitz (see page 92). "Perhaps C. will be remembered as the great love of my life," Weston wrote on December 9. "Already I have achieved certain heights reached with no other love."[6] In 1936 Weston moved with his sons, Chandler, Brett, and Neil (ages 25, 24, and 18), to Southern California. There Edward and Brett often worked side by side, with Charis providing inspiration and moral support. One day Edward spread a wool blanket on the sundeck above the garage of their tiny bungalow in Santa Monica Canyon and positioned Charis partly in sunlight, partly in shadow to achieve a bold network of diagonal lines and elongated shapes that are softened by the human reality of flesh and hair (PLATE 85). By skillfully employing light to reconfigure the ordinary, Weston redefined the word "imagination" as applied to photography.

1. Edward Weston, *Edward Weston on Photography*, ed. Peter C. Bunnell (Salt Lake City: G. M. Smith, P. Smith Books, 1983), 62.
2. Edward Weston, "Random Notes on Photography," in Weston, *Edward Weston on Photography*, 27.
3. Nancy Newhall, ed., *The Daybooks of Edward Weston*, vol. 2: *California* (New York: Aperture, 1973), 3.
4. Newhall, *Daybooks*, 12.
5. Newhall, *Daybooks*, 3.
6. Newhall, *Daybooks*, 283.

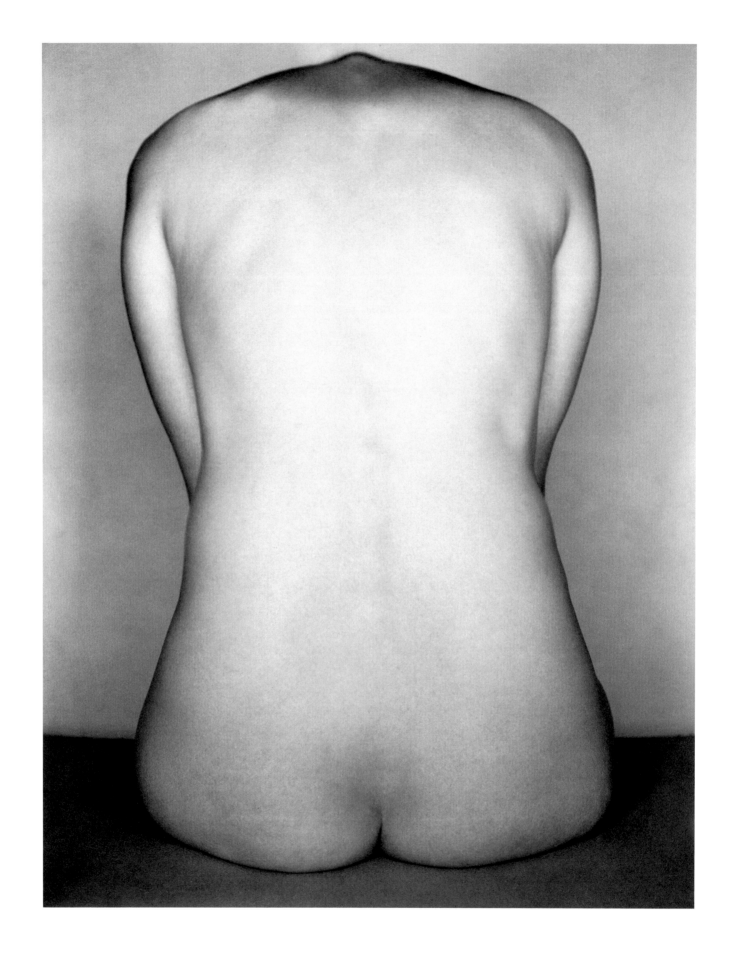

EDWARD WESTON

Nude, Los Angeles 1927

Gelatin silver print; 23.8 × 18.6 cm (9⅜ × 7⁵⁄₁₆ in.). 86.XM.676.1

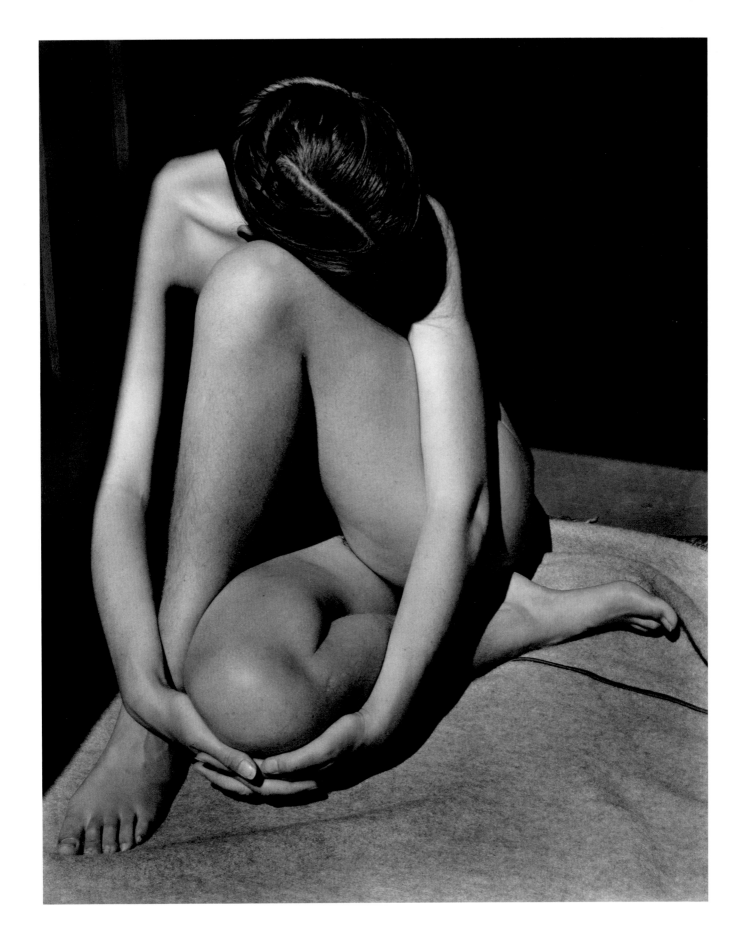

PLATE 85

EDWARD WESTON

Nude, Santa Monica 1936

Gelatin silver print; 24.1 × 19.2 cm (9¹⁵⁄₃₂ × 7⁹⁄₁₆ in.). 84.XM.1381.1

Photography has its own technique and its own means. Trying to use these means to achieve painterly effects brings the photographer into conflict with the truthfulness and unequivocalness of his medium, his material, his technique. —ALBERT RENGER-PATZSCH[1]

Albert Renger-Patzsch

Toward the end of the 1920s a furious debate arose over what the ingredients for a strong photograph should be. Purist photographers—such as Alfred Stieglitz (see page 92), Paul Strand (see page 88), Edward Weston (see page 124), and Walker Evans (see page 144)—all asked the same question: Can a worthy photograph be inspired by painting or should it be the result of a different kind of thinking that emerges from the materials of photography? The question of whether a good photograph should resemble a painting had been at the root of verbal sparring in the mid-1920s between László Moholy-Nagy (see page 120) and Albert Renger-Patzsch (German, 1897–1966), both of whom were ahead of their time.[2] Both artists considered productivity central to photography, but they approached the issue from opposite perspectives. Moholy-Nagy advocated endless experimentation with materials and existing processes to achieve progress.[3] Renger-Patzsch, however, considered Moholy-Nagy's experiments unproductive because they were grounded in the languishing tradition of easel painting rather than in the new use of the tools of photography—camera and lens. For Renger-Patzsch "productive" meant "practical." For Moholy-Nagy "productive" meant advance into unseen realms.

Renger-Patzsch's study of a brick smokestack (PLATE 86) was presumably made at a factory near Cologne or Düsseldorf, where the mills and coal mines produced 80 percent of Germany's iron and steel. With a tripod positioned close to the structure, and with the camera held vertically and nearly perpendicular to the horizon, the outlines of the structure, which were actually parallel, seem almost to converge at infinity in the photograph. After first recognizing the dramatic form, our eyes are drawn to the details—the countless irregular rows of bricks and the jagged, vertical fracture at the center. This structural flaw in the smokestack must have been the focus of Renger-Patzsch's attention. He was probably brought to this site by the factory management, who hired him to create a document that would be useful for engineering analysis. Shortly after Renger-Patzsch created this image,

Moholy-Nagy encountered a reproduction of it and copied it for use in a collage satirizing Renger-Patzsch's work.[4]

By today's criteria Renger-Patzsch's factory smokestack is clearly a work of art. However, it was not included in the 1928 book *Die Welt ist schön* (The world is beautiful), in which one hundred Renger-Patzsch photographs were reproduced, each on its own page, in a skillfully arranged sequence. The images ranged from *Sacred Baboon (Mantelpavian)* (PLATE 87) to *Flatirons for Shoe Manufacture* (PLATE 88). In the first, Renger-Patzsch presents the baboon in a head-and-shoulders shot from a three-quarter perspective, as if it were the portrait of a human being. He used a tripod-mounted camera to make a high-resolution, six-by-nine-inch glass negative. The subtle pattern of thousands of bristly hairs is recorded with infinite detail. The photograph contrasts the tough, dark skin of the nose with the delicate skin of the eyelids and brows.

This attention to detail is equally strong in the flatirons. This still life of iron lasts (tools used to form shoes) faithfully records the shiny, hard metal and textured wood handles. Renger-Patzsch skillfully chronicles the power of these shapes. He portrays utilitarian objects as objects, and alludes to the Marxist ideal of productivity. The arrangement of the iron lasts is mysterious and elusive, as well as a bit menacing, endowing the instruments of production with poetic strength.

The work of Renger-Patzsch defines the New Objectivity in German photography, in which beauty is seen in subjects that once would have been considered unworthy of attention.

1. Albert Renger-Patzsch, "Aims," trans. Joel Agee, in Christopher Phillips, ed. *Photography in the Modern Era: European Documents and Critical Writings, 1913–1940* (New York: The Metropolitan Museum of Art / Aperture, 1989), 105.
2. Writings by Albert Renger-Patzsch and László Moholy-Nagy in Phillips, *Photography in the Modern Era*, 79, 83, 104, 108, 132, 142.
3. Albert Renger-Patzsch, "Joy Before The Object," trans. Joel Agee, in Phillips, *Photography in the Modern Era*, 108.
4. Katherine Ware, *In Focus: László Moholy-Nagy*, Photographs from the J. Paul Getty Museum (Malibu: J. Paul Getty Museum, 1996), 109–11.

PLATE 86

ALBERT RENGER-PATZSCH

Factory Smokestack ca. 1925

Gelatin silver print; 23 × 16.8 cm (9¹⁄₁₆ × 6⁵⁄₈ in.). 84.XM.138.23

ALBERT RENGER-PATZSCH

Sacred Baboon (Mantelpavian) ca. 1928

Gelatin silver print; 37.7 × 27.5 cm (14¹³⁄₁₆ × 10¹³⁄₁₆ in.). 90.XM.101.10

ALBERT RENGER-PATZSCH

Flatirons for Shoe Manufacture ca. 1926

Gelatin silver print; 22.9 × 16.8 cm (9 × 6⅝ in.). 84.XM.138.1

I reported ages ago that [Paris at Night] *was done except for a few photos. Yet the explanation is simple:*
The more pictures I took, the more adept I became at night photography (and I can claim to have made history
in this field). —Brassaï [1]

Brassaï

Gyula Halász (French, born Hungary, 1899–1984) coined his public name—Brassaï—from his birthplace, Brassó (Brasov), north of Bucharest (now in Romania).[2] Like André Kertész (see page 104), Brassaï was conscripted into the Hungarian army and then, after the First World War, enrolled in the Academy of Fine Arts in Budapest. He fled in 1920 to Berlin to escape the same political turmoil that caused Kertész and László Moholy-Nagy (see page 120) to leave Hungary at about the same time. In Berlin, Brassaï studied painting and sculpture while supporting himself by writing articles for hometown publications on topics ranging from the exiled German kaiser to the composer Béla Bartók.[3] In early 1924 Brassaï left Berlin for Paris, where he lived for the rest of his life.

In photography the name Brassaï is synonymous with Paris after dark. After living there for almost five years and working as a writer, good luck brought him together with Kertész, and the two worked briefly as a writer-photographer team. Kertész taught his younger friend the professional tricks of night photography, and soon Brassaï bought his own camera and carried it with him as he prowled through Paris.[4] He established a pattern of "going to bed at sunrise, getting up at sunset," according to his friend the writer Henry Miller, who made Brassaï a character in his novel *Tropic of Cancer*.[5]

Beginning around 1930 Brassaï began to haunt the hangouts of the Paris underworld to create a series of photographs that was published in 1933 under the title *Paris at Night*. His motivation to make photographs was as much literary as it was visual. The camera, however, cannot distinguish between fantasy and reality, as with his picture of two men dancing (PLATE 89), whom he observed at the dance hall of the Montagne Sainte-Geneviève. Brassaï had discovered a nightclub where the dance floor was "populated by only couples of men or couples of women."[6] Brassaï suggested the mix of fantasy and reality when he said about this photograph, "Butchers from the neighborhood...with hearts full of feminine longings...would hold hands—thick calloused hands—timid like children, and would waltz solemnly together, their eyes downcast, blushing wildly."[7]

Photographing at night presented certain technical issues that Brassaï cleverly solved. Very long exposures were required to achieve detail in the dimly lit shadows and turned the light sources into enormous white circles. He avoided this by choosing vantage points shielded from the light source, as in *Lovers, rue Croulebarbe, Paris* (PLATE 90). From his first day in Paris, Brassaï saw something special in Parisian women. He noticed that public displays of affection were commonplace and saw couples congregating in alleyways to kiss after the movies, with no one but him apparently paying attention.[8] He recorded couples seated in cafés, on park benches, and at street fairs, as is the case with the couple kissing on a swing (PLATE 91). Photographs that strive to realize deep emotions must start from real experience. We are each invited to create our own stories around Brassaï's reality, and these fictions can be as intriguing as any novel.

1. Brassaï, *Brassaï: Letters to My Parents*, trans. Peter Laki and Barna Kantor (Chicago and London: Univ. of Chicago, 1997), 191.
2. Anne Wilkes Tucker, with Richard Howard and Avis Berman, *Brassaï: The Eye of Paris*, exh. cat. (Houston: Museum of Fine Arts, 1999), 19.
3. Brassaï, *Brassaï: Letters to my Parents*, 13.
4. A. Kraszna-Krausz, ed., *Masters of the Camera: Camera in Paris, Brassaï* (New York: The Focal Press, 1949), 20.

5. Sandra S. Phillips, David Travis, and Weston Naef, *André Kertész: Of Paris and New York*, exh. cat. (New York: The Metropolitan Museum of Art; Chicago: Art Institute of Chicago; London: Thames and Hudson, 1985), 80.
6. Brassaï, *The Secret Paris of the 30's* (New York: Pantheon, 1976), [189].
7. Brassaï, *Secret Paris of the 30's*, [171].
8. Brassaï, *Secret Paris of the 30's*, [69].

PLATE 89

BRASSAÏ

Two Butchers Dancing, Paris ca. 1931

Gelatin silver print; 29.7 × 23 cm (11 9/16 × 9 1/16 in.). 84.XM.1024.6

PLATE 90

BRASSAÏ

Lovers, rue Croulebarbe, Paris ca. 1932

Gelatin silver print; 29.7 × 22.5 cm (11 11/16 × 8 7/8 in.). 84.XM.1024.19

PLATE 91

BRASSAÏ

Kiss on the Swing 1935–37

Gelatin silver print; 29.7 × 23.3 cm (11¹¹⁄₁₆ × 9³⁄₁₆ in.). 84.XM.1024.18

He uses a miniature camera [Leica] with an apparently effortless reflex action. When a subject presents visual possibilities, he seeks the most revealing camera position rapidly. At the split-second when the lighting, the form and the expression are one, he releases the shutter. —BEAUMONT NEWHALL[1]

Henri Cartier-Bresson

The first love of Henri Cartier-Bresson (French, born 1908) was painting, which he learned as an apprentice in the studio of André Lhotte. There he was steeped in the academic principles of design. His best friend, the poet André Pieyre de Mandiargues, described their youthful shared interests as "Cubist painting, Negro art, the Surrealist movement, the poetry of Rimbaud and Lautréamont, James Joyce, the poetry of Blake, the philosophy of Hegel, Marx and communism."[2]

Completely self-taught in photography, Cartier-Bresson first approached it in accordance with his devout belief that firsthand experience is essential for knowledge about life. His passion for experience led him to travel widely in and beyond Western Europe. In the early 1930s he made photographs in various parts of Africa and then traveled to Germany and Eastern Europe (1931), Italy and Spain (1932–33), Morocco (1933), and Mexico (1934), as well as within France. He quickly established an international reputation for his understated observations.

Cartier-Bresson wavered between two objectives. Sometimes he sought to capture a single instant in time that could represent the entirety of a place or situation, while at other times he thought of himself as a reporter, whose goal was to bring together the scattered elements of an unfolding event.[3] He discovered the small, quiet, and efficiently designed Leica camera in 1932 after returning from Africa. "It became the extension of my eye," he reflected twenty years later, "and I have never been separated from it."[4]

One day he was at the Mediterranean seaside village of Hyères, an hour east of Marseille, when he encountered a highly energetic young woman on the beach (PLATE 92). The moving figure, with clothing that seems to explode around her, is set against three static rectangles of sand, water, and sky drawn by light in different shades of gray. On paper these elements are transformed into geometry, a strategy of design he learned from Lhotte. "Composition must be one of our constant preoccupations," wrote Cartier-Bresson, "but at the moment of shooting it can stem only from our intuition, for we are out to capture the fugitive moment, and all the interrelationships involved are on the move."[5]

Cartier-Bresson was an enthusiastic sightseer and took his time in each place to be able to digest what he saw. For example, in 1932 and 1933 he spent blocks of time in Spain, where he made many photographs. In one of these (PLATE 93), the subject is a child's animated body language, his head tossed back and fingers brushing against the wall. In contrast to the geometry of the seaside image discussed earlier, here an active two-dimensional surface becomes infinite, like the surface of a Joan Miró painting. "In photography there is a new kind of plasticity, [a] product of the instantaneous lines made by movements of the subject," the photographer wrote. "We work in unison with movement as though it were a presentiment of the way in which life itself unfolds. But inside movement there is one moment at which the elements in motion are in balance. Photography must seize upon this moment and hold immobile the equilibrium of it."[6]

Photographic portraiture is inherently static, yet as a genre it appealed to Cartier-Bresson because of its detail and specificity. In Spain he also encountered a weary traveler lying on a stone bench, head on his suitcase—an image to which the artist could perhaps relate from his own extensive travels (PLATE 94). Cartier-Bresson wrote, as if to explain his intention here, "In photography, the smallest thing can be a great subject. The little, human detail can become a leitmotiv."[7]

1. Beaumont Newhall, *The Photographs of Henri Cartier-Bresson*, exh. cat. (New York: Museum of Modern Art, 1947), 12.
2. Peter Galassi, *Henri Cartier-Bresson: The Early Work*, exh. cat. (New York: Museum of Modern Art, 1987), 15.
3. Henri Cartier-Bresson, *The Decisive Moment: Photography by Henri Cartier-Bresson* (New York: Simon and Schuster, 1952), [v].
4. Cartier-Bresson, *The Decisive Moment*, [iv].
5. Cartier-Bresson, *The Decisive Moment*, [x–xi].
6. Cartier-Bresson, *The Decisive Moment*, [x].
7. Cartier-Bresson, *The Decisive Moment*, [viii–ix].

PLATE 92

HENRI CARTIER-BRESSON

Hyères, France 1932

Gelatin silver print; 15.6 × 23.8 cm (6⅛ × 9⅜ in.). 85.XM.400.1

PLATE 93

HENRI CARTIER-BRESSON

Valencia, Spain 1933

Gelatin silver print; 23.2 × 29.5 cm (9⅛ × 11⅝ in.). 84.XM.1008.1

What is life? An illusion, a shadow, a story. And the greatest good is little enough: for all life is a dream, and dreams themselves are only dreams. —PEDRO CALDERÓN DE LA BARCA[1]

Manuel Alvarez Bravo

The son of Manuel Alvarez and Soledad Bravo, Manuel Alvarez Bravo (Mexican, 1902–2002) was born into a family of artists. His father and grandfather were painters who owned cameras, and they instilled in the young man a love of art, literature, and photography. Like Charles Sheeler (see page 108), Alvarez Bravo was first drawn to photographing works of art and manufactured goods, subjects that became central to his mature vision.

Alvarez Bravo was influenced in his early twenties by Hugo Brehme, a German photographer with a precise and objective style. He was also influenced by the photography of the U.S. West Coast through his subscription to the San Francisco publication *Camera Craft*, in which the work of Edward Weston (see page 124) and Dorothea Lange (see page 148) was reproduced. Alvarez Bravo's first cohesive body of work was created in Oaxaca, a city abounding in relics of pre-Columbian civilizations. After returning to Mexico City in 1927 he met Tina Modotti. At Modotti's suggestion, Alvarez Bravo sent Weston, unannounced, a box of his photographs for critical review, to which Weston replied on April 30, 1929, "It is not often I am stimulated to enthusiasm over a group of photographs."[2] That same year, Alvarez Bravo was hired by Diego Rivera to teach photography at the Escuela Central de Artes Plásticas, housed in the old Academia de San Carlos in Mexico City.

Alvarez Bravo's daring photographs emerge from the most typical aspects of Mexican culture and, at the same time, are integrally connected to the experimental tradition in art. In *Optical Parable* (PLATE 95) the storefront of an eyeglass merchant is seen from the perspective of a pedestrian, but all is reversed. The signs, created to advertise the wares and services of the opticians E. and A. Spirito, are reversed in the photograph, making the texts difficult to read, thus canceling the intended purpose of verbal communication. Like a poem in which form and content become one, here the act of seeing becomes process and content. The title phrase "optical parable" can be understood as "a short moral tale for the eyes,"

with the lesson of this particular story being that seeing is not necessarily believing.

Alvarez Bravo's strength, which Rivera admired, was the photographer's ability to find connections between high art and native Mexican culture. In *Box of Visions* (PLATE 96), for example, the disparate realities of urban progress and rural tradition are interwoven.[3] The subject is a homemade contraption, fabricated of wood, stone, and paper, for viewing stereographs at a rural festival. The proprietor of the modest enterprise most likely possessed a stash of views from around the world and charged local people and passersby small sums of money to look through the lenses. Stereographs—such as those produced by the Langenheim brothers (see PLATES 29–31) and Carleton Watkins (see PLATE 32)—were the first form of mass visual communication and a product of urban culture, but they were already out of fashion in the cities by the 1930s and were commercially marginal when this picture was made.

Another Alvarez Bravo photograph that bridges the gap between tradition and modernity is *Daughter of the Dancers* (PLATE 97). The girl is a member of a troupe of folk dancers, whose partners—possibly family members—are performing on the other side of the wall. She gazes at them through a circular window, as though looking into the open lens of a camera obscura. The girl is in the picture, and she is looking at another scene outside of our view. This image is also compelling for its lyrical elements—the solitary girl with bare, crossed feet; her local costume, including a round sombrero echoing the shape of the window; the deteriorating painted pattern on the wall. Poetic and universal, Alvarez Bravo's photographs transcend both time and culture.

1. Pedro Calderón de la Barca, ca. 1650, quoted in Fred R. Parker, *Manuel Alvarez Bravo*, exh. cat. (Pasadena: Pasadena Art Museum, 1971), 18.
2. Edward Weston to Manuel Alvarez Bravo, quoted in Jane Livingston, *Manuel Alvarez Bravo* (Boston: David R. Godine; Washington, D.C.: Corcoran Gallery of Art, Washington, 1978), xxxiv.
3. Roberto Tejada, *In Focus: Manuel Alvarez Bravo*, Photographs from the J. Paul Getty Museum (Malibu: J. Paul Getty Museum, 1996), 54.

PLATE 95

MANUEL ALVAREZ BRAVO

Optical Parable 1934

Gelatin silver print; 19.8 × 21.8 cm (7 ¹³⁄₁₆ × 8 ⁹⁄₁₆ in.). 2003.26

PLATE 96

MANUEL ALVAREZ BRAVO

Box of Visions ca. 1934

Gelatin silver print; 19.6 × 24.4 cm (7 $^{11}/_{16}$ × 9 $^{5}/_{8}$ in.). 2001.56

PLATE 97

MANUEL ALVAREZ BRAVO

Daughter of the Dancers 1933

Gelatin silver print; 23.3 × 16.9 cm (9³⁄₁₆ × 6⅝ in.). 92.XM.23.23

The language of "reality" (in the sense of "reality" we are trying to speak of here) may be the most beautiful and powerful but certainly it must in any case be about the heaviest of all languages. —JAMES AGEE[1]

Walker Evans

Walker Evans (American, 1903–1975) was born in St. Louis, Missouri, and raised in Illinois and Ohio but spent most of his life in New York. His first love was literature, but his genius was for photography. He studied French literature in Paris and then settled in New York in 1927, where he began quietly to pursue photography with a special interest in architecture. His photographs of Victorian houses were exhibited at the Museum of Modern Art in New York in 1933 in its first exhibition devoted to a single photographer.

Evans was largely self-taught in photography, but two early influences on his approach to picture making were Civil War–era photographs, such as those of Timothy O'Sullivan (see page 60), and the work of Alfred Stieglitz (see page 92). In 1929 Evans showed Stieglitz, who was by then cantankerous and withdrawing from the artistic mainstream in New York, a portfolio of his photographs. Evans came away from the meeting with a disdain for the revered elder of American photography and his lyrical style. He decided that he wanted his pictures to look impersonal and documentary instead— more like those of O'Sullivan or Carleton Watkins (see page 56).

In 1935 Evans was invited to join the team of photographers sponsored by the federal Resettlement Administration (renamed in 1936 the Farm Security Administration [FSA]) to photograph rural America during the Great Depression. The next summer Evans took a leave of absence from the project to work for *Fortune* magazine, for which his friend James Agee was a writer. The magazine sent the writer and photographer to Alabama for several weeks in July to report on the daily life of sharecroppers. The Burroughs, Fields, and Tengle families (whom Agee renamed Gudger, Woods, and Ricketts, respectively) from Hale County, Alabama, became the subject of an illustrious collaboration. The pair's work was rejected for publication by *Fortune* but was published in 1941 under the brilliant, intentionally sardonic title

Let Us Now Praise Famous Men. Thirty-one photographs by Evans accompanied approximately 150,000 words (471 pages) by Agee. The two men were credited equally on the title page and, in this instance, every picture was worth five thousand words.

In a chapter devoted to clothing, Agee wrote about Allie Mae Burroughs (called Annie Mae Gudger): "No Southern country woman in good standing uses rouge or lipstick, and her face is colorless."[2] Evans's close-up portrait of her (PLATE 98), reveals more than a colorless face. The woman's tight, anxious brow and pensive stare suggest the hardship of a sharecropper's life during the depression.

Describing their house, Agee writes, "The one static fixture is . . . a wooden shelf, waist-high, and on this shelf, a bucket, a dipper, a basin, and usually a bar of soap, and hanging from the nail just above, a towel. The basin is graniteware, small for a man's hands, with rustmarks [*sic*] on the bottom."[3] Although the Burroughs home was a makeshift, four-room structure, Evans depicts it with dignity in his view of the washroom in the dog run (PLATE 99).

Evans's study *A Baptist Grave, Hale County, Alabama* (PLATE 100) makes visible what Agee describes: "When the grave is still young, it is very sharply distinct, and of a peculiar form. The clay is raised in a long and narrow oval with a sharp ridge, the shape exactly of an inverted boat. . . . On several graves, which I presume to be those of women, there is at the center the prettiest or the oldest and most valued piece of china."[4] Despite the strength and detail of Agee's report in words, it is the searing honesty of Evans's photographs that truly achieves the goal of respectful objectivity.

1. James Agee, in James Agee and Walker Evans, *Let Us Now Praise Famous Men* (1941; reprint, Boston: Houghton Mifflin, 1960), 236. Citations are to the Houghton Mifflin edition.
2. Agee and Evans, *Let Us Now Praise Famous Men*, 259.
3. Agee and Evans, *Let Us Now Praise Famous Men*, 150.
4. Agee and Evans, *Let Us Now Praise Famous Men*, 437–38.

PLATE 98

WALKER EVANS

Allie Mae Burroughs, Hale County, Alabama negative 1936, print 1950s

Gelatin silver print; 25.2 × 20.2 cm (9¹⁵⁄₁₆ × 7¹⁵⁄₁₆ in.). 84.XM.956.301

PLATE 100

WALKER EVANS

A Baptist Grave, Hale County, Alabama 1936

Gelatin silver print; 15.6 × 22.5 cm (6⅛ × 8⅞ in.). 84.XM.956.437

I find that it has become instinctive, habitual, necessary to group photographs. I used to think in terms of single photographs, the bulls-eye technique. No more. —DOROTHEA LANGE[1]

Dorothea Lange

Dorothea Lange (American, 1895–1965) was born in New Jersey and educated in New York City. She became interested in photography as a teenager and pursued this interest through classes at the Clarence White School, which was a bastion of Pictorialism. She soon became an assistant in the New York portrait studio of Arnold Genthe. As an apprentice to Genthe, Lange learned the trade secrets of upscale portrait photography, yet her genius was not in the repetition of formulas but in the harnessing of instinct that would lead her to unexpected pictures.

In 1918 Lange settled in San Francisco. Between 1930 and 1934 she began spending more time outside her portrait studio photographing subjects of social relevance. In 1935 she began working in what would later be called the Farm Security Administration photography project under the direction of Roy E. Stryker—a project that also included Walker Evans (see page 144) and for which she worked until 1939. Her first assignment was to photograph migrant farm workers in California and New Mexico.[2]

Lange's destiny was to create the most famous photograph made in America, *Migrant Mother*, a work she originally called *Human Erosion in California* (PLATE 101). The setting was near a pea pickers' camp near Nipomo, California, halfway between San Luis Obispo and Santa Maria. The subjects were Florence Owens, a migrant agricultural worker of Cherokee ancestry, and three of her eight children. The family had been at the Nipomo camp just a short time, stalled in transit between jobs because of car trouble, when Lange encountered them. Using her large, handheld Graflex camera, which commanded the interest of her subjects, she exposed six four-by-five-inch negatives, each showing Florence seated on a cardboard carton with different children.[3]

The family of migrant workers gave Lange their full cooperation, allowing her to move increasingly closer to their humble dwelling, rearranging themselves at least six times. In the famous *Migrant Mother* photograph, Florence grasps the tent pole (at the right edge of the picture) to balance herself

and gazes into the distance with a look of tense resignation on her face. Her expression came to symbolize the despair of an entire generation of American working people during the Great Depression. Achieving this remarkable image required the technical skills of an experienced portraitist and the emotional depth of a great artist.

The depression ended in California with an increase in industrialization brought about by the Second World War. Richmond, with its productive shipyards, was located a half hour north of Berkeley, where Lange had settled with her second husband, Paul Taylor, in 1940, about a year after her work with the Farm Security Administration had ended. Lange assigned the title *Lovers, Richmond, California* (PLATE 102) to an equivocal image in which much lies below the surface. The context of this relationship is a hardworking industrial community where a man and woman, possibly coworkers, lean against an expired parking meter, mirroring the time-bound condition of factory life. Shooting with a miniaturized version of the Graflex camera used for *Migrant Mother*, Lange composed the picture from waist level, looking up, with the parking meter dominating the foreground.

In 1953 Lange traveled to Utah with Ansel Adams and her older son, Daniel, who was an aspiring writer. She was transfixed by the deeply bonded family life cultivated by the Mormon people who inhabited the three isolated communities she visited. The photograph of two women embracing after church (PLATE 103) in Toquerville, Utah, continues Lange's persistent focus on relationships. The women are drawn from ordinary life, but they are portrayed in the photograph with elegance.

1. Dorothea Lange—Photographs—1163 Euclid Ave—Berkeley 8, California [ca. 1958], facsimile reproduction in Dorothea Lange, *Dorothea Lange Looks at the American Country Woman* (Fort Worth: Amon Carter Museum), 70.

2. Judith Keller, *In Focus: Dorothea Lange*, Photographs from the J. Paul Getty Museum (Los Angeles: J. Paul Getty Museum, 2002), 140.

3. Keller, *In Focus*, 30, 32.

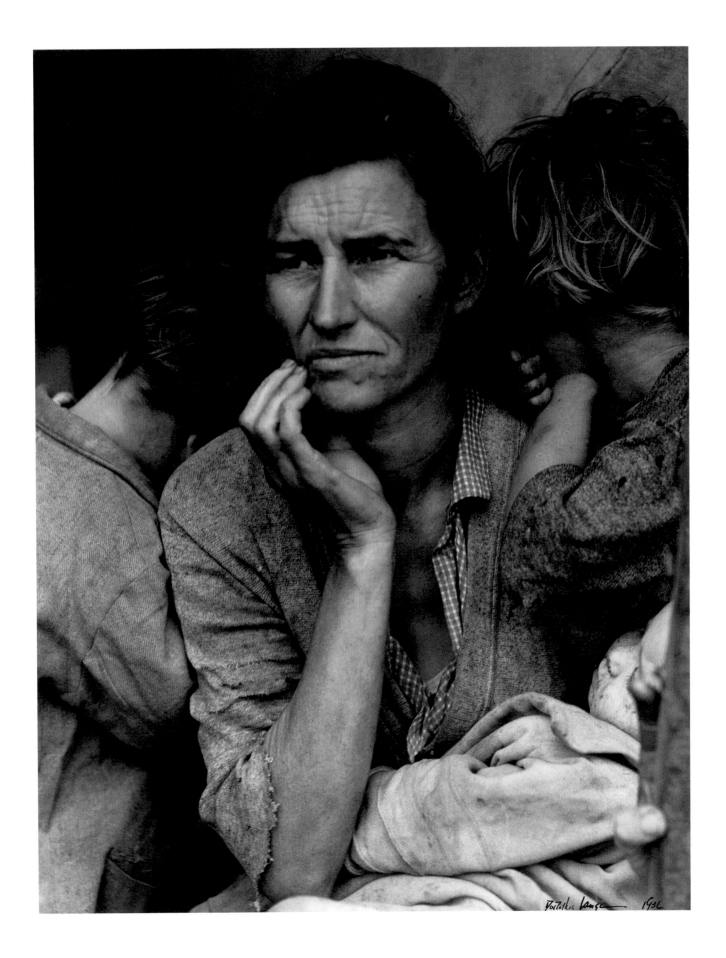

PLATE 101

Dorothea Lange

Human Erosion in California (Migrant Mother) 1936

Gelatin silver print; 34.1 × 26.8 cm (13⁷⁄₁₆ × 10⁹⁄₁₆ in.). 98.XM.162

DOROTHEA LANGE

Lovers, Richmond, California 1942

Gelatin silver print; 25.1 × 25.6 cm (9⅞ × 10¹/₁₆ in.). 2000.50.19

PLATE 103

DOROTHEA LANGE

After Church, Toquerville, Utah 1953

Gelatin silver print; 19.8 × 18.6 cm (7¹³⁄₁₆ × 7⁵⁄₁₆ in.). 2000.50.31

To me, photography itself is an illusion. Stieglitz, one of the greatest photographers, once told me, about taking pictures, "Something happens; it's a fleeting part of a second. It's up to the photographer to capture that on film. Because once it's gone, it's like a dying day. It will never come back. —WEEGEE[1]

Weegee

As a young boy Usher Fellig (American, born Austria, 1899–1968) arrived by steamer at Ellis Island in the New York harbor not long after Lewis Hine (see page 84) had made his seminal photographs there of newly arrived immigrants. Originally assigned the American name Arthur—by which he was known to family, friends, and employers for the first half of his life—he adopted a new identity in the late 1930s as, simply, Weegee.

Arthur fell in love with the magic of photography at an early age, after seeing a tintype of himself made by a New York street photographer. Inspired, he bought a complete outfit for making tintypes, taught himself the procedures, and soon began to make portraits of passersby for a quarter each on the streets of the lower east side of Manhattan. "I think I was what you might call a 'natural born' photographer, with hypo [fixing solution] in my blood," he recalled.[2] Before turning twenty he got a job in the photography studio of Ducket and Adler, where he learned all aspects of commercial photography from cleaning the darkroom to operating a camera.[3]

He held darkroom technician jobs at news picture agencies from 1921 to about 1935, when he abruptly quit to become a freelance news photographer. Weegee, as he was by then probably known, rented an apartment across from central New York Police Department headquarters in lower Manhattan, a few blocks from where he had grown up. With the cooperation of police authorities, he began showing up with his camera at the scenes of crime and disaster. His specialties were depravity and its opposite—high society, which he saw with a cynic's eye. He sold his pictures for reproduction in the city papers, including the *Herald Tribune*, *World Telegram*, and the *Daily News*.[4]

On January 16, 1941, Weegee was given the unusual opportunity of being in the lineup room when Anthony Esposito (PLATE 104) was being booked by detectives (whose backs are to the camera). The picture was reproduced in *PM* magazine with the headline "Gunman Doesn't Want His Picture Taken." The photographer recorded Esposito's face, bruised and bandaged, after the beating he received during

capture. Weegee's handheld four-by-five Speed Graphic camera was standard equipment for news photographers of his era. With Weegee standing his usual six to ten feet from his subject, the flashbulb, which he used even in daylight, blasted the center of the picture with white light, creating a feeling of great immediacy and inviting the viewer to become a participant in the unfolding drama.

Weegee sometimes used infrared film, devised during the Second World War for military purposes, to snoop into the private moments of complete strangers. Because the film was sensitive chiefly to red light, his red flashbulbs were undetected by his subjects, such as a couple seated in a nightclub six feet from the camera (PLATE 105). With this furtive technique, Weegee captured a gesture halfway between tender and severe.

Movie theaters were another of Weegee's favorite locations for infrared photography. Under cover of darkness, his subjects found escape, privacy, and seclusion. Weegee would walk up and down the aisles disguised as an ice-cream man. About the couple in the Times Square theater (PLATE 106), Weegee said, "I could spot them as soon as they came into the theater, walking down the aisle holding hands, with stars in their eyes. They would hardly get seated before he would begin to kiss her."[5]

Most of Weegee's photographs were not this fanciful. Weegee inhabited a callous and threatening urban Hades of his own making, where he was an outsider even in his own underworld community and where sheer survival was paramount. His photographs challenged the accepted heroic ideals of national identity. Although Weegee was the author of countless images devoted to squalor, greed, violence, and human degradation, he was nevertheless devoted to the primacy of humankind.

1. Weegee, *Weegee's Creative Camera* (New York: Hanover House, 1959), 8.
2. Weegee, *Weegee by Weegee: An Autobiography* (New York: Ziff-Davis, 1961), 14.
3. Weegee, *Weegee by Weegee*, 15.
4. Louis Stettner, *Weegee* (New York: Alfred A. Knopf, 1977), 21.
5. Weegee, *Weegee's Creative Camera*, 99.

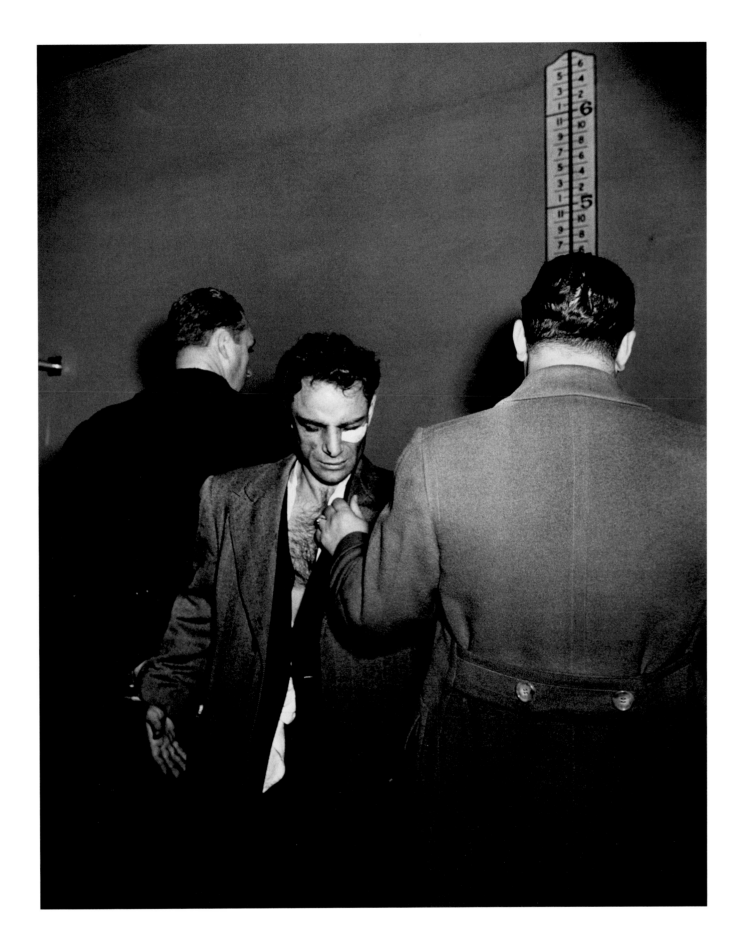

PLATE 104

WEEGEE

Cop Killer January 16, 1941

Gelatin silver print; 33.7 × 26.8 cm (13¼ × 10⁹⁄₁₆ in.). 84.XM.190.30

PLATE 105

WEEGEE

New York 1943

Gelatin silver print; 26.7 × 27.1 cm (10¹/₂ × 10¹¹/₁₆ in.). 86.XM.4.5

PLATE 106

WEEGEE

Palace Theatre, Times Square, New York ca. 1952

Gelatin silver print; 26.7 × 35.4 cm (10¹/₂ × 13¹⁵/₁₆ in.). 84.XM.190.1

Everything around us, dead or alive, in the eyes of a crazy photographer mysteriously takes on many variations, so that a seemingly dead object comes to life through light or by its surrounding. —JOSEF SUDEK[1]

Josef Sudek

Josef Sudek (Czechoslovakian, 1896–1976) was born in the small city of Kolín, about thirty miles east of Prague on the Elbe River, formerly a part of the kingdom of Bohemia. Sudek tragically lost his right arm at the shoulder in the First World War and turned to photography for therapy during his recuperation.[2] In 1921 he was admitted to the School of Graphic Arts in Prague, where he trained in professional photographic practice. In late 1926 Sudek established a makeshift studio on Újezd Street, close to a historic park. This modest space remained his workplace and residence for more than thirty years. He was assisted in all aspects of his life and work by his younger sister, Božena, who, like him, never married.[3]

Sudek adored antiquated, special-purpose cameras, such as those designed to photograph large groups of people on long, narrow negatives, as well as very large commercial cameras designed for copying flat source materials. He was also a collector of cultural artifacts, ranging from books, maps, and paper ephemera to masks, dress mannequins, and prosthetic devices. From this hoard he selected and arranged individual objects, often on a windowsill, and photographed them in natural light. *Late Roses* (PLATE 107) was created in 1959, almost twenty years into this series, and represents several realms of existence. One is the emotional realm of the poet-photographer, which drew him to objects with romantic content. Another is the character of the room interior, where peeling paint and rough carpentry reveal the artist's humble environment. A third is the physical atmosphere outside the room on a rainy day. In *Late Roses*, traces of human activity are admitted in the form of thumbtacks, a stack of books, a vase, and carpentry, yet nature dominates, in the form of flowers, a shell, the rain, and the light. An aura of pensive sadness permeates the scene.

A year or so later Sudek created another arrangement drawn from his stockpile of art-making resources. In *Memories, the Coming of the Night* (PLATE 108), light is harnessed to enliven a puzzling scene. An ordinary utility lamp, the kind used by mechanics, hangs near a wall, which shows patterns projected from the lamp's protective grill. Another light was placed on the table behind a plaster bust. Two garden chairs are keys to understanding this image. The chairs were designed by Sudek's architect friend Otto Rothmayer, who died in 1966. Rothmayer and Sudek collaborated over the years on a series of photographs created in the architect's unusual garden. The chairs, along with found objects and makeshift lighting, made frequent appearances in this series.[4] In this particular image the chairs are emblematic of Rothmayer, and the scene is an homage to Sudek's friend.

Memories of friends inspired Sudek to create other works of art as well, and because political turmoil forced many to flee their Czech homeland, letters were integral to maintaining relationships and became instrumental objects of memory. Sudek faithfully corresponded with several exiles and used the envelopes received from abroad, with their decorative stamps and postmarks, as elements in deeply layered still lifes. Wrinkled cellophane, pigeon feathers, and a glass sphere (PLATE 109) have no immediately recognizable interrelationship. If there is hidden meaning here it is in the language of poetry, as expressed by Czech poet Jan Skácel: "Poets don't invent poems / The poem is somewhere behind / It's been there for a long time / The poet merely discovers it."[5] It took a genius to discover beauty in what many would call debris.

1. Josef Sudek, quoted in Anna Farova, *Josef Sudek, Poet of Prague: A Photographer's Life* (New York: Aperture in Association with Philadelphia Museum of Art, 1990), 52.
2. Farova, *Josef Sudek*, 7.
3. Farova, *Josef Sudek*, 12.
4. Farova, *Josef Sudek*, 86.
5. Jan Skácel, quoted in Farova, *Josef Sudek*, 6.

PLATE 107

JOSEF SUDEK

Late Roses 1959

Gelatin silver print; 40 × 29.8 cm (15¾ × 11¾ in.). 84.XM.149.13

PLATE 108

JOSEF SUDEK

Memories, the Coming of the Night 1960

Gelatin silver print; 27.6 × 37.5 cm (10⅞ × 14¾ in.). 2000.25.4

JOSEF SUDEK

Airmail Memories for Dr. Joseph Brumlik 1971

Gelatin silver print; 29.1 × 23 cm (11⁷/₁₆ × 9¹/₁₆ in.). 2000.64

The photographer is the originator of an imaginative reality, a reality which is valid only to the extent it remains a fluid and constantly changing poetic act. —FREDERICK SOMMER[1]

Frederick Sommer

Born to a Swiss mother and German father, Frederick Sommer (American, born Italy, 1905–1999) had an international upbringing. His father, who was trained in architecture and planning, moved the family to Brazil in 1913. Sommer learned to draw at an early age and assisted his father as a draftsman in the design of parks and gardens in Rio de Janeiro. He won a prize for this work, in competition with professionals, at the age of sixteen.[2] At twenty Sommer was so competent at architectural drawing that, on the basis of his portfolio and his skills in four languages (Italian, German, Portuguese, and French), he was accepted in 1925 as a graduate student at Cornell University, though he had no undergraduate degree and was still learning English. He earned his master of arts degree in landscape architecture under the direction of Edward Gorton Davis, who introduced him to his future wife, Frances Watson. The two married in 1928 and, in 1935, settled in Prescott, Arizona, where they remained, with occasional travels to Los Angeles, Chicago, and New York.

Sommer had been making photographs with a handheld camera for nearly a decade before he met Edward Weston (see page 124) in Los Angeles. Weston inspired him to take photography more seriously. In 1938 Sommer purchased a large-format camera, like the one he had seen Weston using, designed to expose sheets of eight-by-ten-inch film. Photographers have turned to still life for experimental purposes ever since Talbot's and Bayard's studies of botanical specimens (e.g., see PLATE 1), so it is not surprising that Sommer's first trials were also still-life arrangements. However, Sommer chose subjects never before seen in photography. He challenged the meaning of the word "surrealism" by depicting grotesquely powerful objects in perfect detail. *The Anatomy of a Chicken* (PLATE 110), for example, reveals an obsession with reconciling opposing ideas: life versus death, ugly versus beautiful, visceral versus decorative, and commonplace versus unique. This image, like other Sommer photographs, is a visual theorem proposing that death can generate art; that beauty can emerge from ugliness; that the organic core of

nature is inherently decorative; and that, as in this case, chicken parts have a place not only in a poultry market but also in art.

Working outside the mainstream and living in Arizona, where he lacked, in the early 1940s, the opportunity for regular interaction with other artists, Sommer produced his photographs in a near vacuum. He was guided, however, by some of the classical rules of aesthetics—simplicity, logic, and formal balance—which he applied to photography in distinctly original ways. His picture of an amputated foot (PLATE 111) is gruesome evidence of an accident involving a railroad employee. When asked what meaning this image held, the artist replied philosophically, "We cannot afford to be overcome by what we do not understand in our thinking."[3]

Sommer was restrained in his production of art but voracious in his appetite to accomplish cross-fertilization between drawing, sculpture, music, philosophy, and photography. The climax of this interplay was the production of negatives without the use of a camera. Sommer would squeeze paint between two layers of cellophane and, while the paint was still wet, place the transparency in the enlarger and project it onto photographic paper. He would then develop the print as if it had been made with an in-camera negative.

Imagination and transformation are central to Sommer's art, and he gloried in making us see one thing in the shape of another. *Paracelsus* (PLATE 112), for example, is an abstraction that uncannily resembles a flayed, eviscerated human torso. The title refers to the visionary, fifteenth-century German physician and Renaissance humanist who taught that life is inseparable from the spirit and that physicians must minister to the spirit as well as to the body, ideas with which Sommer closely identified.

1. Frederick Sommer, letter to Edward Steichen, May 14, 1952, in Sheryl Conkelton, ed., *Frederick Sommer: Selected Texts and Bibliography* (Oxford: Clio, 1995), 35.

2. Conkelton, *Frederick Sommer*, xv.
3. Frederick Sommer, letter to the author, June 15, 1994.

PLATE 110

FREDERICK SOMMER

The Anatomy of a Chicken 1939

Gelatin silver print; 24 × 18.5 cm (9¹⁵⁄₃₂ × 7⁹⁄₃₂ in.). 94.XM.37.98

PLATE 111

FREDERICK SOMMER

Untitled 1939

Gelatin silver print; 24.1 × 19.2 cm (9½ × 7⁹⁄₁₆ in.). 94.XM.37.95

PLATE 112

FREDERICK SOMMER

Paracelsus 1957

Gelatin silver print; 34.2 × 25.6 cm (13½ × 10¹⁄₁₆ in.). 94.XM.37.51

The thing that's important to know is that you never know. You're always sort of feeling your way.
—DIANE ARBUS[1]

Diane Arbus

Diane Arbus (née Nemerov, American, 1923–1971) was born and raised in New York City. In the mid-1940s she and her husband, Allan Arbus, learned to develop and print photographs and established a business partnership in fashion photography. In 1947 they were included in a *Glamour* magazine article on young couples collaborating on joint careers. "Working very slowly and carefully, they compose in the camera instead of relying largely on cropping and other mechanical photographic tricks," wrote the editors.[2] This way of working marked Diane Arbus indelibly. She became remembered for cultivating a snapshot-like style that greatly depended on planning and skillful editing.

In 1957, after a decade of working almost exclusively in the fashion world, where models were selected chiefly for their beauty and adorned by others, Diane Arbus embarked on an independent career as a documentary photographer, free to explore the world around her. She turned to established photographers as role models—among them her principal mentor, Lisette Model; Walker Evans (see page 144); Robert Frank; and Richard Avedon. Arbus's curiosity led her back to Lewis Hine (see page 84), who had once taught at the Ethical Culture School, where she later studied,[3] and to Paul Strand (see page 88), who had also been educated there.

Working on location requires a different set of procedures than those practiced in studio photography, where the subject is chosen by the client and the picture-taking environment made perfect. Documentary photography involves choosing the place and the subject and then making the best use of the available light and setting. In one emblematic series, Arbus photographed carnival sideshow performers she found at county fairs throughout New Jersey, New England, and Pennsylvania, as well as on Forty-second Street in New York City. Like fashion models, sideshow performers are generally costumed and well lit for display. However, as in *Headless Woman, N.Y.C.* (PLATE 113) of 1961, the key elements of glamorous fashion photography are absent. The setting is tacky, and the accessories are tired and mismatched. Most dramatic of all, the subject appears decapitated, leaving a mature woman's figure draped in a housewife's frock and well-worn shoes. Here, as in her many other works, Arbus was drawn intuitively to a subject in which the ordinary and extraordinary were interwoven.

Arbus often explored the nature of womanhood, as in *Woman in a Rose Hat, N.Y.C.* of 1966 (PLATE 114). Once again the elements of fashion are subverted. The portrait was made at very close range in natural light (apparently without flash) with the camera held at waist level looking up at the subject, whose bespectacled face and ornate hat nearly fill the frame. Arbus sought a slightly startled look in her subjects, as if the person had just become aware of the photographer at the instant of exposure.

The subject of twins had been treated by August Sander (see page 96) fifty years before Arbus's *Identical Twins, Roselle, N.J.* (PLATE 115). Like Sander, Arbus used generic snapshots as a source of inspiration. From the six exposures Arbus made, she selected the one that most intentionally breaks traditional rules of composition and portraiture.[4] The two girls are not quite centered in the frame, and their legs are omitted from the shins down. The camera is not plumb or parallel to the wall behind—so the floor appears off-kilter. However, as in a fashion photograph, the girls are "dressed up," and their youthful skin glows in the soft light. Despite their "identical" nature—being dressed alike and seemingly joined at the shoulder—the twins are two very different people. The mouth of one turns slightly up, while the other's curves down; the eyes of one are alert, while the other's are drowsy. These twins are simultaneously ordinary in appearance and extraordinary when seen through the artist's eyes.

Guided by an intuitive eye for the unusual in the everyday, Arbus redefined documentary tradition by making works of art that were thoroughly deliberate yet as personal and intimately seen as family snapshots.

1. Diane Arbus, *Diane Arbus: An Aperture Monograph* (New York: Museum of Modern Art, 1972), 14.
2. Reprinted in Patricia Bosworth, *Diane Arbus: A Biography* (New York: Alfred A. Knopf, 1984), 274.
3. Arbus entered the Fieldston high school campus of the Ethical Culture School in 1933.
4. Diane Arbus, *Diane Arbus Revelations* (New York: Random House, 2003), 182.

PLATE 113

DIANE ARBUS

Headless Woman, N.Y.C. negative 1961, print 1961–63

Gelatin silver print mounted on board; 24.1 × 15.7 cm (9½ × 6³⁄₁₆ in.). 2000.23

DIANE ARBUS

Identical Twins, Roselle, N.J. negative 1966–67, print by Neil Selkirk 1970–75

Gelatin silver print; 38.1 × 37.9 cm (15 × 14¹⁵⁄₁₆ in.). 2000.4.1

Selected Getty Publications on Photographs

The following list includes selected exhibition brochures and books published by the J. Paul Getty Museum that feature the photographers represented in this volume. Exhibitions held at the J. Paul Getty Museum in Malibu are indicated by "Malibu"; those held at the Getty Center are indicated by "Los Angeles." The brochures are housed in the Study Room, Department of Photographs, J. Paul Getty Museum, Los Angeles, and may be viewed by appointment.

MANUEL ALVAREZ BRAVO

Blasco, Victoria, *Manuel Alvarez Bravo: Recuerdo de unos años*, exh. brochure, September 22–December 6, 1992, Malibu.

Conway, Mikka Gee, and Roberto Tejada, *Manuel Alvarez Bravo: Optical Parables*, exh. brochure, November 13, 2001–February 2, 2002, Los Angeles.

Tejada, Roberto, *In Focus: Manuel Alvarez Bravo*, Photographs from the J. Paul Getty Museum (Los Angeles: J. Paul Getty Museum, 2001).

DIANE ARBUS

Abbott, Brett, and Keller, Judith, *Strange Days: Photographs from the Sixties by Winogrand, Eggleston, and Arbus*, exh. brochure, July 1–October 5, 2003, Los Angeles.

EUGÈNE ATGET

Baldwin, Gordon, *In Focus: Eugène Atget*, Photographs from the J. Paul Getty Museum (Los Angeles: J. Paul Getty Museum, 1996).

Baldwin, Gordon, *The Man in the Street: Eugène Atget in Paris*, exh. brochure, June 20–October 8, 2000, Los Angeles.

Naef, Weston, *Atget's Magical Analysis: Photographs 1915–1927*, exh. brochure, October 29, 1991–January 5, 1992, Malibu.

BRASSAÏ

Cox, Julian, *Brassaï: The Eye of Paris*, exh. brochure, April 13–July 3, 1999, Los Angeles.

JULIA MARGARET CAMERON

Cox, Julian, *In Focus: Julia Margaret Cameron*, Photographs from the J. Paul Getty Museum (Los Angeles: J. Paul Getty Museum, 1996).

Cox, Julian, *Julia Margaret Cameron: The Creative Process*, exh. brochure, October 15, 1996–January 5, 1997, Malibu.

Cox, Julian, *Julia Margaret Cameron, Photographer*, exh. brochure, October 21, 2003–January 11, 2004, Los Angeles.

Cox, Julian, and Colin Ford, *Julia Margaret Cameron: The Complete Photographs* (Los Angeles: J. Paul Getty Museum, 2003).

Naef, Weston, *Whisper of the Muse: The Work of Julia Margaret Cameron*, exh. brochure, September 10–November 16, 1986, Malibu.

Weaver, Mike, *Whisper of the Muse: The Overstone Album and Other Photographs by Julia Margaret Cameron* (Malibu: J. Paul Getty Museum, 1986).

WALKER EVANS

Codrescu, Andrei, and Judith Keller, *Walker Evans: Signs* (Los Angeles: J. Paul Getty Museum, 1998).

Keller, Judith, *Walker Evans: An Alabama Record*, exh. brochure, April 7–June 21, 1992, Malibu.

Keller, Judith, *Walker Evans: The Getty Museum Collection* (Malibu: J. Paul Getty Museum, 1995).

Keller, Judith, *Walker Evans: New York*, exh. brochure, July 28–October 11, 1998, Los Angeles.

Keller, Judith, and Andrei Codrescu, *Walker Evans: Cuba* (Los Angeles: J. Paul Getty Museum, 2001).

Keller, Judith, and Robert Plunket, *Walker Evans: Florida* (Los Angeles: J. Paul Getty Museum, 2000).

Naef, Weston, *The American Tradition and Walker Evans: Photographs from the Getty Collection*, exh. brochure, July 10–October 28, 2001, Los Angeles.

ROGER FENTON

Baldwin, Gordon, *Roger Fenton: The Orientalist Suite*, exh. brochure, July 16–October 6, 1996, Malibu.

Baldwin, Gordon, *Roger Fenton: Pasha and Bayadère* (Malibu: J. Paul Getty Museum, 1996).

HILL AND ADAMSON

Lyden, Anne M., *In Focus: Hill and Adamson*, Photographs from the J. Paul Getty Museum (Los Angeles: J. Paul Getty Museum, 1999).

Lyden, Anne M., *Light in the Darkness: The Photographs of Hill and Adamson*, exh. brochure, July 20–October 10, 1999, Los Angeles.

GERTRUDE KÄSEBIER

Keller, Judith, *After the Manner of Women: Photographs by Käsebier, Cunningham, and Ulmann*, exh. brochure, September 6–December 31, 1988, Malibu.

ANDRÉ KERTÉSZ

Cox, Julian, *André Kertész: A Centennial Tribute*, exh. brochure, June 28–September 4, 1994, Malibu.

Naef, Weston, *In Focus: André Kertész*, Photographs from the J. Paul Getty Museum (Malibu: J. Paul Getty Museum, 1994).

Naef, Weston, *Rare States and Unusual Subjects: Photographs by Paul Strand, André Kertész, and Man Ray*, exh. brochure, July 7–September 6, 1987, Malibu.

DOROTHEA LANGE

Keller, Judith, *About Life: The Photographs of Dorothea Lange*, exh. brochure, October 15, 2002–February 9, 2003, Los Angeles.

Keller, Judith, *In Focus: Dorothea Lange*, Photographs from the J. Paul Getty Museum (Los Angeles: J. Paul Getty Museum, 2002).

LANGENHEIM BROTHERS

Lyden, Anne M., *Railroad Vision: Photography, Travel, and Perception* (Los Angeles: J. Paul Getty Museum, 2003).

GUSTAVE LE GRAY

Aubenas, Sylvie, *Gustave Le Gray, 1820–1884*, English edition, ed. Gordon Baldwin (Los Angeles: J. Paul Getty Museum, 2002).

Baldwin, Gordon, *Gustave Le Gray*, exh. brochure, March 3–August 23, 1988, Malibu.

Baldwin, Gordon, *Gustave Le Gray, Photographer*, exh. brochure, July 9–September 29, 2002, Los Angeles.

Naef, Weston and Margret Stuffmann, *Pioneers of Landscape Photography: Gustave Le Gray and Carleton E. Watkins—Photographs from the collection of the J. Paul Getty Museum, Malibu*, exh. cat. (Frankfurt: Städtische Galerie; Malibu: J. Paul Getty Museum, 1993).

LÁSZLÓ MOHOLY-NAGY

Ware, Katherine, *In Focus: László Moholy-Nagy*, Photographs from the J. Paul Getty Museum (Malibu: J. Paul Getty Museum, 1995).

Ware, Katherine, *Vision in Motion: The Photographs of László Moholy-Nagy*, exh. brochure, June 27–October 8, 1995, Malibu.

NADAR

Baldwin, Gordon, and Judith Keller, *Nadar/Warhol: Paris/New York*, exh. brochure, July 20–October 10, 1999, Los Angeles.

Baldwin, Gordon, and Judith Keller, *Nadar/Warhol: Paris/New York: Photography and Fame*, exh. cat. (Los Angeles: J. Paul Getty Museum, 1999).

TIMOTHY H. O'SULLIVAN

Baldwin, Gordon, *Grave Testimony: Photographs of the Civil War*, exh. brochure, January 14–March 29, 1992, Malibu.

Wilson, Jackie Napolean, and Weston Naef, *Hidden Witness: African Americans in Early Photography*, exh. brochure, February 28–June 18, 1995, Malibu.

MAN RAY

Naef, Weston, *Rare States and Unusual Subjects: Photographs by Paul Strand, André Kertész, and Man Ray*, exh. brochure, July 7–September 6, 1987, Malibu.

Naef, Weston, *Surrealist Muse: Lee Miller, Roland Penrose, and Man Ray, 1925–1945*, exh. brochure, February 25–June 15, 2003, Los Angeles.

Ware, Katherine, *In Focus: Man Ray*, Photographs from the J. Paul Getty Museum (Los Angeles: J. Paul Getty Museum, 1998).

Ware, Katherine, *A Practical Dreamer: The Photographs of Man Ray*, exh. brochure, October 27, 1998–January 17, 1999, Los Angeles.

ALBERT RENGER-PATZSCH

Dooley, Joan Gallant, *Albert Renger-Patzsch: The Magic of Material Things*, exh. brochure, January 16–March 31, 1996, Malibu.

Kuspit, Donald, *Albert Renger-Patzsch: Joy before the Object* (Malibu: J. Paul Getty Museum, 1993).

ALEXANDER RODCHENKO

Keller, Judith, *Alexander Rodchenko: Modern Photography in Soviet Russia*, exh. brochure, November 24, 1987–January 31, 1988, Malibu.

AUGUST SANDER

Bohn-Spector, Claudia, *In Focus: August Sander*, Photographs from the J. Paul Getty Museum (Los Angeles: J. Paul Getty Museum, 2000).

Keller, Judith, *August Sander: German Portraits, 1918–1933*, exh. brochure, March 6–June 24, 2001, Los Angeles.

Naef, Weston, *August Sander: Faces of the German People*, exh. brochure, March 21–July 28, 1991, Malibu.

CAMILLE SILVY

Haworth-Booth, Mark, *Camille Silvy: River Scene, France*, Getty Museum Studies on Art (Malibu: J. Paul Getty Museum, 1992).

Haworth-Booth, Mark, *Silvy's River Scene, France: The Story of a Photograph*, exh. brochure, December 15, 1992–February 28, 1993, Malibu.

FREDERICK SOMMER

Naef, Weston, *Frederick Sommer: Poetry and Logic*, exh. brochure, December 6, 1993–February 12, 1994, Malibu.

ALFRED STIEGLITZ

Naef, Weston, *Alfred Stieglitz: Seen and Unseen*, exh. brochure, October 17, 1995–January 7, 1996, Malibu.

Naef, Weston, *In Focus: Alfred Stieglitz*, Photographs from the J. Paul Getty Museum (Malibu: J. Paul Getty Museum, 1995).

Naef, Weston, *Two Lives: O'Keeffe by Stieglitz, 1917–1923*, exh. brochure, June 30–September 13, 1992, Malibu.

PAUL STRAND

Keller, Judith, *Paul Strand: People and Place*, exh. brochure, September 11–November 25, 1990, Malibu.

Naef, Weston, *Rare States and Unusual Subjects: Photographs by Paul Strand, André Kertész, and Man Ray*, exh. brochure, July 7–September 6, 1987, Malibu.

WILLIAM HENRY FOX TALBOT

Schaaf, Larry J., *In Focus: William Henry Fox Talbot*, Photographs from the J. Paul Getty Museum (Los Angeles: J. Paul Getty Museum, 2002).

DORIS ULMANN

Keller, Judith, *After the Manner of Women: Photographs by Käsebier, Cunningham, and Ulmann*, exh. brochure, September 6–December 31, 1988, Malibu.

Keller, Judith, *Doris Ulmann: Photography and Folklore*, exh. brochure, April 9–July 7, 1996, Malibu.

Keller, Judith, *In Focus: Doris Ulmann*, Photographs from the J. Paul Getty Museum (Los Angeles: J. Paul Getty Museum, 1996).

CARLETON WATKINS

Fels, Thomas Weston, *Carleton Watkins: Western Landscape and the Classical Vision*, exh. brochure, March 13–May 27, 1990, Malibu.

Naef, Weston, *Carleton Watkins: From Where the View Looked Best*, exh. brochure, February 15–June 4, 2000, Los Angeles.

Naef, Weston, and Margret Stuffmann, *Pioneers of Landscape Photography: Gustave Le Gray, Carleton E. Watkins—Photographs from the Collection of the J. Paul Getty Museum, Malibu*, exh. cat. (Frankfurt: Städtische Galerie; Malibu: J. Paul Getty Museum, 1993).

Palmquist, Peter E., *In Focus: Carleton Watkins*, Photographs from the J. Paul Getty Museum (Malibu: J. Paul Getty Museum, 1997).

EDWARD WESTON

Naef, Weston, *Edward Weston: The Home Spirit and Beyond*, exh. brochure, November 25, 1985–February 1, 1986, Malibu.

Naef, Weston, and Susan Danly, *Edward Weston: The Home Spirit and Beyond* (Malibu and San Marino, Calif.: J. Paul Getty Museum with Henry E. Huntington Library and Art Gallery, 1986).

ADDITIONAL BOOKS

Lowry, Bates, and Isabel Barrett Lowry, *The Silver Canvas: Daguerreotype Masterpieces from the J. Paul Getty Museum* (Los Angeles: J. Paul Getty Museum, 1998).

Masterpieces of the J. Paul Getty Museum: Photographs (Los Angeles: J. Paul Getty Museum, 1999).

Naef, Weston, *The J. Paul Getty Museum Handbook of the Photographs Collection* (Malibu: J. Paul Getty Museum, 1995).

Selected List of Photographers in the J. Paul Getty Museum Collection

The following is a selected list of photographers whose work is represented in the collection of the J. Paul Getty Museum by five or more works. The number to the right of each maker's name represents the number of individual works housed in the photographs collection. These photographs may be viewed by appointment in the Study Room, Department of Photographs, J. Paul Getty Museum, Los Angeles.

Berenice Abbott 19
Abdullah Frères 7
Ansel Adams 39
Robert Adams 44
Comte Olympe Aguado 13
John Albok 26
Charles Allen 7
Eustace Alliot 5
Manuel Alvarez Bravo 104
James Anderson 84
James Craig Annan 5
Thomas Annan 14
Rufus Anson 6
Mark Anthony 9
Diane Arbus 24
Frederick Scott Archer 5
Dick Arentz 10
Bill Arnold 17
Eugène Atget 314
Anna Atkins 121
Charles Aubry 17
Ellen Auerbach 15
Richard Avedon 17
Fédèle Azari 79
Louis Fabian Bachrach 13
Edouard Baldus 54
Russell Ball 6
Theo Ballmer 5
R. Jay Bangs 15
George Barker 26
George N. Barnard 79
Richard Baron 11
C. T. Bartlett 8
Adam Bartos 13
Eugen Batz 15
James Bauer 12
Émile Bayard 5
Hippolyte Bayard 155
Irene Bayer 30
Virginia Beahan 12
Richard Beard 5
Antonio Beato 81
Felice Beato 42
Cecil Beaton 5

Henri Béchard 9
Bernd and Hilla Becher 125
Francis Bedford 46
William A. Bell 24
William H. Bell 20
Hans Bellmer 30
Ernest Benecke 5
H. H. Bennett 6
Ella Bergmann-Michel 11
Robert Bingham 6
Rudolph Binnemann 7
Auguste-Rosalie Bisson 30
Bisson Frères 38
James Wallace Black 18
Louis Désiré Blanquart-Evrard 46
Erwin Blumenfeld 14
Frédéric Boissonnas 9
Émile Bondonneau 6
Félix Bonfils 74
Henry P. Bosse 12
Charles Von Bouell 10
Alice Boughton 11
Samuel Bourne 12
Tony Boussenot 7
Julius Boysen 8
Mathew Brady 44
Anton Bragaglia 14
Bill Brandt 23
Bruno Braquehais 15
Brassaï 42
Adolphe Braun 66
Horace Bristol 25
Giacomo Brogi 36
Ellen Brooks 7
Jeff Brouws 5
John Coates Browne 32
Benjamin Browning 72
Francis Bruguière 62
W. P. Bruning 12
Giovanni Battista Brusa 11
Clarence Sinclair Bull 15
Karl Karlovitz Bulla 87
John G. Bullock 13
Jerry Burchard 6

Douglas Busch 12
Jacob Byerly 518
A. Calavas 14
Harry Callahan 35
Jo Ann Callis 24
Henry Herschel Hay Cameron 5
Julia Margaret Cameron 298
Henry Cammas 29
Giacomo Caneva 9
Alfred Capel-Cure 15
Étienne Carjat 12
William Carrick 7
Lewis Carroll 11
Henri Cartier-Bresson 66
Désiré Charnay 8
Anita Chernewski 5
Carl Chiarenza 17
Thomas Child 9
Vaclav Chochola 7
Larry Clark 7
Antoine Claudet 25
Charles Clifford 26
William Clift 9
Chuck Close 5
Alvin Langdon Coburn 18
Hippolyte-Auguste Collard 100
Edmund Collein 12
Paul Collemant 25
Dimitrios Constantin 16
A. C. Cooper 6
Thomas Joshua Cooper 9
John Coplans 23
Courteoux 7
Konrad Cramer 61
Ralston Crawford 158
Tommaso Cuccioni 29
Robert Cumming 6
Imogen Cunningham 58
Francis Edmond Currey 8
Edward S. Curtis 104
Louise Dahl-Wolfe 14
Louis-Alphonse Davanne 17
George Davidson 58
George Christopher Davies 5
F. Holland Day 5
Lala Deen Dayal 13
Adolf de Meyer 37
Edgar Degas 7
Philip Henry Delamotte 16
Louis-Jean Delton 5
Robert Demachy 7
Achille Devéria 68

Théodule Devéria 68
Cesare Di Liborio 5
Rick Dingus 8
André Adolphe-Eugène Disdéri 40
John Divola 79
Anne Dixon 7
James N. Doolittle 14
Jim Dow 46
Frantisek Drtikol 5
Eugène Druet 9
Maxime Du Camp 12
Louis Pierre Théophile Dubois de Nehaut 6
Louis Jules Duboscq-Soleil 6
Louis-Émile Durandelle 40
Eugène Durieu 11
Thomas Eakins 123
Wolfram Eder 8
Harold Edgerton 9
William Eggleston 268
Josef Ehm 11
Alfred Ehrhardt 7
Rudolph Eickemeyer Jr. 10
Charles H. L. Emanuel 18
Pierre Émonds 9
Chris Enos 5
Mitch Epstein 8
Hugo Erfurth 6
Frank Eugene 7
Frederick H. Evans 106
Walker Evans 1,301
Jean-Gabriel Eynard 92
Charles Famin 7
Farrand Studio [S. B. Johnson] 5
Andreas Feininger 13
T. Lux Feininger 55
Otto Fenn 7
Roger Fenton 528
Albert Fernique 11
Marc Ferrez 13
Jacques Alexandre Ferrier 30
Amadeo Ferroli 11
David Finn 34
Hans Finsler 12
George Fiske 22
Comte Frédéric Flachéron 15
Louis Fleckenstein 2,822
Trude Fleischmann 9
B. E. Flett 6
Robert Flora 31
Douglas Fogelson 5
François Alphonse Fortier 18

172

Giulio Parisio 5
Harold A. Parker 9
Émile Pec 15
Brian Pelletier 13
Charles Perier 24
Philibert Perraud 11
Walter Peterhans 5
Pierre Petit 9
Robert Petschow 6
Adolph Petzold 8
A. R. Phillips Jr. 13
Photoglob 5
Luigi Pirrone 93
John Plumbe Jr. 12
Alphonse-Louis Poitevin 16
Sigmar Polke 39
Carlo Ponti 92
Herbert G. Ponting 5
A. F. Popovsky 18
Ernest Mitchell Pratt 9
Martin Prekop 14
Paul Pretsch 18
William Lake Price 9
William A. Pumphrey 5
Constant Puyo 10
Edward W. Quigley 10
Achille Quinet 16
Carl Rau 6
William H. Rau 22
Timm Rautert 12
Lilo Raymond 5
Henri-Victor Regnault 8
Charles Reid 10
Georg Reisner 6
Oscar Gustave Rejlander 21
Albert Renger-Patzsch 209
Guido Rey 10
Marc Riboud 5
Albert G. Richards 5
Frederick de Bourg Richards 6
Ambrose Richebourg 31
Eugene Robert Richee 6
Robert Richfield 8
Roberto Rive 11
Louis-Rémy Robert 6
Robertson and Beato 9
James Robertson 24
Henry Peach Robinson 11
Don Rodan 6
Alexander Rodchenko 102
Cristina Garcia Rodero 22
H. Roger-Viollet 18

Milton Rogovin 144
Franz Roh 42
Werner Franz Rohde 16
M. Rol 5
Walter Rosenblum 14
Dante Gabriel Rossetti 6
Marie Rossignol 13
Jaroslav Rössler 36
Theodore Roszak 10
Arthur Rothstein 13
Albert Rudomine 14
A. J. Russell 67
Roland Sabatier 5
John Saché 5
Erich Salomon 30
Auguste Salzmann 34
Lucas Samaras 13
August Sander 1,186
Napoleon Sarony 6
C. R. Savage 12
Christian Schad 8
Horst Schaefer 7
Joost Schmidt 7
Adolf Schneeberger 37
Germaine Schneider 14
Herbert Schürmann 20
Wilhelm Schürmann 11
Sébah and Joaillier 9
J. Pascal Sébah 30
George H. Seeley 9
Charles Sheeler 14
Jun Shiraoka 25
Robert Shlaer 5
Stephen Shore 30
Iakob Shteinberg 14
Camille Silvy 279
Art Sinsabaugh 8
Clara E. Sipprell 6
Aaron Siskind 138
W. Eugene Smith 30
Sommer and Behles 18
Frederick Sommer 126
Giorgio Sommer 114
William Stinson Soule 51
Charles Soulier 14
Southworth and Hawes 10
Gregory Spaid 10
Charles Gustave Spitz 8
Edward Steichen 43
Carl Ferdinand Stelzner 5
Joel Sternfeld 11
John Stewart 12

Alfred Stieglitz 164
S. R. Stoddard 20
John Benjamin Stone 5
Paul Strand 150
Karl Struss 103
Carl Strüwe 10
Josef Sudek 89
Frank Meadow Sutcliffe 25
Isaiah W. Taber 10
Madoka Takagi 56
William Henry Fox Talbot 275
Tato 15
A. Taupin 9
Val Telberg 21
Edmund Teske 135
Félix Teynard 7
Else Thalemann 24
Charles Thurston Thompson 6
John Thomson 54
George A. Tice 11
Adrien Alban Tournachon 29
Pierre Trémaux 6
Linneaus Tripe 23
Alfred Tritschler 7
Benjamin Brecknell Turner 5
Shoji Ueda 6
Doris Ulmann 171
B. F. Upton 21
James Valentine 13
Julien Vallou de Villeneuve 15
Robert H. Vance 8
Léon Vidal 10
Vicomte Joseph de Vigier 16
Frantisek Vobecky 21
Pëtr Volkov 12
Adam Clark Vroman 33
Lewis Emory Walker 6
William Walling 6
Andy Warhol 22
George Kendall Warren 8
R. J. Waters 6
Carleton Watkins 711
Coy Watson Jr. 13
Delmar Watson 13
Garry Watson 14
George Watson 49
Eva L. Watson-Schutze 8
Todd Webb 11
Charles Leander Weed 20
Weegee 94
A. G. Wehrli 5
Philip Weiner 14

Brett Weston 258
Edward Weston 261
J. A. Whipple 6
John Whistler 32
Clarence H. White 19
Henry White 11
T. R. Williams 9
George Washington Wilson 9
Garry Winogrand 59
Eugen Wískovsky 33
Joel-Peter Witkin 6
Marion Post Wolcott 12
Paul Wolff 242
Wols 209
Walter B. Woodbury 16
Edward L. Woods 10
Gary Woods 7
Col. H. Stuart Wortley 11
Wurts Brothers 21
David Wilkie Wynfield 7
Dan Wynn 13
Mariana Yampolsky 10
Max Yavno 23
Janica Yoder 5
Thomas Zetterstrom 7
Willy Zielke 32
Piet Zwart 79

Index of Names and Places

About the Author

Weston Naef, curator of photographs at the J. Paul Getty
Museum, came to the Getty from New York in 1984, the year the
Department of Photographs was formed. He is the author
of numerous publications, including *The Collection of Alfred
Stieglitz: Fifty Pioneers in Modern Photography* and *The J. Paul
Getty Museum Handbook of the Photographs Collection*. He has
guided the growth of the museum photographs collection, along
with its exhibition and publication program, for twenty years.